VIKTOR SCHRECKENGOST

American DaVinci

VIKTOR SCHRECKENGOST
AMERICAN DA VINCI

By Henry Adams, Ph.D.

Edited by Sunny McClellan Morton

TIDE-MARK

Windsor, Connecticut

Published by Tide-mark Press Ltd.
P.O. Box 20, Windsor, CT 06095-0020
In Canada: 34 Armstrong Avenue, Georgetown, Ontario L7G 4R9

Printed in Korea by Samhwa Printing Co.

Design and typography by AMV Graphics.

Library of Congress Control Number 2006925078

ISBN 978-15949-0220-8

TABLE OF CONTENTS

ABOUT THE AUTHOR

Henry Adams has served as curator of Fine Arts at the Carnegie Museum of Art in Pittsburgh; as curator of American Art at the Nelson-Atkins Museum of Art in Kansas City; as Curator of American Art at the Cleveland Museum of Art; as director of the Cummer Museum of Art in Jacksonville, Florida; and as interim director of the Kemper Museum of Contemporary Art and Design in Kansas City. Recently singled out by *Art News* as one of the foremost experts in the field of American art, Dr. Adams has produced more than 200 publications including *John La Farge* (1987), *Thomas Hart Benton: An American Original* (1989), *Thomas Hart Benton: Drawing from Life* (1990), *Albert Bloch: The American Blue Rider* (1997), *Viktor Schreckengost and 20th-Century Design* (2000), *Eakins Revealed* (2005), and *Andrew Wyeth: Master Drawings from the Artist's Collection* (2006). In 2001 he received the Northern Ohio Live Visual Arts Award for the best art exhibition of the year in Northern Ohio. He is Professor of American Art at Case Western Reserve University in Cleveland, Ohio.

ABOUT THE EDITOR

Sunny McClellan Morton is the publications director for the Viktor Schreckengost Foundation and a freelance writer. With ten years of writing and editing experience, she has published previously in the fields of history and medical research, and recently coauthored a musical theater production. Sunny lives in a Cleveland suburb with her husband Jeremy and two sons, Jeremy and Alex, and is expecting her third child soon after the publication of this book.

ACKNOWLEDGMENTS

We would like to acknowledge the Viktor Schreckengost Foundation, which commissioned this book and provided information and images not available elsewhere. We would like to acknowledge the valuable contributions and assistance of several people at the Foundation, including Craig Bara, Heather Carr, Cheryl McClellan, Richard D. McClellan, Chip Nowacek, Meghan Olis, Suzy Hertzfeld, John Ely, and David Waldman. We thank contributing experts Mark Bassett, Jo Cunningham, Leon Dixon, Chris Lesser, and Michael A. Pratt for their insights and Jennifer Renk at Tide-mark Press for her patience and dedication in bringing this publication to completion. Many thanks to Gene Schreckengost for guidance, support, and proofreading; finally, we gratefully acknowledge both Gene and Viktor Schreckengost, who have opened their home and private collection and spent hours sharing memories and information about Viktor's life and work.

PREFACE

In 1999, when I organized the first major exhibition of Viktor Schreckengost's work at the Cleveland Museum of Art, I initially met with much skepticism, if not outright hostility. As peculiar objects like teacups and bicycles arrived at the loading dock of the museum, many people on the staff became convinced that the show would be incoherent and that the museum's reputation would be tarnished. What sense would the public make of such a strange assortment of objects? What finally turned the tide in my favor was Viktor himself. When I invited the ninety-four-year-old artist to talk to the museum staff about his life, his magnetism made enthusiastic converts of them. A newly inspired staff realized that, not only was Viktor's work worthy of an exhibition, but that his show offered creative possibilities that the museum had never explored before.

In the end, the show offered a number of firsts for the museum: the first use of music in the galleries (we played jazz in the room where we displayed *The Jazz Bowl*); the first use of multimedia projection; the first time the museum made a film for television; the first time it developed an interactive web site;

and of course, the first time it displayed bicycles, electric fans, and flashlights alongside more traditional art. Worries about how the public would respond proved groundless. The show drew three times the expected attendance, received glowing praise in the visitors' log, and rang up amazing profits in the museum store.

But what was most interesting about the show was that it was visually coherent. Although each new room displayed entirely different kinds of objects from the last, in every field of design something about Viktor's personality came through. One could sense that they were the products of the same artist, the same creative vision. What gave the show such coherence? This is not easy to articulate, although in a general way one can single out the qualities of Viktor's approach. For one thing, all his designs, in keeping with the principles of good modern design, have powerful, simplified forms. They also have a playful quality. The forms are generally rounded and friendly. Indeed, many of his creations have a cartoonlike quality. They are fun.

And it has been fun to get to know Viktor.

My own introduction to this remarkable man came about because of a series of happy accidents. Around the time that I moved to Cleveland, I became interested in the style known as Art Deco—the jazz-age streamlined style of the 1930s. One object particularly caught my fancy: *The Jazz Bowl*, a large black and turquoise punch bowl with jazzy decoration of martini glass, ocean liners, skyscrapers, musical instruments, and other symbols of 1930s New York. It was reproduced in every book on the subject, and one of the books I thumbed through most frequently, *The Look of

the Century, reproduced it twice. Along with the spire of the Chrysler building, it seemed to represent the pinnacle of American achievement in this vein.

When I found out that the creator of *The Jazz Bowl*, Viktor Schreckengost, lived in Cleveland, I looked him up on a whim. He agreed to visit with me at the Cleveland Museum of Art, where I was then curator. Viktor was then in his early nineties, but the years dropped away as he spoke. (Or perhaps the years added themselves to me: after our conversation, I was startled to realize that we had covered events from thirty or forty years before I was born.) At our first meeting, we briefly covered his career in pottery, sculpture, and industrial design. Frankly, what interested me most at the time was not his own work but that he had known Charles Burchfield and Rockwell Kent, American artists from the 1930s whose work I revere. I thought it would be interesting to collect Viktor's memories, and he seemed amenable to the process.

By good fortune I found a young graduate student, Shannon Masterson, who agreed to transcribe my tape-recorded interviews with Viktor. I was curious to see whether Viktor, who was nearly a century older than she, would seem to her a dusty antique, as remote as a veteran of the Civil War.

I need not have worried. Shannon attended that first interview with me, where we covered Viktor's childhood in the potteries, his study in Vienna, his work for Cowan Pottery, and his involvement with bicycles, pedal cars, and trucks. She was fascinated by Viktor's account of *The Jazz Bowl*, an object she thought was really marvelous. But what impressed her most was find-

ing out that Viktor had designed the bicycle she had owned as a child. This glorious machine was painted bright magenta and boasted streamers, pretzel handlebars, and a sissy bar behind the seat. She had carefully selected it herself, at the age of seven or eight, and it had been a major fixture of her childhood—the focus of many of her best memories of growing up. Bicycle aside, it was clear that she also responded to Viktor's zest for life, his colorful stories, and his genius for coming up with clever solutions to problems of design. As we left the house, Shannon turned to me, as if I were too dumb to figure it out for myself, and said: "You know, Viktor is wicked cool."

Making Sense of His Legacy

Only six years ago, when I began working on the Schreckengost exhibition at the Cleveland Museum of Art, much of Viktor's work was buried in his attic. I went up there often with him to look for watercolors and dinnerware and regularly made exciting finds, but much of what was up there was virtually inaccessible. I remember once going back into a crawl space behind the wall and removing several boxes filled with old plates and appliances from the studio in Sebring until finally I reached a box filled with slabs of some sort neatly wrapped in brown paper. These proved to be the original maquettes of his bird sculptures for the Cleveland Zoo. A week or so later, Viktor turned up a full-scale plaster of his Hugh O'Neill memorial. The fact that I hadn't noticed this statue, which stands nearly four feet high, suggests how deeply objects were buried in the morass.

Fortunately, the Viktor Schreckengost Foundation has started to go systematically through this trove, finding, recording, photographing, and conserving this material. There have been some wonderful finds of lost masterworks, such as the discovery of the last of the four heads that Viktor exhibited at the 1939 World's Fair in New York. As of the end of 2005, roughly 700–800 pieces and 1,200 archival documents have been digitally catalogued and photographed by the Viktor Schreckengost Foundation.

To my way of thinking, however, the most exciting development has been the discovery of Viktor's working drawings, including many preliminary drawings for dinnerware and even his first studies of the cab-over-engine truck, one of the most innovative industrial designs of the twentieth century. Accompanying these drawings are mounds of content-rich letters, price lists, and other documentation. Viktor's correspondence, for example, provides a detailed record of his commercial dinnerware designs and will probably eventually make it possible to date most of his forms and decorative patterns with precision. He kept old advertisements that provide pictures of products he mentioned to me, but about which I had no other information, such as the first pedal vehicles he made for Steelcraft. Sorting through this material will surely take decades, but already we can fill in pieces of Viktor's achievement that were shadowy before. I have been pleased to draw on this new material in this catalogue.

Henry Adams, Professor of Art History
Case Western Reserve University
November 30, 2005

VIKTOR SCHRECKENGOST: AN AMERICAN DA VINCI

Viktor Schreckengost, who turns one hundred years old on June 26, 2006, has been termed "an American Leonardo da Vinci" because of the amazing range of his accomplishments. Not only a noted painter, potter, and sculptor, he has also excelled in product design—everything from artificial limbs to velocipedes. Indeed, he is one of the pioneers of modern industrial design, a term which first came into use right about the time he started his professional career.

Viktor was born in Sebring, Ohio, the son of a potter. He studied from 1925 to 1929 at the Cleveland School of Art (now called the Cleveland Institute of Art), where he was both first in his class and president of his class all four years. After graduation, he continued his education in Vienna, where he worked under the potter Michael Powolny and the famed architect Josef Hoffmann, the leading figure of the Wiener Werkstätte. On his return to the United States in 1930, Viktor pursued a triple career, winning awards in art exhibitions for his paintings and sculpture while simultaneously designing for

5

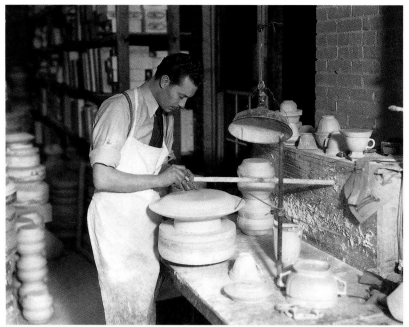

Viktor Schreckengost, ca 1930s, at work as a dinnerware designer.

for example, was an exceptionally talented draftsman; but, as his career progressed, he set aside his artistic talents to focus on salesmanship and the growth of his business. Eventually he did little design work even within his own firm, let alone in other artistic ventures. The same might be said of Norman Bel Geddes. Viktor, on the other hand, remained highly productive as a fine artist throughout his career as an industrial designer. He regularly exhibited his paintings, pottery, and sculpture.

mass production. Additionally, he taught at the Cleveland Institute of Art, and initiated there in 1933 what is often regarded as the first modern industrial design program in the United States.

Industrial Design Pioneer

The term *industrial design* was first used by Norman Bel Geddes in 1927, and the birth of industrial design as a profession is often fixed at 1929, when Raymond Loewy designed the Gestetner Duplicator. Viktor Schreckengost was part of this founding generation: he began his career as an industrial designer in 1930, only a year after Raymond Loewy.

Among this first generation of modern industrial designers, however, Viktor stands out, for he never abandoned his career as a fine artist. Raymond Loewy,

There is a conscious philosophy that guided Viktor's work, about which he wrote on more than one occasion: good design should be available to everyone. Mass production makes possible the ideal that beautiful, functional, finely made objects can be produced at low cost. Objects can and should go beyond simple usefulness and add value and pleasure to one's life. In an undated typescript describing his approach to design, Schreckengost wrote:

My work has been constantly involved in the struggle between fine arts and their development into some functional form of what we call the applied or commercial arts. It took many years for me to realize that they need

Viktor Schreckengost as a student in Vienna.

not conflict, that a basic philosophy, conviction or understanding may be common to both.... There is no separate set of rules for each, nor need there be a prostitution of one's artistic integrity. There can and must be a continuity, a basic concept in the artist's mind which will show up in everything he does.

In most cases the additional limitations of mass production, volume distribution, and quantity place even greater responsibility on the artist. Within these restrictions there is still ample room

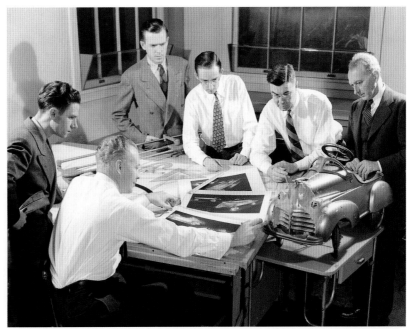

Viktor, in foreground, meets with executives, salesmen, and engineers at Murray Ohio. This photo was taken around 1939.

for the artist to express himself and speak to a multitude of people, to affect their lives and increase their understanding for better things.[1]

"Viktor Schreckengost remains one of America's most awarded artist-designers and the earliest and oldest living recipient of the Binns Medal (1938), this nation's highest honor in the ceramic arts."

—Michael Pratt, mid-century modern design researcher

Viktor's design career alone would have constituted an extremely busy, fulfilling professional life. He was chief designer for three different companies simultaneously: American Limoges (dinnerware, early 1930s to early 1940s); Salem China Company (dinnerware, 1930s to mid-1950s); and Murray Ohio (bicycles and pedal cars, 1937 to 1971). In addition, he consulted for several manufacturers and retailers from the 1930s through the 1960s: Sears, Roebuck; Delta Electric; Firestone; Goodyear; Western Auto; JC Penney; General Electric; R. R. Donnelly &

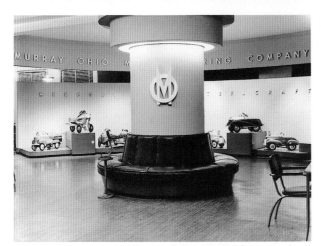

Murray showroom in New York (ca 1950), featuring both a logo and layout that were redesigned by Viktor.

1 "The Artist's Way is Strait" by Viktor Schreckengost. Undated typed manuscript. Viktor Schreckengost Archives, Cleveland Heights, Ohio. Online version available at www.viktorschreckengost.org.

Sons (Chicago); the Holophane Corporation; White Motor Company (for whom he designed the first cab-over-engine truck); Harris-Seybold (for whom he designed printing presses); and others. But Viktor also produced hundreds of museum-quality ceramics, watercolors, and other fine art pieces during his long lifetime.

Fine Artist

Viktor Schreckengost is one of the most versatile and original ceramic artists America has produced. The *Jazz Bowl* series, produced when Viktor was still in his twenties, is recognized as an icon of the Art Deco era. His decorated bowls and plates of the 1930s, such as *Pegasus* and *Leda and the Swan*, are increasingly reproduced in books on Art Deco and stand out as masterworks of their period. In the 1930s and 1940s he also produced wonderful clay statuettes, which moved clay sculpture away from the stale classical allegories then in vogue and introduced lively, vernacular subject matter

Viktor at work on the 1949 O'Neill Memorial

like jazz musicians and humorously caricatured animals. His magnificent ventures into political commentary, such as *The Dictator* and *Apocalypse '42*, are simply unparalleled in the ceramic art of the period, both for their irreverent originality and power of statement: they look forward to the Funk Aesthetic introduced by Robert Arneson some thirty years later.

Viktor's "slab forms" of the late 1940s brought another new approach to American work in clay: he created ceramic vessels off the pottery wheel that he treated as pure sculpture. Like his political sculptures, the slab forms were prophetic, anticipating the much-later creations of Peter Voulkos. Viktor has also been a successful sculptor on a monumental scale. His projects for the Cleveland Zoo and Lakewood (Ohio) High School have become local landmarks.

Finally, Viktor was an outstanding prize-winning watercolorist who explored a wide range of subject matter, from still-life to landscape, in an ever-changing series of styles, from realistic to abstract. In the 1950s and 1960s, he won four purchase prizes from the American Watercolor Society. His watercolors have been reproduced in books, prints, posters, and greeting cards.

Over the years, Viktor won more prizes at the Cleveland Museum of Art's May Show than any other artist. He was a 1938 Charles Fergus Binns Medal winner from the American Ce-

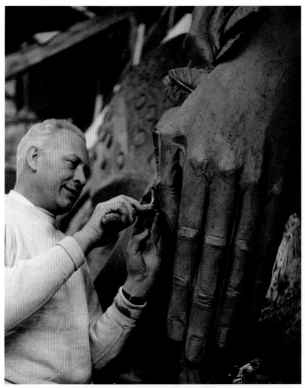

One of Viktor's largest projects: *Early Settler*

ramic Society (Outstanding Contribution to the Ceramics Field). In 1952, he was the only sculptor in clay to have his work included in a prestigious survey of American sculpture at the Metropolitan Museum of Art in New York. His lifetime artistic achievement awards include the State of Ohio Governor's Award for the Arts (2000) and Honorary Lifetime Membership award from the American Ceramic Society (1982).

Viktor's Character and Influence

To those who know Viktor, two of his traits are particularly striking: his childlike playfulness and his iron discipline. Whenever I visited his house, he would have a new plaything on the dining room table to show me, and he kept a collection of them on a shelf in his library—a wind-up car, a spinning top, a duck with an egg on its back

that would turn oddly when it rolled forward, a geodesic dome that one could twist into different shapes. At some point it occurred to me that all these toys were aimed at children ages seven to eleven, and that Viktor was good at designing for this age group because he himself had never ceased to think and feel like a child.

Seemingly in contradiction to this is the forcefulness of Viktor's character. This is a man who was first in his class, who was president of his class, who enjoyed basic training in the Navy because it tested his stamina, and who produced a significant work of art every two weeks for over seventy years, meticulously keeping a file card record on each one.

Somehow the combination of these two qualities created a figure who was endlessly creative, who could come up with an interesting solution to any problem thrown at him. Viktor was always ready to take on any challenge of design, whether for party decorations, a school insignia, a punch bowl, a monumental sculpture, a chair, a flashlight, a printing press, or a bicycle. Over the years, it is remarkable how many times he not only came up with a good design but revolutionized an entire industry. In retrospect, some of these ideas seem remarkably simple except that no one had come up with them before. He changed truck design by putting the engine under the cab; he changed children's toys by greatly simplifying the process by which they were made, that is, by stamping them out of a single piece of metal that was simply bent into shape; he transformed bicycle design by figuring out how to do the welds all at one moment in a hydrogen braz-

ing furnace; he transformed printing presses by enclosing the working parts so that they were safe and clean and by adding electronic controls; he devised riding lawn mowers that one could ride without losing one's toes. Viktor developed some fundamental innovation in nearly every field of industrial design in which he engaged.

Some of the basic concepts Viktor introduced were borrowed from what he had learned in Europe through his knowledge of design groups such as the Wiener Werkstätte and the Bauhaus. Two basic principles were that design should make use of the unique qualities of the machine and mass production; and that modern design should eliminate fussiness and frills and employ direct, simple, cleanly functional forms. He was also in-

terested in the idea that good principles of design could be applied across industries—that someone who designed good dinnerware could also design a good flashlight. European design often had an elitist quality, and Viktor successfully translated these ideas into an American setting. Viktor knew how to work with American businessmen to produce products that met the needs of the American marketplace. What he practiced and taught was not abstract theory but knowledge that could quickly be put to practical use.

Perhaps Viktor's greatest contribution to design is that his objects are friendly and fun. Modern design has generally been studied from a formalistic point of view, most notably by the Museum of Modern Art in New York. But objects that look nice on a museum pedestal do not always work well in the home and often do not seem appealing to the average buyer. Viktor had a genius for cre-

Throughout his life Viktor has loved being around children, though he never had young children of his own (he gained grown stepchildren with his second marriage). Viktor is shown here as a young man in 1922 with his nephew Don Eckleberry, who later became a distinguished ornithologist and Audubon bird artist, and as a much older man with some neighborhood children in his backyard.

Viktor's toy designs fired the imaginations of children.

strict but open up the possibilities of play and fully engage a child's fantasy and imagination. Remarkably, his riding lawn mowers appeal to many of the same instincts. His tractor lawn mower, for example, allows men to pretend that they are driving a tractor rather than just cutting the grass.

Though Viktor's playfulness has profoundly influenced modern American design, to my knowledge this has never been commented on or recognized. Over the years, Viktor has had about a thousand industrial design students at the Cleveland Institute of Art. They have gone on to spread his influence in many different industries but particularly in the fields of car and toy design, where they have designed products that have contributed billions to the American economy. His influence can be traced most directly in toy design. His students John Nottingham and John Spirk, for example, openly acknowledge his influence on the children's toys and play equipment that they have designed for Little Tikes. The evidence can be found in the products themselves: bright colors; friendly, playful, cartoonlike shapes; and the way that everything is adjusted to the scale and proportions of a child.

In automotive design, Viktor's influence as a teacher possibly has been even more profound. Viktor was adept at establishing networks with powerful executives and in placing his students

ating objects that seem friendly. It is intriguing, for example, to compare Viktor's early dinnerware designs with those of the Wiener Werkstätte or of his pottery teacher at the Kunstgewerbeschule, Michael Powolny. Viktor's Manhattan dinnerware, for example, uses globular shapes that are similar to some of Powolny's designs, but the final effect is entirely different. Powolny's designs feel stiff and formal; Viktor's are at home in a diner or Mom's kitchen.

Viktor's ability to make designs with such grass-roots popular appeal had something to do with his inherently childlike qualities. He recognized that most adults are children at heart. Many of his designs both engage our sense of play and have a cartoonlike quality. Viktor's pedal cars, for example, were revolutionary because they did not try to look exactly like real cars. They are cartoonlike cars, and for that very reason they are more fun to play with since they do not re-

in major American companies such as Ford and General Motors. One of his students, Joe Oros, was responsible for the design of the Ford Mustang, one of the most significant designs in automotive history. The Mustang was financially significant for Ford, for its immense popularity rescued a company that was hovering on the verge of bankruptcy. Equally important, it introduced a new sense of what an automobile could be. It was not just a mundane form of transportation but a car for young people, a car with a cartoonlike sleekness, a car that was sexy, a car that was a plaything for adults. In many ways, the Mustang marks the beginning of contemporary car design. Viktor's legacy continues even today. The Cleveland Institute of Art, for example, is still considered one of the three leading schools in the United States in the field of automotive design.

One can list a great many reasons why Viktor's work is so appealing, but at the heart of the matter is that Viktor is a lovely person who loves people and, in some peculiar fashion, this is communicated in his work. Those who knew Viktor as a young man recall him as a tall, handsome, blonde Viking, who would arrive at the Cleveland Institute of Art on gray winter mornings looking relaxed, cheerful, and tan, no matter how miserable the weather. He is no longer blonde and tan, but it is still a delight to see him—his enthusiasm for life is infectious. This love of life, people, and play is a fundamental quality of his designs.

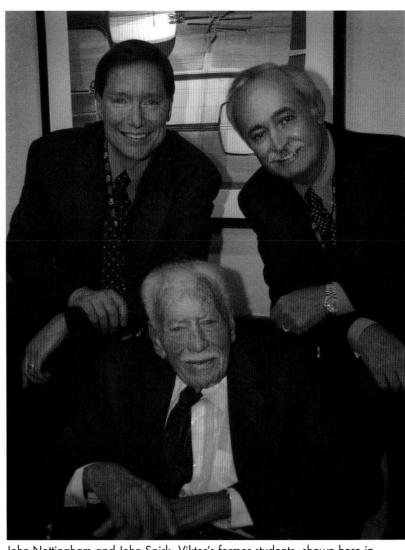

John Nottingham and John Spirk, Viktor's former students, shown here in 2005 with their teacher Viktor Schreckengost at a fund-raising dinner for the Cleveland Institute of Art. The gala affair included a fully mounted show of Viktor's designs and verbal tribute to his influence on modern design and specifically on Nottingham and Spirk. Nottingham-Spirk Design Associates is a leading product invention and development group that is responsible for the creation of hundreds of successful products with more than 400 commercialized patents. Combined sales of products created by Nottingham-Spirk exceed thirty billion dollars.

THE *JAZZ BOWL* STORY

It comes as a surprise to Viktor Schreckengost that his signature work has become the *Jazz Bowl*. The initial popularity of this punch bowl, originally designed for Eleanor Roosevelt in 1930, led to the creation of an entire series of jazz-related pieces in the 1930s. But the bowl gradually disappeared from Viktor's A-list of achievements as later ceramics and industrial designs supplanted his earlier works. By the 1940s, the *Jazz Bowl* didn't even rate a mention in articles that frequently appeared on Viktor's works. When Art Deco became popular during the early 1980s, the *Jazz Bowl* was immediately identified as an iconic piece. Its bold blue and black motifs exude the modern sensibility and glamour of urban nightlife at the height of Prohibition in the United States. The bowl's common reproduction in Art Deco texts, regular appearance in exhibitions, and skyrocketing sales prices have led to its emergence as Schreckengost's banner piece in the years since Viktor's retirement.

The *Jazz Bowl* is featured in the following publications:

Crockery and Glass Journal, December 1930

Cowan Pottery, *Catalogue*, 1931 (illustrates *Cocktails and Cigarettes* punch bowl)

"Statement of the Jury," *The Bulletin of the Cleveland Museum of Art*, no. 5, May 1931, not paginated. Jurors were Henry E. Schnakenberg, Gertrude Herdle, and John Sloan

"Youthful Designer Inherited His Taste for Art," *Cleveland News*, November 2, 1931

"Art Alliance Dinner for Cleveland Artist," *The Youngstown Vindicator*, Youngstown, Ohio, Sunday, December 4, 1932

"Fine Craftsmanship," *London Studio*, February 1933, p. 131

"Viktor Schreckengost of Ohio" (a transcribed conversation). The Studio Potter 2:1, December 1982, p. 74–79 .

Eva Weber, *Art Deco in America*, Exeter Books, New York, 1985

Richard Guy Wilson and Dianne H. Pilgrim, *The Machine Age in America, 1918–1941*, The Brooklyn Museum in association with Harry N. Abrams, Inc., Publishers, New York, 1988

Elaine Levin, *The History of American Ceramics, 1607 to the Present: From Pipkins and Bean Pots to Contemporary Forms*, Harry N. Abrams, Inc., Publishers, New York, 1988

Cara Greenberg, "Metro," *Metropolitan Home*, November 1989 (*Poor Man's Bowl* illustrated in color)

Sharon Pinzone, "Rocky River's Lost Colony of Artists," *Avenues* (Cleveland), December 1989

John Russell, "The Cooper-Hewitt Displays More of its Design Trove," *The New York Times*, Friday, September 6, 1991, The Living Arts, B1

Derek Ostergard, *Art Deco Masterpieces*, Macmillan Publishing Company, New York, 1991 (one of only two American works included)

Jonathan Fairbanks, et. al., *Collecting American Decorative Arts and Sculpture, 1971–1991*, Museum of Fine Arts, Boston, 1991

Postcard, Museum of Fine Arts, Boston, 1991

Henry Hawley, "Cleveland's Cowan Pottery," *Western Reserve Antiques Show*, 1993

Christina Corsiglia, "Viktor Schreckengost: Evolution of a Cleveland Ceramist," *Cleveland as a Center of Regional American Art*. Proceedings of Symposium of the Cleveland Artists' Foundation, Cleveland Museum of Art, Cleveland, Ohio, Nov 13–14, 1993, p. 100–112.

Leslie Pina, *Pottery, Modern Wares 1900–1960*, Schiffer Publishing, Ltd. Atglen, Pennsylvania, 1994

American Art at Harvard: Cultures and Contexts. Harvard Art Museums Gallery Series, No. 9. Exhibition Catalogue, October 1–December 30, 1994

Tim and Jamie Saloff, *The Collector's Encyclopedia of Cowan Pottery, Identification and Values*, Collector Books, A Division of Schroeder Publishing Co., Inc. Paducah, Kentucky, 1994

Karen Lucic, "Seeing Through Surfaces: American Craft as Material Culture," in *Craft in the Machine Age, 1920–1945*, edited by Janet Kardon, New York Abrams and the American Craft Museum, 1995

Christine Temin, "Fogg's Matchmaking Recasts Art History," *The Boston Globe*, September 1, 1995, p.101. Reviews exhibition *The Persistence of Memory: Change and Continuity in America's Cultures* at the Fogg Art Museum, Harvard University, Cambridge, Massachusetts

Laura E. Bronson, "Cross Country," *Country Living*, November 1995

Dennis W. Griffith, Curator, *The Spirit of Cleveland: Visual Arts Recipients of the Cleveland Arts Prize, 1961–1995*

Karen McCready and Garth Clark, *Art Deco and Modernist Ceramics*, Thames and Hudson Ltd., London, 1995

20th Century Sale, February 12, 1995, Treadway Gallery, Inc., Cincinnati, Ohio

William Robinson and David Steinberg, *Transformations in Cleveland Art, 1796–1946*, The Cleveland Museum of Art, distributed by Ohio University Press, 1996

Michael Tambini, *The Look of the Century*, DK Publishing, New York, 1996 (reproduced twice).

Mark Bassett and Victoria Naumann, *Cowan Pottery and the Cleveland School*, Schiffer Publishing, Ltd., Atglen, Pennsylvania, 1997

William Daley, "In Conversation: Viktor Schreckengost/William Daley," *American Craft*, June–July 1997

"Reflections on Art and Culture: A Series of Lectures and Gallery Talks" (mailer), The High Museum of Art, February 1998

Judith Miller, ed, *Miller's Antiques Encyclopedia*, Reed Consumer Books, Ltd, London, 1998

Henry Adams, *Viktor Schreckengost and 20th-Century Design*, The Cleveland Museum of Art, 1999

Henry Adams, "Cocktails and Cigarettes," member's magazine, Cleveland Museum of Art, December 2000

Barbara Haskell, *The American Century: Art & Culture 1900–1950*, Whitney Museum of American Art, New York, in association with W. W. Norton & Company; New York, London 1999 (the only ceramic included)

Mark Favermann, "Viktor Schreckengost: An American Design Giant," *The Journal of Antiques and Collectibles*, January 2001, p. 27–29

Paul Makovsky, "Pedal to the Metal," excerpt from "Nine over Ninety," *Metropolis Magazine*, special issue, January 2001, p. 80–83

Henry Adams, "Viktor Schreckengost at 99," *Modernism Magazine*, vol. 8, no. 3, Fall 2005, p. 72–83

The Creation of the *Jazz Bowl*

Schreckengost designed his single most famous piece, now known commonly as the *Jazz Bowl*, in 1930, soon after returning to Cleveland from Vienna. At the time, he was working for Cowan Pottery in Rocky River, Ohio, run by his former teacher at the Cleveland Institute of Art, Guy Cowan. Viktor recalls, "Guy had a hopper in the office and, if you ran out of assignments, you could reach in there and pull out a suggestion. I reached in and pulled out this thing. A gallery in New York said there was a woman who wanted a New Yorkish punch bowl. And Guy said, 'Why don't you do that, Vik?'"[1]

Not long before, Viktor had celebrated New Year's Eve in New York. He visited the Cotton Club and a show at the Radio City Music Hall where the organ came up through the floor.

Then I tried to think: what would be New Yorkish? And then I remembered New York. As I recalled, it was this peculiar blue light that came over the city at night. With all the high buildings and the stop and go lights and the jazz bands that were playing the Cotton Club, and Duke Ellington. So I started to put these ideas together. [2]

The word "punch" comes from the Hindustani word *panch*, meaning "five," which refers to the five ingredients then used in the drink, namely tea, arrack, sugar, lemons, and water. In the 1930s, punch contained alcohol, so the order of a punch bowl implied that the owners loved a good party. Despite Prohibition, Viktor included images of cocktails and wine bottles. But his main theme was music.

The design Viktor devised tells the story of a visit to New York on New Year's Eve. It begins with a row of gentlemen wearing hats who are standing by gleaming streetlights and a clock that reads 3:30—clearly the morning rather than the afternoon. We then move on to signs reading "Stop" and "Go"—admonitions that apparently humorously allude to drinking. We then proceed past a group of high-rise buildings and ships on the Hudson River. At that point we encounter a scene of musical instruments, including an organ based on the one in Radio City Music Hall and a drum head that bears the word "Jazz." Finally, the journey ends with a scene of a bottle, cocktail glasses, and stars.

Viktor's design represented a new approach in American ceramics. Previous hand-made American ceramics had appealed to "good taste" and had generally either imitated Chinese porcelain or had been designed in an Art Nouveau style that paid tribute to the beauty of nature and natural forms. Viktor's design was new both in its Art Deco style (and in its references to artistic approaches such as Cubism) and in its irreverent, popular subject matter, including somewhat naughty pleasures, such as cocktails and African-American jazz music. As a critic for *The New York Times* recently wrote:

There is nothing stuffy about the glazed porcelain punch bowl called Jazz.... *If ever there was a period piece with a period name on it, this is it. This [bowl] does a great job of pretending that there was no such thing as the Depression. Generous enough to call*

1 Interview with Henry Adams, June 21, 1999, Archives of the Cleveland Museum of Art, typescript page 5.

2 Op. cit, page 6.

for a big ladle, it features on its side an ocean liner, a starry night filled with the sound of jazz and the words Dance and Follies in huge letters. On shore, New York is shown in terms of unrestricted upward energy, and we cannot believe that on that liner the life jackets will ever be needed. Sophistication could not be more wistfully portrayed.[3]

Viktor's method of making the bowl was also novel. Because the dimensions of the bowl he planned made it too large to throw on the potter's wheel, a mold was first made from plaster. His purely parabolic design was cast separately from the foot. Then, he explains,

A hard, white vitreous clay was cast into the mold. After drying, a hard deep brownblack slip was sprayed over the white body and the decoration cut through, allowing the white body to show. After a bisque fire a deep blue-green Egyptian Blue glaze was applied and fired again.[4]

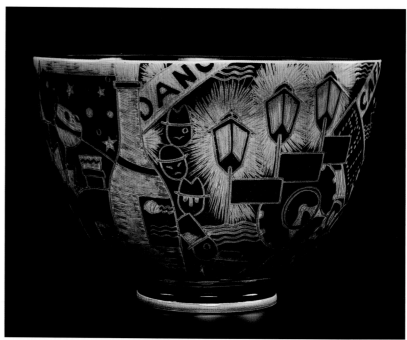

The New Yorker Jazz Bowl, parabolic, 1931. H. 28.7 cm. The *Jazz Bowl* tells a story in-the-round of an evening on the town in New York City.

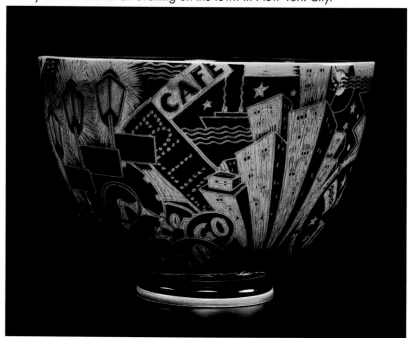

The New Yorker Jazz Bowl, parabolic, 1931. Additional view.

3 Russell, John, "Cooper-Hewitt Displays More of Its Design Trove," *The New York Times.* September 6, 1991, page C5

4 Letter from Viktor Schreckengost to Homer Kripke, One Park Avenue, New York, February 15, 1954, Viktor Schreckengost Foundation.

Since the design was scratched through by hand, it has a hand-made, slightly rough quality, which makes the color glow like stained glass. The slightly rough quality of the work gives the

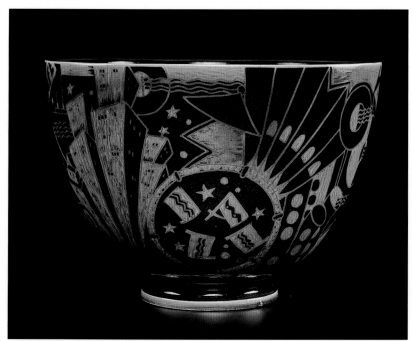

The New Yorker Jazz Bowl, parabolic, 1931. Additional view.

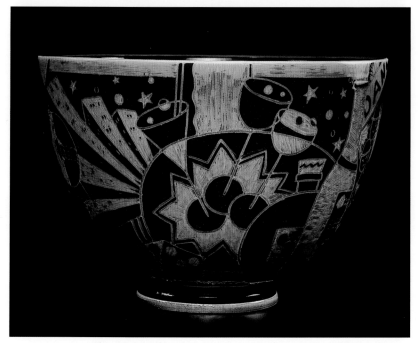

The New Yorker Jazz Bowl, parabolic, 1931. Additional view.

Once the bowl was complete, Cowan shipped it off to New York—it was only at this point that Viktor learned who had been the patron of the piece. *In about a week we had a letter back saying that the lady was crazy about the bowl and she wanted two more, one for Hyde Park and one for the White House—she was sure Franklin was going to win.*[5]

At that point he realized the purchaser was Eleanor Roosevelt. According to a 1931 article in the *Cleveland News*, Eleanor originally considered asking *New Yorker* cartoonist Peter Arno to create a design but turned to Cowan Pottery on the advice of the gallery. She paid $50 for the piece, seemingly a small sum today but a lot of money during the Great Depression.[6]

On January 4, 1954, a lawyer in New York named Homer Kripke wrote to Viktor from his office at One Park Avenue, reporting that he had just purchased a large punch bowl inscribed with Vik-

piece a vigor that contrasts with the more pristine but also less exciting execution of French ceramics of this period.

5 Henry Adams, interview with Viktor Schreckengost, June 21, 1999, typescript page 6–7.
6 Article in the *Cleveland News*, November 2, 1931, Schreckengost scrapbook #1, Viktor Schreckengost Foundation.

tor's name and the word "jazz" from a decorator shop in Boston.[7]

I have noted that there are innumerable articles on your work in the Reader's Guide to Periodical Literature *on the arts, and I have read those which appear to deal with punch bowls or vases but have not found any reference to this one. I should appreciate it if you can tell me whether this is a unique piece or whether you did several like it. If it has been written up anywhere, I should appreciate a reference to the article. My wife and I are very pleased with it.*[8]

Kripke's letter reveals that the *Jazz Bowl* was not well known at this time, while Viktor's response provides one of the first accounts of the commission. On February 15, 1954, Viktor wrote back:

According to my records you have one of a series of bowls which I made for the Cowan Pottery Co., Rocky River, Ohio in 1930–31. It became part of a limited edition line after a very interesting commission.

A request was received from New York to submit a sketch for a Punch bowl which showed a New York theme. Several sketches of mine were submitted and this one selected. Upon completion, we received a very nice letter stating that the wife of the New York Governor, Mrs. Franklin D. Roosevelt, was very well pleased with it.[9]

Production of the *Jazz Bowl*

Today the piece is generally known as the *Jazz Bowl*, but Cowan Pottery marketed it under the name *The New Yorker*, and Viktor liked to call it *New Year's Eve in New York*. Three different variations of the *Jazz Bowl* were produced and, in addition, Viktor made several variations of the design exploring similar Jazz-Age themes.

The *Jazz Bowl* produced for Eleanor Roosevelt had a dramatically simple semicircular or parabolic shape. Cowan Pottery produced two variations of the same design. The first of these variations was virtually identical to the original bowl but had a flared rim. There was a practical reason for making this change—adding a flare provided supplemental strength to the rim and made it less likely to warp in the kiln. In addition, Guy Cowan seems to have liked slightly fussier shapes than Viktor. (Before the *Jazz Bowl* commission, he had insisted on adding handles to Viktor's globular vase.) He seems to have felt that Viktor's original shape for the *Jazz Bowl* was too bold and simple.

Viktor never liked the flared shape. To keep bowls of his original shape from deforming in the kiln, he proposed making a circular ring that would surround the rim of the inverted bowl and hold it in place. This ring could then be finished as the frame for a mirror. Guy Cowan, however,

7 Kripke's letter is actually dated 1953, but this was apparently a careless error as the subsequent letters between him and Viktor are all dated 1954. Since it was early in January, the mistake was natural.

8 Letter from Homer Kripke to Viktor Schreckengost, January 4, 1954, Viktor Schreckengost Foundation.

9 Letter from Viktor Schreckengost to Homer Kripke, February 15, 1954, Viktor Schreckengost Foundation.

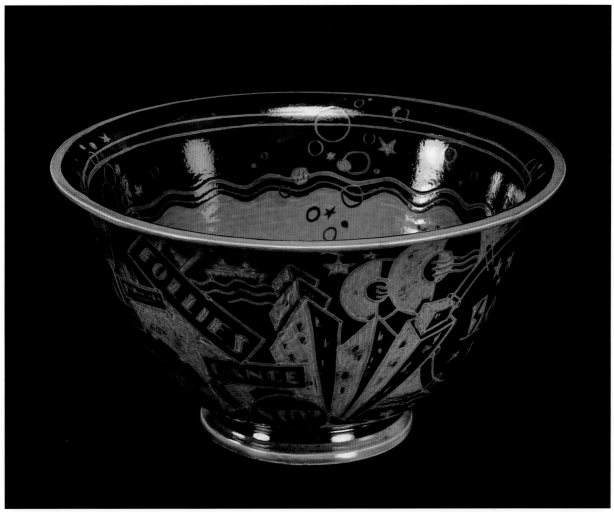

The New Yorker Jazz Bowl, flared. 1931. H. 21.6 cm.

did not like this suggestion, and it is not clear if the design was even attempted.

In addition, a third version of the *Jazz Bowl* was made—known today as the *Poor Man's Bowl* since, from the time it was made, it has always sold for about half the price of the original *Jazz Bowl*. (Today it retails for over $50,000, a bargain compared to the other bowl although sadly more than most of us can afford.)

The design for the original *Jazz Bowl*, in both the flared and unflared versions, was done by sgraffito, a method of scratching the design by hand back through the initial engobe with the aid of stencils. While Viktor sometimes scratched out the entire design without assistance, he often scraped away only the outlines, and young women in the shop would finish his design, using his outlines as a guide. Because only the major outlines were done with stencils and the interior drawing and scratching were done freehand, there is considerable variation from one *Jazz Bowl* to another. A 2005–2006 re-creation of the *Jazz Bowl* by the Viktor Schreckengost Foundation confirms that the scratching effort is quite time-intensive: modern assistants take about fifteen hours to complete each bowl after the major outlines are

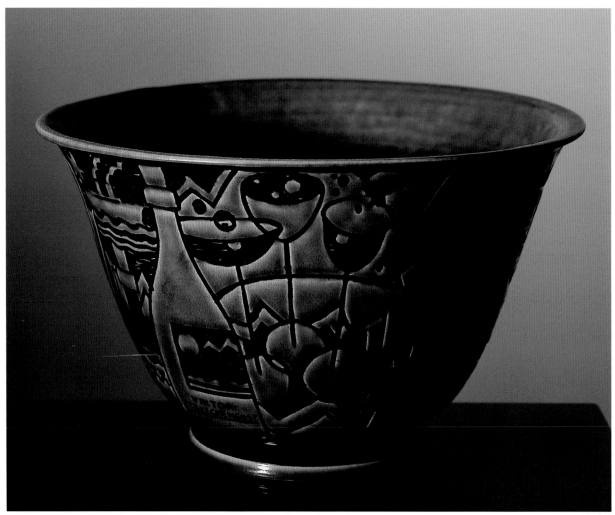

This version of the *Jazz Bowl*, available in both blue and green, was known as the *Poor Man's Bowl* because its easier production process made the bowl more affordable.

drawn by the supervising artist in much the same fashion that Viktor and his staff worked seventy-five years ago.[10]

The *Poor Man's Bowl* employed a different technique. Viktor carved the design on a form from which a mold was made. The resulting bowls had the design in relief. After the shape was fired, the bowl was covered with black engobe. The engobe was then scraped off the raised areas but remained in the "valleys" in between. In other words, the design could be created by

scraping the raised surfaces rather than scratching out the design line by line. In a sense, this "poor man's" technique was the reverse of that used for the sgraffito *Jazz Bowl*s, since the light areas of the latter were scratched through the surface and were slightly lower than the dark areas, whereas with the *Poor Man's Bowl*, the light areas were higher. As a result, the technique employed for the *Poor Man's Bowl* was much less labor-intensive. Scraping away the engobe only took an hour or so. While beautiful, the design is also a step down from the sgraffito *Jazz Bowl*s—the former is slightly more mechanical in feeling and

10 For more information on this endeavor, go to www.viktorschreckengost.org.

has less detail. In addition, the overall shape of the bowl is less bold and dynamic with slightly straighter sides and a flared rim that breaks the rhythm of the curve.

Other Jazz-theme Punch Bowls

Viktor's 1953 letter to Homer Kripke mentions that he made some variations on the design:

With a few exhibitions coming up, I decided to make a few more, using the same technique, with different subjects. A very similar one won the First Award, Cleveland Museum of Art, in May 1931. Another was shown at the Metropolitan Museum, N.Y. in the Fall of 1931.[11]

An original parabolic bowl was displayed at the Metropolitan Museum of Art in 1931. A closely related design, *Cocktails and Cigarettes*, was the award-winner Viktor mentioned for the 1931 Cleveland May Show. There it received an award from the jury—which consisted of Henry E. Schnakenberg, Gertrude Herdle, and John

11 Viktor Schreckengost to Homer Kripke, February 15, 1954, Viktor Schreckengost Foundation.

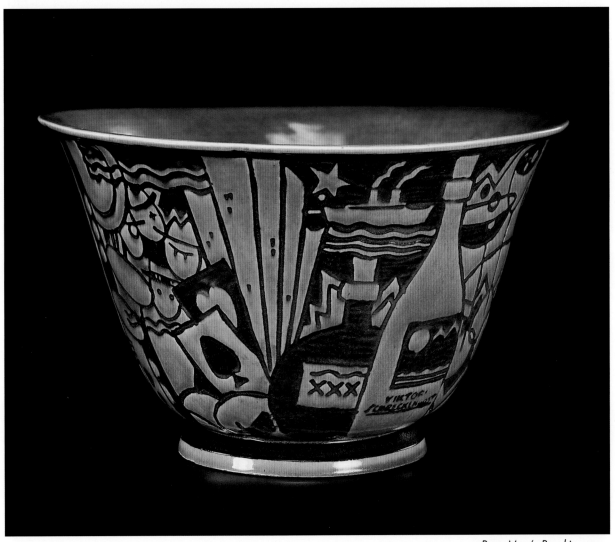

Poor Man's Bowl in green

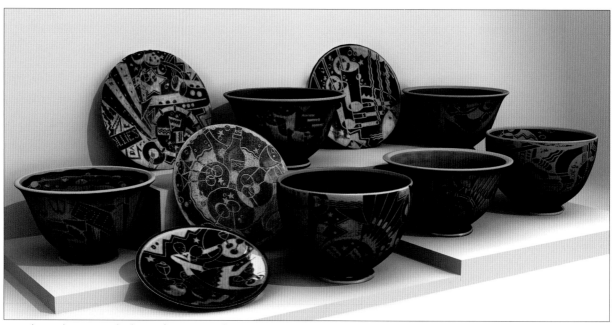

Jazz-themed pieces. Clockwise from center front: 1) *The New Yorker Jazz Bowl* (originally named by Viktor *New Year's Eve in New York*). Parabolic shape, originally designed for Eleanor Roosevelt. 2) *Cocktails* plate. 3) *Danse Moderne* plate (originally titled *Moderne*). 4) *New Yorker Jazz Bowl*. Flared rim. 5) *Jazz* plate. 6) *Cocktails and Cigarettes* punch bowl. 7) *Cocktails and Cigarettes* plate. 8) *Night Club* bowl. 9) *Rhythm in Blue* bowl. 10) *Poor Man's Bowl*. Computer-generated composite photo, The Viktor Schreckengost Foundation, 2005

Sloan—and was purchased from the show by S. Livingston Mather. By an odd coincidence, one of Mather's ancestors, Samuel Mather, the son of Cotton Mather, wrote a poem about punch in 1757 that opens:

> You know from Eastern India came
> The skill of making punch as did the name.
> And as the name consists of letters five,
> By five ingredients is it kept alive.

In 2000, when William Mather's descendents were asked to look for the bowl, they reported that they owned no such object. After an intensive search, they eventually discovered it in a pantry, hidden behind some other crockery, and generously donated it to the Cleveland Museum of Art. According to Viktor, when it was purchased by Mather, Cowan agreed not to put it into production.[12]

12 Adams, Henry, "Cocktails and Cigarettes," *Member's Magazine*, Cleveland Museum of Art, December 2000.

"**The large punch bowl [*Cocktails and Cigarettes*] by Viktor Schreckengost took the premier award. Not only is the color of this piece beautiful, but the choice of motif and the adaptation of that motif to the design is singularly happy.**"

"Statement of the Jury," *The Bulletin of the Cleveland Museum of Art*, May 1931.

Two additional punch bowl designs, *Night Club* and *Rhythm in Blue*, appear in a February 1933 issue of *London Studio*, along with a *Poor Man's Bowl*. The caption identified them all as the work of Viktor Schreckengost, although it misspelled his name and said he was from Vienna. (Of course Viktor had studied in Vienna in 1929–30.) *Night Club* was a flared bowl with dancers similar to those on the *Danse Moderne* plate. *Rhythm in Blue* featured a guitar and other musical instruments.

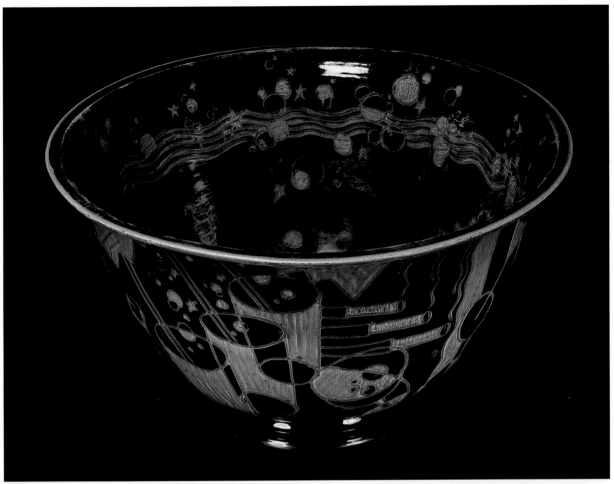

Cocktails and Cigarettes, 1931. H. 23.5 cm.

To date, only this photo and two reference cards from Viktor Schreckengost's archives attest to the existence of these two bowls. The reference card that Viktor kept for *Rhythm in Blue* states that the bowl was exhibited at a one-man show in Akron in 1931 and then "returned to Cowan Pottery—destiny unknown." The reference card for *Night Club* states that the bowl was damaged but sold by a gallery in 1937 for a reduced price. The *London Studio* photo is not

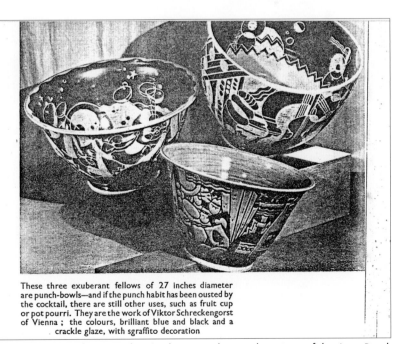

These three exuberant fellows of 27 inches diameter are punch-bowls—and if the punch habit has been ousted by the cocktail, there are still other uses, such as fruit cup or pot pourri. They are the work of Viktor Schreckengorst of Vienna ; the colours, brilliant blue and black and a crackle glaze, with sgraffito decoration

An article in *London Studio* praised several versions of the *Jazz Bowl*.

an advertisement but a report of "Fine Craftsmanship," and does not mention sales information. It is likely that neither of these two bowls was put into production. Very likely, they both were unique objects.

Still another punch bowl, *Firmament*, is recorded in Viktor's files as a black-on-Egyptian-blue-glaze bowl. It was exhibited in the 1938 May Show and sold through the Cleveland Museum of Art, but no photo ex-

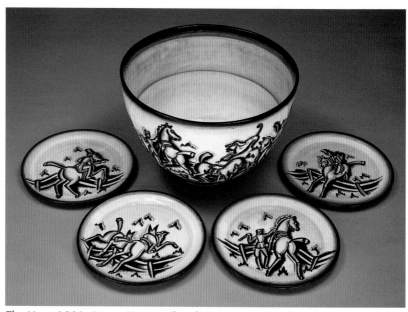

The Hunt, 1931. Diam 41.9 cm (bowl); 29.2 cm (plates).

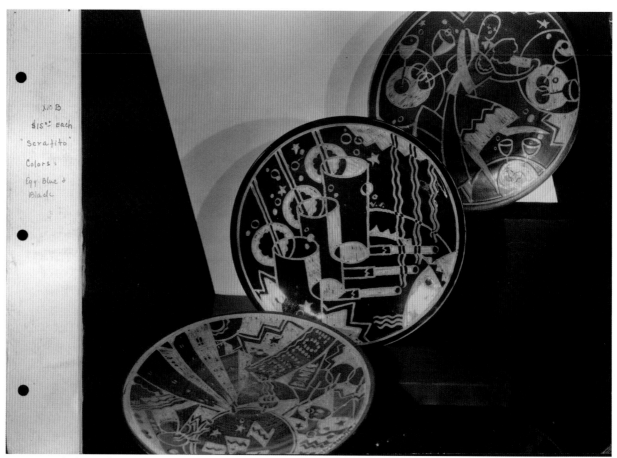

Promotional photo of Jazz-theme plates. From front: *Jazz, Cocktails and Cigarettes,* and *Danse Moderne.* Photo courtesy of Cowan Pottery Museum Associates. Note their original cost: $15 each. The current sales record for a *Danse Moderne* plate is more than $20,000.

ists of it and its present location is unknown. The title suggests that it featured a design of planets similar to that found on the interior of several of the *Jazz Bowls*.

Jazz Plates

When Viktor created an earlier punch bowl called *The Hunt*, he also painted four accompanying plates, and he exhibited the whole group together at the May Show. In a similar spirit, he seems to have created matching plates to go with his jazz-theme punch bowls. Presumably an affluent person could purchase both bowl and plates to create a set.

A promotional flyer for Cowan Pottery reproduces three of these jazz-theme plates: *Jazz*; *Cocktails and Cigarettes*; and *Danse Moderne*. All three of these designs carry motifs that easily pair them with jazz-theme bowls: the *Jazz* and *Cocktails and Cigarettes* plates with the bowls by the same name, and *Danse Moderne* with *Night Club*. While these pieces were featured in advertisements, Cowan Pottery seems to have folded

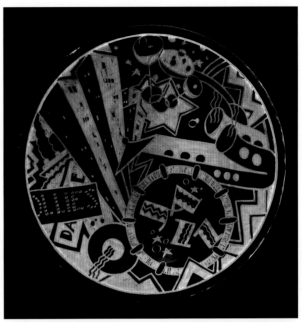

New Yorker Jazz Plate, 1931. Diam 29.3 cm.

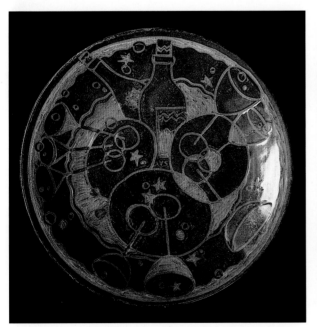

Cocktails Jazz Plate, 1931. Diam 29.2 cm.

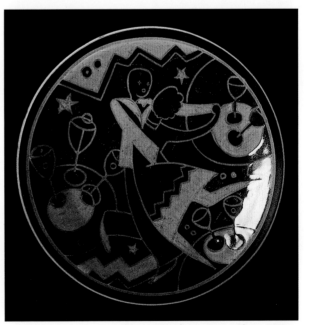

Danse Moderne Jazz Plate, 1931.

before any of them were put into full production. All of these objects seem to have been produced in very small editions. Indeed, with the exception of *Danse Moderne*, these jazz-theme plates have almost entirely disappeared. A *Danse Moderne* plate is in the collection of the Western Reserve Historical Society in Cleveland; several grace private collections; and the Viktor Schreckengost Foundation owns a full-color version (yellow, red, green, blue, and black). A private collector owns the only *Jazz* plate known to the Foundation; he bought it on eBay. *Cocktails and Cigarettes* is known only from photos. A single example of a fourth plate, *Cocktails*, is also known to exist, although a matching bowl has not been identified. Cowan Pottery originally offered these plates for $15 each; now they may command up to $20,000 or more at auction.

How Many *Jazz Bowl*s Were Produced?

How many *Jazz Bowl*s were made and how many varieties or companion pieces exist? This is difficult to determine since Cowan Pottery went out of business just as they were starting to manufacture the *Jazz Bowl*, and it seems that production was disrupted. *Cocktails and Cigarettes*, *Night Club*, *Rhythm in Blue*, and *Firmament* may have been unique.

The *Jazz Bowl* was produced in slightly larger numbers, but the edition seems to have been quite small. Making a *Jazz Bowl* was an expensive undertaking. Most likely the pottery only made these bowls when they had specific orders to fill. Two numbers resurface in discussions of the *Jazz Bowl*: fifty and twenty-five. An early article in *The*

Cleveland News states that the Brownell-Lambert Gallery in New York was so pleased by the bowl made for Eleanor Roosevelt that they ordered fifty more. It seems likely, however, that this order was never entirely filled, because Cowan Pottery went into bankruptcy. In his letter of 1953, describing the bowl, Viktor stated:

Mr. Cowan then decided to make a limited group for his line. Perhaps twenty-five were made from my molds and sketches. One or two other artists assisted me and all signed my name.[13]

What is not clear is whether this number of twenty-five refers only to production of the original hand-incised, parabolic bowl or whether it also includes the design with a flared rim as well as the *Poor Man's Bowl*. Alternatively, Viktor may have been referring to both types of sgraffito bowls, but not to the *Poor Man's Bowl*. In other words, very likely about twenty-five sgraffito bowls were produced and perhaps an equal number of *Poor Man's Bowl*s. Today, eleven examples of the parabolic *Jazz Bowl* are recorded, and six with a flared rim. There are eleven known examples of the *Poor Man's Bowl*. Given that some bowls must have been broken, very likely there are between six and twelve sgraffito *Jazz Bowl*s that still survive but are unrecorded, and a roughly equal number of the *Poor Man's Bowl*. This of course is a guess, and it will be interesting to see whether time bears it out. The American nationally syndicated series *Antiques Roadshow FYI*'s "Missing Masterpieces" segment featured the *Jazz Bowl* in 2005, but no new bowls appear to have been discovered. As

13 Viktor Schreckengost, letter to Homer Kripke, February 15, 1954, Viktor Schreckengost Foundation.

prices rise for the *Jazz Bowl*, however, it becomes less and less likely that examples will remain undetected. In another twenty years we should be able to make a close-to-exact count of how many survive.

All the sgraffito *Jazz Bowl*s that have been located so far are black and Egyptian blue, but the *Poor Man's Bowl* exists not only in Egyptian blue but in other colors, including green and yellow. These green and yellow bowls may have been produced by Cowan Pottery, which advertised one of Viktor's bowls with a note indicating that it was available in "dark blue, green, or yellow." In addition, Viktor has said on multiple occasions that he thought some of the oddly colored *Jazz Bowl*s might have been made by Russell Barnett Aitken and Whitney Atchley, who purchased some of the Cowan molds. However, this supposition has not been verified by modern research; the owner of a green or yellow *Jazz Bowl* may still with confidence trace its pedigree to Cowan Pottery.

The production of the various *Jazz* plates also seems to have been quite small. Only *Danse Moderne* seems to have been put into production, and it exists in very small numbers. The others were most likely unique pieces.

Revival of Interest in the *Jazz Bowl*

With the collapse of Cowan Pottery, production of the *Jazz Bowl* and the other related designs came to a halt. With the exception of the lawyer, Homer Kripke, who wrote to Viktor in the early 1950s, no one paid any attention to the *Jazz Bowl* for some fifty years. Then in the mid-1980s, with a revival of interest in Art Deco, it

began to be featured in museum exhibitions. In 1985, for example, the bowl was featured in Eva Weber's book *Art Deco in America*, and in the same year it was included in a major show on *The Machine Age*, organized by Richard Guy Wilson and Dianne Pilgrim for the Brooklyn Museum of Art. By this time, no one even knew its original name, *New Year's Eve in New York*. Consequently, it was named the *Jazz Bowl* since the word "Jazz" appears on a drum head in the scene evoking the Cotton Club.

One of the pioneers in appreciating the bowl was lawyer John Axelrod, who recognized its significance "way back when nobody wanted Art Deco."[14] In the early 1980s, Axelrod acquired both a parabolic *Jazz Bowl*, which he donated to the Museum of Fine Arts in Boston, and a *Poor Man's Bowl*, which he still owns. "I knew it was an icon of Art Deco before anybody else had a clue," he asserts.

Within a decade the *Jazz Bowl* became widely recognized as one of the masterpieces of the period—without much doubt the single most important ceramic ever created in America. Most recently it was featured in the traveling Art Deco International Exhibition of 2003–2005, which originated at London's Victoria and Albert Museum and closed at Boston's Museum of Fine Arts. Since the 1980s, it has roughly doubled in value every five years. Today, *Jazz Bowl*s now fetch up to a quarter of a million dollars: one sold at a Sotheby's auction in December 2004 for $254,400.

14 Interview with The Viktor Schreckengost Foundation, October 2005.

ALL THAT JAZZ: A METAPHORICAL APPROACH TO VIKTOR SCHRECKENGOST'S PHILOSOPHY OF DESIGN

by Mark Bassett

Documentary filmmaker Ken Burns has called jazz "an improvisational art, making itself up as it goes along—just like the country that gave it birth. It rewards individual expression but demands selfless collaboration.... It has a rich tradition and its own rules, but it is brand-new every night. It is about just making a living and taking terrible risks, losing everything and finding love, making things simple and dressing to the nines." Such characteristics also describe industrial design at its best: innovation within a pragmatic context, collaboration that values individual expression, and fresh, responsive interpretation of perennially familiar needs and desires. Perhaps it should not surprise us that Viktor Schreckengost's favorite musical style—jazz—also provides an effective metaphor for understanding his philosophy of design.

Viktor was first exposed to jazz through his sister, Pearl, who enjoyed listening to jazz records on her phonograph. Around the time he turned twenty-one—the same year, 1927, when Duke Ellington's band took up a residency at Harlem's notorious speakeasy, the Cotton Club—Viktor began making regular forays into Manhattan, often with art-school friends, thumbing rides there and staying in art students' dorms to listen to jazz and see the sights. Today he delights in recalling the music he first heard back then at the Cotton Club, particularly vocalist Cab Calloway, whose legendary renditions of "Happy Feet," "Minnie the Moocher," "St. Louis Blues," and "Some of These Days" were originally recorded in 1930.

Both Viktor's abiding love of jazz, and his versatility and imagination as a designer, were well established by the time he created his famous *Jazz Bowl* for Cowan Pottery in 1931. From age eight to eighteen, he worked part time at the French China Co. in his hometown of Sebring, Ohio, learning firsthand about factory production lines, the division of labor, and group behavior. During the year after his 1924 high-school graduation, he juggled several occupations—improvising a pattern he would follow for many a decade. In his full-time job at the Gem Clay Forming Co., Viktor designed patterns for gas stove mantel rings. He began doing freelance design work for other pottery companies in Sebring. And he proved himself proficient at saxophone and clarinet by performing part-time with a local jazz group, the Kem Weber Band.

At the Cleveland School (now Institute) of Art (CSA), where Viktor enrolled in the fall of 1925, the program demanded versatility: all students explored principles of drawing, sculpture, painting, commercial illustration, ceramics, design, etc before choosing a focus. There Viktor decided to major in Design, with a minor in Ceramics. After graduation, in the fall of 1929 Schreckengost went to Vienna to study ceramic sculpture at the Kunstgewerbeschule. There Michael Powolny taught him to apply the highest standards to his work on the potter's wheel, and invited him to participate in creating architectural ceramic sculpture. But perhaps most importantly, as Henry Adams notes in *Viktor Schreckengost and 20th-Century Design* (Cleveland Museum of Art, 2000), Vik also ab-

sorbed a leading principle deriving from the Wiener Werkstätte, which defined "every aspect of home design as related, from the architecture itself to the chairs, plates, silverware and so forth.... The Werkstätte thus helped transform design from a field for specialized artisans to one for multifaceted artists, ready to attack any medium. Indeed, its tenets eventually created a new field—industrial design."

After Vienna, Viktor was perfectly suited to accept the innovative employment offer R. Guy Cowan had devised: three days a week Schreckengost would work as a Cowan Pottery designer, and the other three days he would teach design at the Cleveland School of Art. Both as a designer and as an educator, Viktor insisted on the importance of a meticulous, inquisitive analysis, driven largely, as Adams writes, by two "human factors": what we now call "ergonomics," or design that fits both the human form and the user's psychology; and "sales points," meaning "features that made his product either better or more visually exciting than that of his rival." In terms of the jazz metaphor, one might think of these human factors as the modality or key in which Vik typically played.

For one example of the process, consider the many questions addressed while designing pedal cars. Consultations with car designers in Detroit helped him predict the shape of new cars, and keep his designs fresh. Countless measurements of children were taken; kids in children's homes, hospitals, and playgrounds tried out proposed designs. Streamlining allowed Viktor to abstract details and

suggest speed while respecting pragmatic issues like width (to ensure a Pursuit Plane could be ridden through a standard interior doorway) and weight (to keep shipping costs down). For ease of manufacture, some models used similar or identical parts, painted differently for different marketing schemes. Like the various stanzas of an especially dynamic jazz improvisation, the entire design, manufacturing, and marketing process was also recursive, meaning that various questions could be reconsidered whenever desirable or necessary.

Just as an individual jazz musician's solo is enlivened and completed only in reference to the jam session in which it presents itself, some Viktor Schreckengost designs can be fully appreciated only in relation to one another. Take the Primitive pattern Viktor created for his biomorphic Free Form shape dinnerware, produced by Salem (Ohio) China Company in 1955. The Primitive decal designs involve stylized "cavemen," a series of stick figures whose attenuated XY outlines represent the speed of the hunt, and a "family" of male and female elk who congregate, unmolested, nearby. Reminiscent of the pigments found on antique Anasazi or Pueblo pottery, Vik's choices for Primitive were rust and charcoal, which he used on a background resembling nutmeg sprinkled over cream.

The arrangement of motifs is humorous, as hunters and prey are seldom located on the same surface of a piece of hollowware. Only when the table is set can we see from one perspective the entire herd of animals, and witness the great many hunters in this chase, all mistakenly dashing along in a mad game of "follow the leader." In addition, the variety of form in this ensemble is significant: Viktor recreates in china the individual differences that animate our daily lives. Metaphorically, the table setting asks us to seek pleasure in variation—both because each "personality" is distinctive as a soloist, and because contrasts in shape echo the different serving functions required of the objects themselves. The entire service seems chatty and casual, as if there were a conversation in progress that we might overhear by listening carefully.

His love of jazz—his understanding of its mathematical base and flexible, eclectic artistic superstructure—superbly informs Viktor Schreckengost's most famous piece, the internationally acclaimed *Jazz Bowl*. From mathematics, he borrowed the idea of a pure parabola, so that Guy Cowan's moldmakers could form a one-piece plaster mold that would eliminate seams entirely. From Arthur Baggs's experiments at Cowan Pottery, he borrowed the Egyptian Blue glaze and the concept of using underglaze sgrafitto to decorate the surface. From R. Guy Cowan himself, Viktor borrowed liberally—not only from their relationship as teacher and student, but from Cowan's own demanding specifications during technical developmental work and production at the pottery. From fine art, Viktor borrowed analytical Cubism; and from the merchants of Times Square, a note of P.T. Barnum and the cartooning devices of his youth.

First Schreckengost drew onto the surface of the punch bowl all those iconic decorations that define this Art Deco masterpiece: skyscrapers all akimbo, an ocean liner in the harbor, neon lettering, street lights, a host of celestial bodies, oversize liquor and wine bottles, cocktail glasses tilting precariously on a small tabletop, images of dice and playing cards, the clock at Times Square, a group of drunken stick figures, the organ pipes of the Broadway theatres, and even three elements of a jazz band—a pair of saxophones, a set of high-hat cymbals, and a bass drum.

As he worked, he used an almost pointillist sgrafitto technique to nick away at the engobe-covered vessel and reveal the white clay underneath, wherever he wanted brilliant blue to contrast with a sparkling black background. At first Viktor had not yet selected the lettering he planned to write across the face of the large circle representing the drumhead. Was he remembering his trips to New York at that time? Considering the glaze colors he'd chosen for this work, did he mull over the ambiguities in the lyrics of Louis Armstrong's 1929 hit "(What Did I Do to Be So) Black and Blue?"

Viktor was improvising, in true jazz spirit. His finishing touch for the bowl was not entirely premeditated, but was left open to inspiration that came through the creative process itself. Eventually, this talented but self-effacing, handsome and gracious, upbeat, fun-loving young man experienced what one could only imagine must have been a definitive Eureka moment for the artist and designer. He added one word—the only possible word—which could summarize everything he meant to express . . . JAZZ.

Where are Viktor's jazz-theme pieces today?

The following owners and prices include those known to the Viktor Schreckengost Foundation.

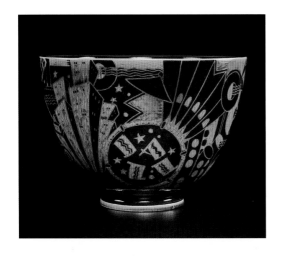

The New Yorker The Jazz Bowl. Parabolic, about 29.5 cm.

Examples of this bowl are owned by the Viktor Schreckengost Foundation, Cowan Pottery Museum Associates, the Cleveland Museum of Art, the Cooper-Hewitt National Design Museum, the High Museum, and several private collectors. High sale: $254,400, Sotheby's, 2004.

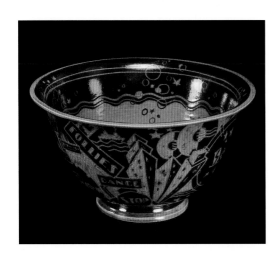

The New Yorker The Jazz Bowl. Flared.

Flared bowls are owned by the Art Institute of Chicago, Museum of Fine Arts (Boston), the Erie Art Museum (PA) and at least two private collectors. High sale: $153,000, Sotheby's, 2003.

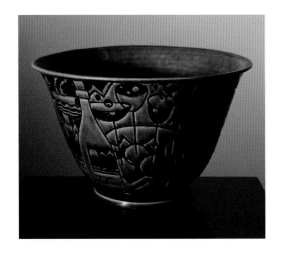

Poor Man's Bowl.

Examples of this bowl are owned by the Wadsworth Atheneum, the Baltimore Museum of Art, the Fogg (Harvard University), and several private collectors. High sale: $53,000, Rago, 2000.

Cocktails and Cigarettes.

Owned by the Cleveland Museum of Art (donated by the Mather family). No recent sale price.

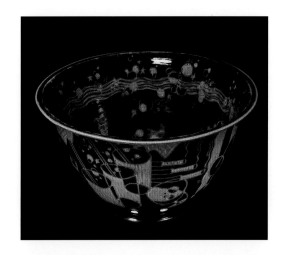

Danse Moderne plate.

Examples are owned by the Viktor Schreckengost Foundation, the Western Reserve Historical Society (Cleveland, Ohio), and several private collectors. High sale: $22,000.

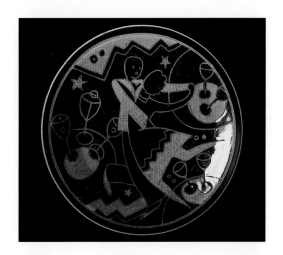

Jazz plate.

Private owner bought it on eBay in 2001 for an undisclosed amount.

No *Cocktails* or *Cocktails and Cigarettes* plates are known to have been on the market in recent years.

STUDYING IN VIENNA

Photographs of pieces that Viktor created while study-ing for a year in Vienna suggest how deeply his train-ing there influenced his later work. Viktor's renderings of African-American subjects and of heads made by slightly altering vase forms have already been discussed in literature about him, but other pieces that foreshadow his later work have been overlooked. For example, a photo of hand-paint-ed vessels made at this time includes a tall beaker-like vase decorated with a skyscraper in reverse perspective. Viktor would later employ this motif in the *Jazz Bowl*. In the same photo, a humorous elephant, equipped with a dish for hold-

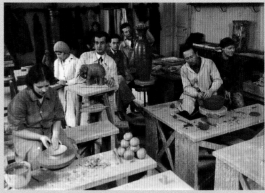

Viktor's classroom in Vienna.

ing nuts, reduces an animal shape to its fundamental essence. It and a ceramic figurine of a steer anticipate his animal sculptures of the 1940s and 1950s. A group of grotesque human and animal figures composed out of little lumps of clay shows his talent as a cartoonist and resembles his humorous ceramics of the early 1940s. There are hints of Art Deco in a graceful clay sculpture of a gazelle; his later renderings of flying horses express a similar taste.

Steer ceramic figurine, ca 1929.

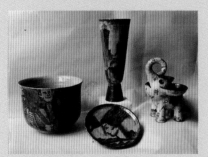

Miscellaneous ceramic figures, 1929–30.

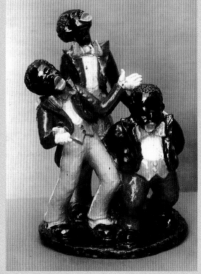

Harlem Melodies, 1930. H. 31.8 cm.

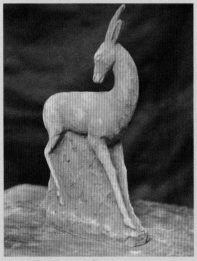

Gazelle ceramic figurine, ca 1929.

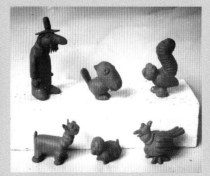

Miscellaneous ceramic figures, 1929–30.

Hand-Thrown Head, 1929.

CERAMICS

Upon his return from Vienna, Viktor immediately went to work for Guy Cowan. While his efforts at Cowan included some sculpture, the majority of his energy went into hand-painted ceramics—a preview of his focus for the rest of the decade. Throughout the 1930s, Viktor regularly exhibited (and received prizes for) his plates, bowls, and vases in shows across the country. Since few potters have well-developed drawing skills, these objects showcased his unusual range of artistic abilities. The earlier examples of this sort tend to be on handmade vessels and employ the *sgraffito* technique (as with the *Jazz Bowls*), but as the thirties progressed, Viktor increasingly mastered techniques to "paint" his ceramic pieces rather than scratching away the engobe. To achieve his effects, he mixed his glazes with a variety of media, including water, turpentine, glue, and wax.

33

Fish Vase, circa 1930

One of Viktor's first projects for Cowan Pottery was a decoration of fish and seaweed that anticipated the technique he soon used for the *Jazz Bowls*. Viktor fashioned a stencil of the design and it was applied to Cowan's vases V-90 and V-86 utilizing sgraffito—Viktor would cover the surface with a black engobe (clay mixed with black glaze) and then laboriously scratch away the design—on a simple, dramatically configured shape. Most commonly, the vases were then covered in melon green, though some were glazed in Egyptian blue. Because the decoration was executed by hand, no two vases are identical.

House Tops, circa 1930

Around the same time, Viktor tackled a request from Gump's in San Francisco for a children's service—a cereal bowl, mug, plate, and other shapes.

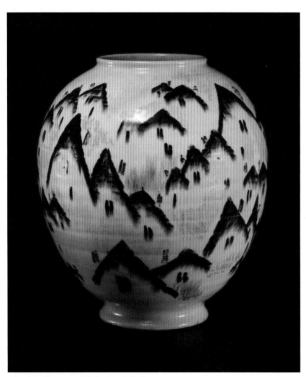

House Tops, 1931. H. 22.9 cm.

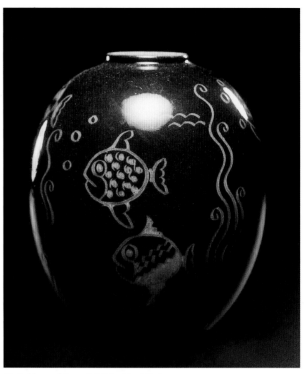

Fish Vase, blue, 1931. H. 15.2 cm.

After deciding to sketch the children's rhyme of "Jack and Jill," Viktor devised an unusual method: he mixed underglaze colors into melted wax and created crayons with which he could draw on the clay surface. As a child Viktor had poured melted wax over little homemade clay models of football figures as a substitute for glazing them, and the "underglaze crayons" he devised for the Gump's project were possibly inspired in part by his early experiments. Unfortunately, the pieces Viktor made for Gump's have disappeared, but two examples of his crayon technique survive—a vase with a city scene and a Congo Vase that he gifted to his friend and teacher Paul Travis.

Globular Vase, 1931

For this vase, Viktor wanted to create a dramatically simple shape—a cylindrical neck on a small sphere that could easily be cupped in the hand.

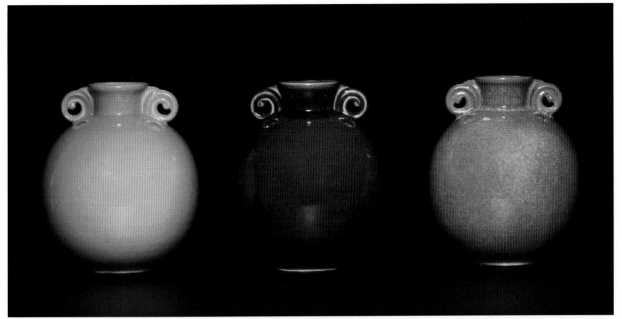

Globular Vases, 1931. H. 16.5 cm.

To Cowan this seemed too stark and he proposed adding clumsy handles on the side. Viktor felt this disfigured the purity of the shape, so he devised a thickened neck with ring handles on either side as an alternative. The result was a compromise between Viktor's aesthetic ideals and those of Guy Cowan. Though not so pure as the original design, the effect is visually harmonious. And like the *Jazz Bowls* and *The Hunt* punch set from the same era, Viktor's globular vase is defiantly simple in form, required some design compromise, and is among the very few vessel shapes Viktor created at Cowan.

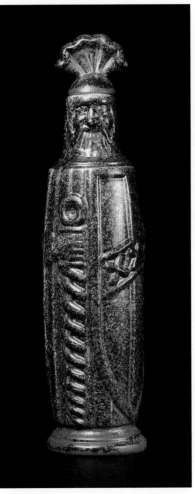

Crusader Decanter, 1931. H. 38.1 cm.

Crusader Decanter, 1931

During the height of Prohibition, Viktor was commissioned to produce a decanter for a group of Cleveland artists and writers who met from time to time in each other's homes and termed themselves the "The Crusaders"; their crusade was to end Prohibition. They wanted Viktor to design a decanter that would hide their liquor and double as a desktop sculpture. Viktor's design is replete with humorous symbolism: The warrior is two-faced to suggest the two-faced nature of Prohibition; one shield carries three X's, symbolizing whiskey, and the other bears three stars for Three Star

Hennessey Malt Liquor; the sword is a corkscrew. Because of the naughty nature of the piece, it did not carry the Cowan Pottery mark.

Sports Plates

In June 1930 a decorator with the Arden Studios in New York, Ruth Meigs, wrote to Cowan Pottery proposing that they produce a table service decorated with different sports—golf, tennis, hunting, polo, yachting, shooting, swimming, and so forth. Such subjects, she felt, would be in accord with the comfortable informality of modern life and could be used for dining outside on patios and terraces, which was becoming increasingly popular.

Cowan passed the project on to Viktor, who started by making drawings of energetic figures playing sports in a style modeled on that of John Held Jr., the popular cartoonist of the Jazz Age. Cowan then marked the sketches he liked best and Viktor organized them into a decorative composition. Before the factory closed, Viktor had put into production plates showing tennis, polo, hunting, football, swimming, and golf. He also drew six more subjects—archery, basketball, fencing, baseball, skiing, and soccer—but never completed designs for the last three scenes, including a large chop plate on which he planned to place the umpire of a baseball game. (Several of Viktor's lively pencil sketches recently surfaced. They include drawings of cycling, football, tennis, hockey, and golf. One can make out the X's and checkmarks that Guy Cowan placed beside the drawings that he liked best.)

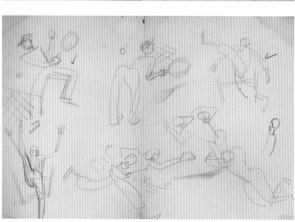

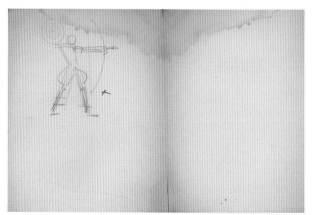

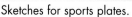
Sketches for sports plates.

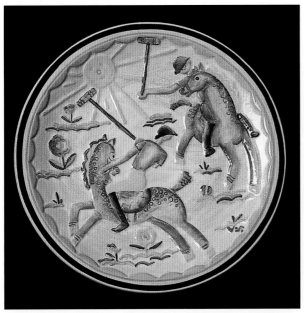

Polo plate, 1934. Diam 243. cm.

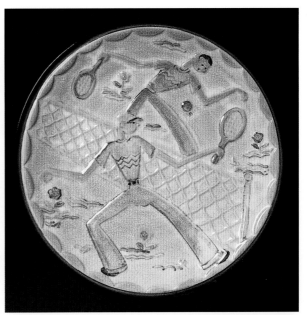

Tennis plate, 1930.

To produce the plates, he devised an ingenious technique. After sketching his designs onto the initial shapes, he painted all the areas except the lines with black lacquer paint. Once the paint had dried, he poured a thin layer of slip over the whole surface, which adhered only to the unpainted areas, creating a raised surface. After waiting half an hour for the slip to dry, he rinsed off the portion that had not adhered, creating a raised version of his drawing. From the plaster he then made a mold from which to cast the plates in clay. Since the raised design was not very high, the plates could be used and would stack, although Viktor seems to have conceived them principally as decorative plaques.

The original plates produced by Cowan were decorated in multiple colors although the intensity of the color effect varies from piece to piece due to irregularities in the firing process. When Guy Cowan moved to Onondaga Pottery in Syracuse in 1933, he brought samples of some molds

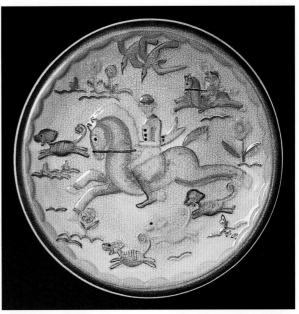

The Chase plate, 1930.

with him, including Viktor's sport plates. There he produced a few runs of Viktor's plates although the project was never approved for full production. The Syracuse samples are easy to distinguish from the original edition because they are monochromatic rather than colored.

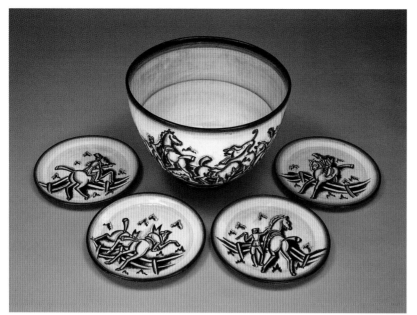

The Hunt, 1931. Diam 41.9 cm (bowl); 29.2 cm (plates).

The Hunt, 1931

The sport plates were not the only series Viktor created. For instance, *The Hunt* (1931) contains a punch bowl and four plates. The bowl is the same shape used for the parabolic *Jazz Bowls (The New Yorker* and *Rhythm in Blue)*, but the four plates and the side of the bowl are decorated with fox-hunting scenes. As a joke, the fox itself is hidden at the inside bottom of the bowl such that you need to empty the bowl to find it.

Viktor also produced a series of plates presenting the signs of the zodiac (1935), another showing ten performers in a symphony orchestra (1938), and a third with ten baseball players (1939).

Other Plates & Plaques

Viktor created many stand-alone plates and plaques, all showcasing his skills in applying his artistry and design sense to a ceramic medium. *Leda* is one of Viktor's earliest sgraffito plates, executed on a handmade piece in 1931; the first *Leda* plate was given to Alexander Blazys, then head of the Sculpting department at the Cleveland School of Art. The *Pegasus* plate (1934) employs the same sgraffito technique, but the plate is a blank rather than a hand-turned form. One of his earliest painted plates is his *Still Life* plaque (1932),

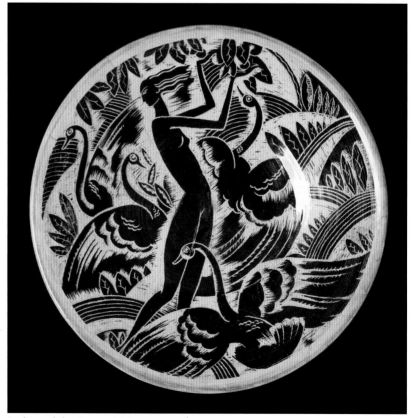

Leda and the Swan, 1931. Diam. 41.8 cm.

Still Life plaque, 1931. Diam 41.3 cm.

Plaque #5, Warrior Heads, 1931. Diam 45.7 cm.

Neptune plaque, ca 1935.

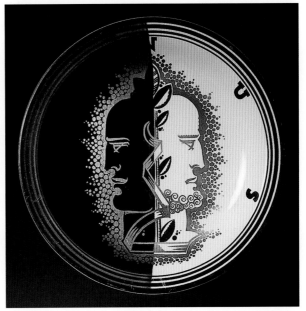

Janus plaque, 1936. Diam 39 cm.

which is hand-turned and received the Special Award for Pottery at the 1932 May Show. Most of the painted pieces, however, are on blanks left over from the Cowan Pottery.

Viktor also produced several large decorative plates, including *Warriors* (1931), *Neptune*, and *Janus* (1936), which feature deities and classical heads. The later pieces often use overglaze painting, particularly with metallic luster such as copper, gold, and platinum.

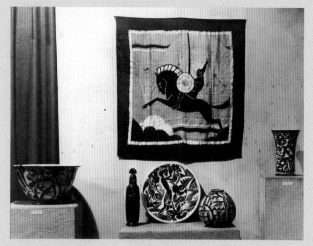

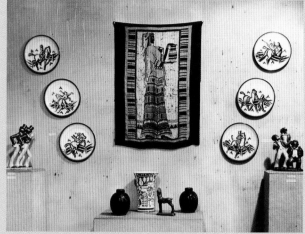

In 1931, the Akron Art Institute in Akron, Ohio, hosted a one-man show for Viktor Schreckengost, who was only twenty-five at the time. A typed piece list from this show was recently found in Viktor's archives. Many of the pieces discussed in this chapter were exhibited, as were at least three *Jazz Bowls*, four batiks, the *Madonna* sculpture, and a number of pieces yet to be identified, such as "pair vases, Egyptian blue," "Close Harmony," and four items listed only as "Bowl." Photographs from the exhibition give an idea of the style used for grouping pieces, as well as tantalizing shots of pieces that have yet to be identified.

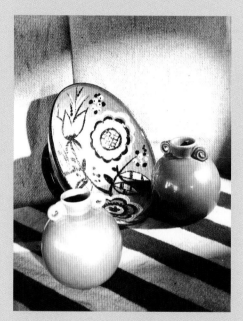

Ceramic Greeting Cards

Viktor started making his own greeting cards as a student at the Cleveland Institute of Art in the 1920s. It was very common then to do woodcuts and then stamp them onto paper. In addition to the woodcut cards, Viktor produced small ceramic plates in the form of colorful little ceramic saucers, most of them decorated in circular patterns reminiscent of the target paintings of Kenneth Noland. He and his wife Nadine sent these out as Christmas cards during the 1930s and early 1940s. They are inscribed: "Greetings from Nadine and

Ceramic Greeting Card, 1936.

Ceramic Greeting Card, 1940.

Ceramic Greeting Card, 1937.

Ceramic Greeting Card, 1941.

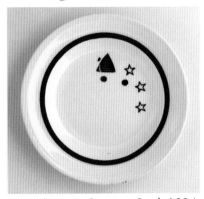

Ceramic Greeting Card, 1934.

Ceramic Greeting Card, 1938.

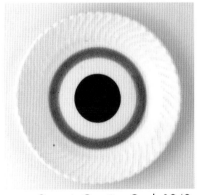

Ceramic Greeting Card, 1942.

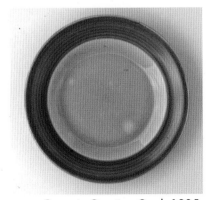

Ceramic Greeting Card, 1935.

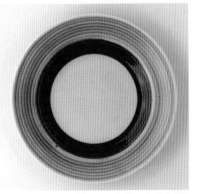

Ceramic Greeting Card, 1939.

Viktor Schreckengost." Several are to be the subject of an exhibition, *Greetings from the Schreckengosts*, at the 2006 Annual Benefit of the Cleveland Artists Foundation, a nonprofit regional art history organization that exhibits and collects the works of northeast Ohio artists.

Slab Forms

From the late 1940s to mid-1950s, Viktor exhibited a group of vessels at the Cleveland Museum of Art and other prestigious venues that changed the fundamental nature of ceramics since, rather than being thrown on a wheel, they were carved from slabs. The basic idea was to consider vessels not as a craft but as an art form—a form of sculpture. Viktor explained, "The wheel and the jigger set basic limitations. Everything was always based on the circle. I thought that I could get a more sculptural quality if I just took a big lump of clay, made an interesting form that I like, and scooped it out. It didn't have to be round. I could also make bigger shapes than would normally be possible throwing on a

> "I was stymied by mechanical methods and tried to imagine pottery not as a handicraft, but as a fine art. I wanted to get away from the normal medium that dictated utilitarian shapes, and looked for a method where form, rather than utility, was of primary interest."
>
> —Viktor Schreckengost

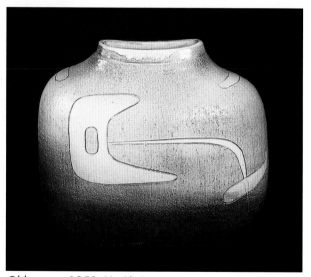

Oblongata, 1950. H. 40.6 cm.

wheel—things that were more sculptural. New forms, free forms, which were not limited by the device itself." While the final product generally retained the character of a vessel of some sort, it achieved its primary visual impact as a large, abstract piece of sculpture, similar to the work being produced at the time by figures such as Barbara Hepworth and Henry Moore.

Butter-Nut, 1949. H. 45.7 cm.

Like Hepworth and Moore, Viktor was interested in cutting holes through the center of a piece to intensify the viewer's sense of its sculptural qualities, a technique exhibited in *Cellular*. He also often explored references to other man-made and natural forms. *Canoa* takes the shape of a dug-out canoe, while many other pieces of this

to retain the form, he then turned the piece over and scooped out the inside. Rather than glazing the surface of the clay, he mixed glazes right into the clay. Occasionally, to get a special accent, he would wipe glazes over the surface of the clay or laminate a piece with clay of a different color.

Viktor's emphasis on art rather than utility set a new direction in American ceramics. Shortly afterwards, for example, Peter Voulkos began to create sculptural forms that served no useful function out of great slabs of clay.

Canoa, 1951. H. 14 cm.

period, such as *Calabash*, are based on the shapes of gourds. Such an emphasis on organic qualities was a common theme in the work of other leading craft innovators of the period, including George Nakashima, who incorporated the knots, irregularities, and natural contours of wood into his lovingly handcrafted furniture.

While simple in concept, execution of these hewn forms was extremely demanding. Hours of kneading were required to build up huge hunks of clay. Viktor first carved the outside shape. When the outside was sufficiently dry

Cellular, ca 1950. H. 41.4 cm.

SCULPTURE

Viktor has produced sculpture in a range of different styles. The sculpture made to be cast on bronze or other metals tends to be more realistic and academic in approach than his ceramic work, although sometimes it has an Art Deco flavor. With ceramic sculpture, Viktor was able to dispense with the metal armature that is necessary for traditional academic sculpture and to model more freely, creating a more playful effect. Some of these pieces play with the idea of transforming a ceramic vessel into a figure. Finally, Viktor produced a few outstanding architectural sculptures that, a half century after their creation, remain as vibrant and appealing as when he first created them.

Cast Sculpture
Jeddu (1931) and *Mangbettu Child* (1933)

Viktor's remarkable busts of *Jeddu* and *Mangbettu Child* are both based on photographs that his teacher from the Cleveland Institute of Art, Paul Travis, brought back from a trip to Africa a few years earlier. In 1927 Travis had received funds for foreign travel, with the assumption that he would go to France to paint and study. Instead, he decided to indulge a long-held dream of going to Africa, which he had read about as a child in Henry Stanley's famous book, *Darkest Africa*. Starting in Capetown, Travis spent a full year traversing Africa from its southern tip to Cairo.

In March of 1928, toward the end of his journey, Travis visited Feradje in the Belgian Congo, where he stayed with Baron Van Zulens, the administrator of the district. Van Zulens told him of a Russian artist, Alexandre Iacobleff, who had made marvelous drawings not long before of the nearby tribe, the Mangbettu. In the eighteenth century the Mangbettu had moved from the Sudan into the northeastern Congo and had established themselves as aristocratic rulers of the local population. The Mangbettu court was notable for its elaborate etiquette and for its rich traditions of painting, weaving, metalwork, and sculpture. The people were also physically striking and noted for their fine physiques and ability as dancers. Excited by Van Zulens's report, Travis drove west 165 miles to the Mangbettu village near Niangara, the home of the king, Ekibondo. He stayed there three days, taking photographs and gathering artifacts. Ekibondo entertained him lavishly, and Travis later reported that Ekibondo offered his wives as hospitality, an offer he declined. Many years later,

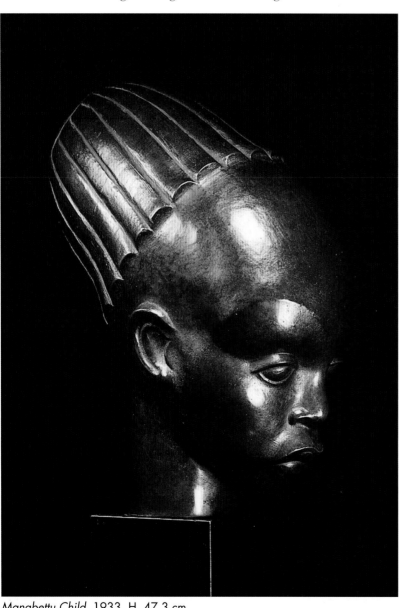

Mangbettu Child, 1933. H. 47.3 cm.

Viktor's teacher, Paul Travis, with African child. Inspiration for *Mangbettu Child*.

most reminiscent of the works of Romanian sculptor Constantin Brancusi in its simplification.

Travis also brought back with him a photograph of Jeddukieh taken by a French photographer, George Sprecht. The photograph shows her in a dramatic profile in which the line of the forehead is continued by a beautifully fashioned coil of hair. This photograph served as the basis for Viktor's bust *Jeddu*. Viktor was clearly struck by the remarkable resemblance between Sprecht's photograph and a famous, recently discovered bust of the Egyptian Queen Nefertiti in Berlin. Indeed, it is quite possible that Jeddukieh had Egyptian ancestry since the Mangbettu originated in the region around the source of the Nile, which was once under Egyptian control. To emphasize the resemblance to Nefertiti, he cut off the figure at the neck and dramatically simplified the forms.

Interestingly, the noted American academic sculptor Malvina Hoffman, who had studied with Rodin, used the same photograph by Sprecht as

Ekibondo's son, who was attending Princeton University, visited Travis in Cleveland.

A striking photograph taken in 1928 shows Travis with a child on his lap—Legenda, the daughter of Ekibondo and his wife Jeddukieh (also known as Jeddu). This photograph served as the basis for Schreckengost's bust *Mangbettu Child*. The Mangbettu bound the heads of their children to create a sloping forehead that they considered beautiful. Schreckengost was clearly taken with the unusual profile that this practice created. His bust expands the profile into three dimensions to create a dramatic, simplified egg-shaped form, al-

This photo of a Mangbettu woman, taken by George Sprecht, inspired Viktor's *Jeddu*.

the basis for a sculpture. Her rendering is more literal than that of Schreckengost. Comparison of the two pieces reveals the way in which Viktor slightly exaggerated the forward tilt of the head and slightly elongated Jeddukieh's features. Schreckengost has noted that he was intrigued by the way that Jeddukieh's appearance seemed primordial, even "primitive," and at the same time was immensely refined and elegant.

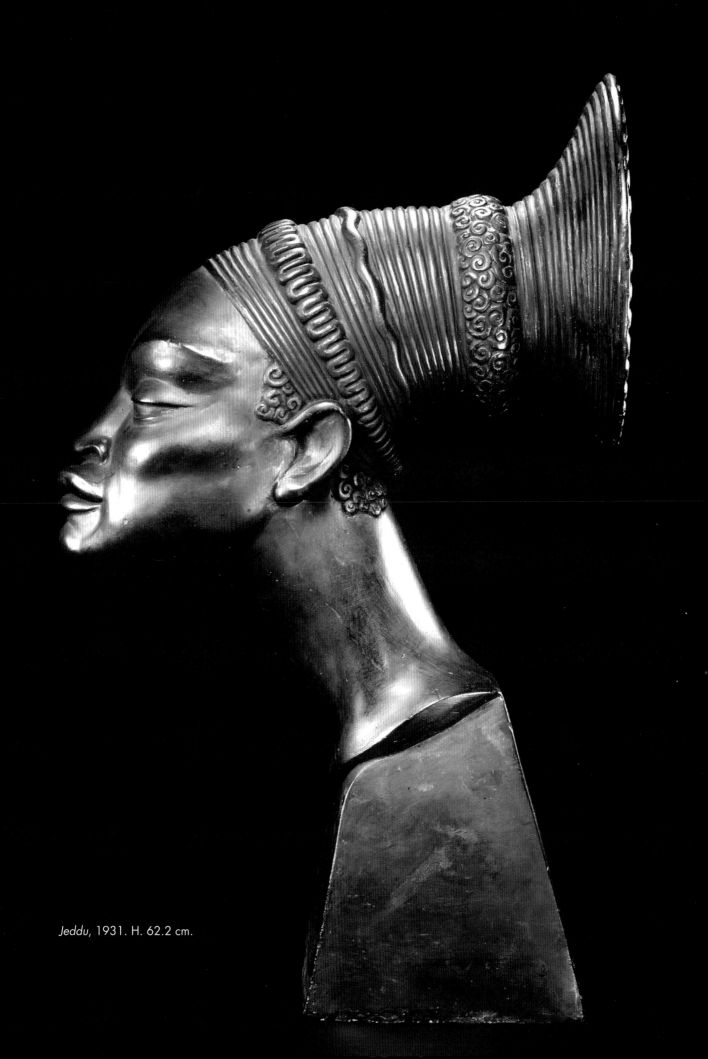

Jeddu, 1931. H. 62.2 cm.

Her sophisticated sense of style and visual effect was revealed by the attention she devoted to her perfectly coiled hair. A fascinating aspect of Schrekengost's piece is that, to some extent, it blends Jeddukieh's features with his own to create an image that has aspects of a self-portrait but in which he transforms himself into an African and a woman.

Viktor was clearly immensely proud of the piece, and he not only exhibited it in several shows but also in his home as the dramatic focus of his living room. For years the bust existed only in plaster, but in 2000, shortly before the major exhibition of Schreckengost's work at the Cleveland Museum, Schreckengost authorized several castings, which were made in Cleveland.

Trophies and Monuments: Culver and O'Neill

In the 1930s Ohio was a major center of airplane manufacturing and aviation, and Cleveland hosted a number of major air races and air shows. This led to one of Viktor's most unusual commissions: in 1939 he was asked to create the Culver Air Trophy, an award established by K. K. Culver, the head of the Dart Aircraft Corporation in Columbus, Ohio. The accomplishments of Amelia Earhart had made it clear that women could fly planes as well as men, and the newly established Culver Air Trophy honored the winner of an event that had just been added to the Miami All American Air Maneuvers in Florida—a women's air race over a fifty-mile straight course.

Viktor's splendid creation, which is one of the masterworks of American Art Deco and streamlined design, featured a central shaft in the shape of an airplane wing, which rises from a stepped base formed like the stepped skyscrapers of the period. This airplane wing supports a graceful female figure, representing the feminine spirit of flight. The beauty of the piece depends on the way that both airplane wing and figure possess a similar streamlined effect—an effect that is emphasized by the shimmering silver-plated surface. Contestants needed to win the race three times in order to keep the trophy, but did get to keep a small airplane in the female figure's hands, which was changed annually. The winners' names were inscribed on the stepped base.

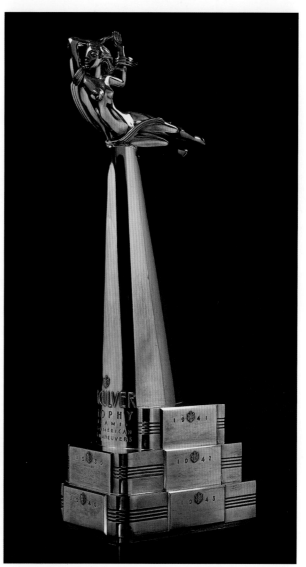

Culver Women's Flying Trophy, 1939. H. 101.6 cm.

Hugh M. O'Neill Police Memorial Monument,
1949. H. 68.5 cm.

In 1949 Viktor was asked to create a memorial sculpture in honor of Hugh M. O'Neill, who was principally responsible for creating the mounted police force in Cleveland. In keeping with O'Neill's interests, Viktor chose to execute a monumental horse's head, boldly streamlining and stylizing the forms in a way that reflects the influence of Cubism and Art Deco. Unfortunately, the bronze casting, which was carried out by the Gorham Foundry, was not completed in time for the dedication so Viktor used the colored plaster original for the ceremony and quietly substituted the bronze cast when it was ready. He keeps the plaster

Chinese Head, 1930.

cast in his library, where he proudly tells visitors that it was blessed by a bishop.

Ceramic Sculpture

During the 1930s, Viktor regularly competed with another American ceramicist who had studied in Vienna, Russell Barnett Aitken. Like Viktor, Aitken attended the Cleveland Institute of Art, and he also went to study in Vienna although, unlike Viktor, he never settled down to formal schooling and spent much of his time skiing, dueling, and engaging in other athletic pursuits. After his return to Cleveland, Aitken began producing vigorous free-form sculpture, often humorous in nature, loosely based on what he had seen in Vienna.

During the early 1930s, while both exhibited in the May Show at the Cleveland Museum of Art, Viktor tended to show ceramic forms while Aitken concentrated on sculpture. As the decade progressed, however, Viktor began also to produce sculpture on a regular basis, generally focusing either on animals or on African-American subjects. Several other artists followed their lead, including Whitney Atchley, Thelma Frazier Winter, and Edris Eckhardt. Essentially, this created a "Cleveland school" of ceramics, which is arguably the first "school" of ceramic sculpture in the United States. Aitken and Atchley both moved out of Cleveland around 1940, but Schrekengost, Winter, and

Eckhardt exhibited their work widely well into the 1950s.

Ceramic Heads

While studying in Vienna, Viktor sometimes produced masklike heads in clay, such as *Chinese Head* (1930), which were made by taking a vessel form and only slightly modifying it. He would push out the wall to create a nose and poke through the wall to create two eyes, but he did not attempt to change the basic vase shape of the clay by imposing naturalistic modeling on the face. Viktor's model for such pieces was his teacher, Michael Powolny, who had produced several heads of this type. While this technique of fabricating a head had probably been used for some time, Powolny seems to have been the first to modify the vase form only slightly so that the viewer can easily discern the method of construction when he views the piece.

Between 1937 and 1939 Viktor returned to this technique and produced several masklike heads in clay by this method. Perhaps the cleverest of

Keramos, 1939. H. 48.9 cm.

these pieces was his head of *Keramos*, which provides a nice example of Viktor's love of the interplay of verbal and visual references. The vase shape of Keramos's head alludes to his role as the patron deity of ceramics. His head is garlanded with stars and purple grapes, which refer to his mother, Ariadne, who became a constellation, and his father, Bacchus, the Greek god of wine. Keramos's kinship with Bacchus is also intimated by the Greek vase in his hand since it is a wine jar.

Another series of heads done in a style similar to *Keramos* led Viktor to a commission for the 1939 New York World's Fair. That year one of Viktor's former Cowan colleagues, Waylande Gregory, saw *The Seasons*, a series of four ceramic heads created by Viktor, at the Ceramic National Exhibition in Syracuse, New York. Gregory invited him to propose something similar for the New York World's Fair. Viktor promptly sent off four air-brushed renderings of *The Four*

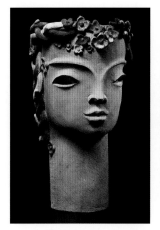

The Seasons: Spring,
1938. H. 43.2 cm.

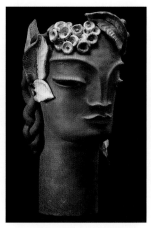

The Seasons: Summer,
1938. H. 45.2 cm.

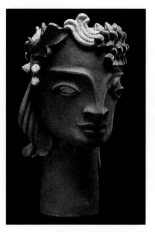

The Seasons: Fall,
1938. H. 45.2 cm.

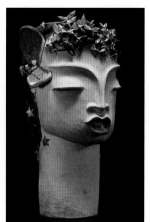

The Seasons: Winter,
1938. H. 43.9 cm.

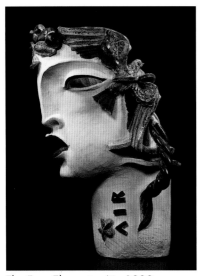
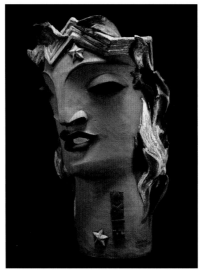
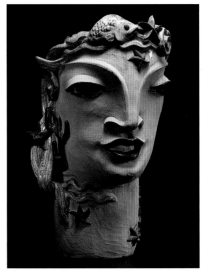

The Four Elements: Air, 1939.
H. 50.8 cm.

The Four Elements: Fire, 1939.

The Four Elements: Water, 1939.

These sculptures were displayed at the 1939 World's Fair on ten-foot pedestals, with beams of light coming out of their eyes. The fourth piece of the set, *Earth*, was found in pieces in 2005 and is currently undergoing restoration; no photo is available.

Elements, portraying the four elements of early Greek philosophy: *Water, Air, Earth*, and *Fire*.

Unfortunately, due to administrative confusion, he got no response until March of 1939—just six weeks before the fair opened—when Walter Dorwin Teague, who had just been placed in charge of the décor, sent a telegram asking him to execute the work as soon as possible. Because time was so short, Viktor eliminated a step and fired both clay and glazes at the same time. Luckily this worked. Indeed, it gave the heads an interesting look, since the glazes soaked into the clay in an unusual way.

Viktor hurriedly shipped off the pieces to New York, and they were installed on projecting wooden pedestals in the American pavilion. The 1939 World's Fair included not only these sculptures but, as will be discussed in a later chapter on Viktor's industrial designs, an example of his first major bicycle design, the 1939 Murray Mercury.

At the time of the 1999 retrospective of Viktor's work at the Cleveland Museum of Art, only three of these heads could be located. The fourth, *Earth*, was recently discovered in a box in a hidden closet in Viktor's attic. It is currently undergoing restoration and has not yet been photographed.

Glory, Glory

During the 1930s Viktor made many sculptures of African-American subjects, which reflected his interest in jazz, African-American nightclubs, and his contact with African-American students, who were entering the Cleveland Institute of Art for the first time. Some of his sculptures were based on his experiences as a child, when he observed African-American church services at a religious campground in Sebring and witnessed dancing, singing, and even speaking in tongues. As he later recalled:

When I was a kid there was a campground that the Sebring brothers had built up on the hill. They brought in all the top evangelists. Billy Sunday was there… They'd get the top brass in the business there. Following them would come a group of African-Americans,

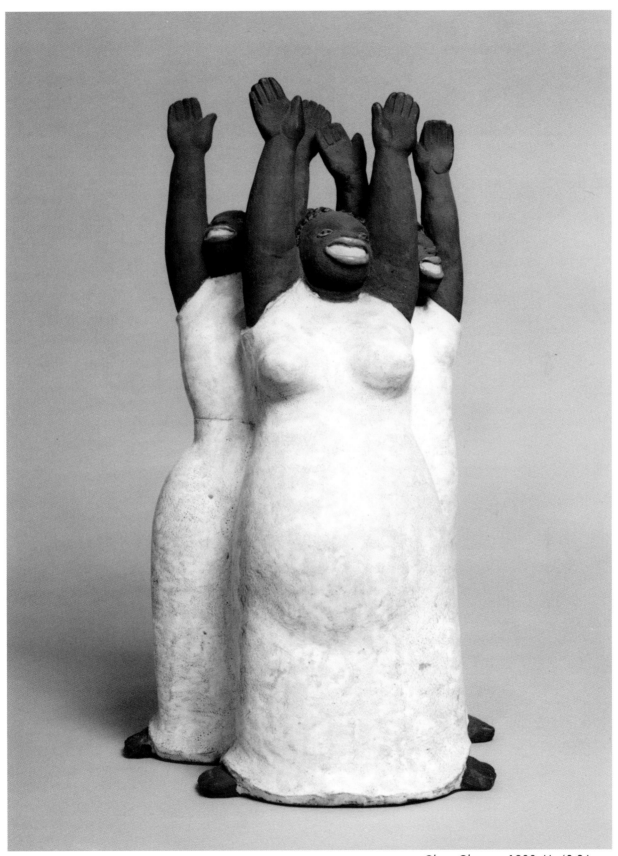

Glory, Glory, ca 1938. H. 48.26 cm.

SCULPTURE

VIKTOR SCHRECKENGOST AND CARICATURE

In recent years, Viktor's renderings of African-Americans have sometimes been criticized for their use of caricature. That they contain an element of caricature is undeniable. So for that matter do Viktor's representations of white people, Mexicans, Russian musicians, and animals. Whether rendering a tiger or a kangaroo, he would humorously exaggerate its most memorable traits.

There is no question that when we look at Viktor's renderings of African-Americans today, his use of caricature is often jolting. But what should not be overlooked is the use to which this caricature was put. Viktor's African-Americans are never shown as servants or menials or pictured in a subservient light. His two central themes were religion, as in *Shadrach, Meschach and Abednego* (1938; Metropolitan Museum of Art), which shows three believers saved from the flames of the fiery furnace by their faith in God, and African-American music, as in *Harlem Melodies* (1930; col-

lection of John Axelrod) or *Rhythm of the Soil* (1947; Cleveland Museum of Art). Often he combined these two motifs, as in *Glory, Glory* (circa 1938; Smithsonian American Art Museum), which shows a group of gospel singers. He was also interested in the beauty of African-American women, showing them both in the guise of classical goddesses, as in his statuette *The Abduction* (1940; Viktor Schreck-

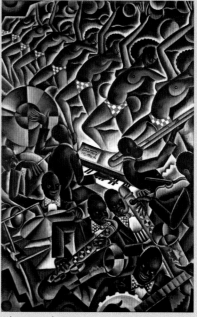

Blue Revel, 1931. H. 127 cm.

engost Foundation), which portrays Europa as an African, or as uninhibited and scantily clad dancers, as in *Blue Revel* (1931; Cleveland Museum of Art), an ambitious painting based on sketches made from life at The Globe Theater in Cleveland.

At a time when African-Americans were largely segregated from whites, it must have been a shock

to walk into an art museum and find such subjects. Viktor's use of caricature intensified the impact of this moment. There was absolutely no mistaking that these figures were African-Americans through and through—not African-Americans trying to look and behave

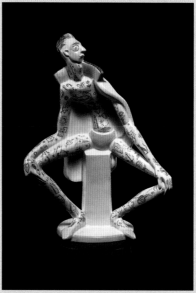

The Circus Group #1: Henri the Great, 1935. H. 22.8 cm.

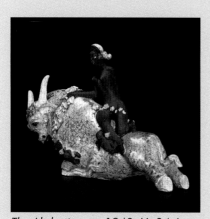

The Abduction, ca 1940. H. 34.6 cm.

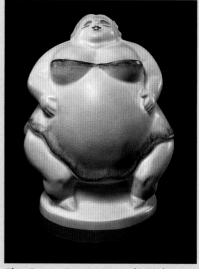

The Circus Group #1: Little Nel, 1935. H. 14.4 cm.

like white people. Yet the underlying message of all these pieces is positive: they stress religious faith, captivating music, and physical exuberance. Indeed, at its deepest level, the message seems to be that white people should also learn to lighten up, have some fun, and see the beauty of their fellow humans regardless of the color of their skin.

Other artists of the 1930s, such as Miguel Covarrubias and Thomas Hart Benton, used caricature in a similar way. Benton has been much criticized for this; Covarrubias has largely escaped this criticism, no doubt because of his Mexican heritage, although his book *Negro Drawings* (1926) seems to have introduced caricature of this sort into American art. What is striking is that, like Viktor, Benton and Covarrubias were firm advocates of equal rights for African-Americans. Like Viktor, they saw their art not as demeaning but celebratory. The very element of

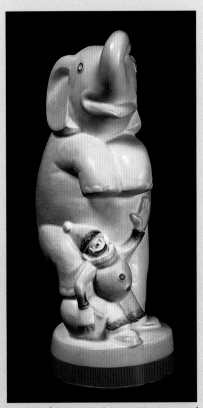

The Circus Group #1: Jum and Jumbo, 1935. H. 25.8 cm.

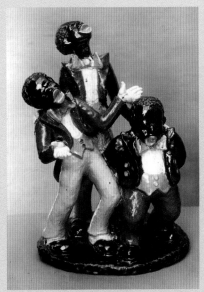

Harlem Melodies, 1930. H. 31.8 cm.

caricature and exaggeration that seems shocking today underscored the humanitarian themes of these works in the 1930s.

Interestingly, at the same time that Viktor was making these pieces, he was teaching the first group of African-American students to attend the Cleveland Institute of Art, including Charles Sallee. Their work has never been criticized as Viktor's has, but it shows a similar interest in using caricature to bring out the salient aspects of African-American culture, particularly distinctive African-American styles of music and dance.

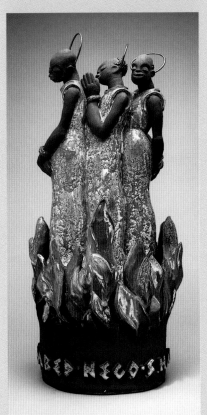

Shadrach, Meshach, and Abednego, 1938. H. 71.7 cm.

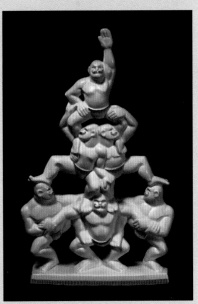

The Circus Group #1: Six Cellinis, 1935. H. 39.5 cm.

who held their camp meeting in the same place. And I just loved to hear the singing. It was the most marvelous sound. Images that I did later—Glory, Glory and things like that—reminded me of that campground. [1]

Animals

Someone once remarked of Leonardo da Vinci that he looked on nature as if it were made by a fellow designer. Similarly, Viktor looks on animals as things that were designed with a particu-

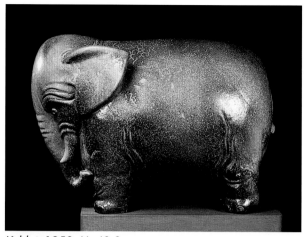

Kublai, 1950. H. 48.3 cm.

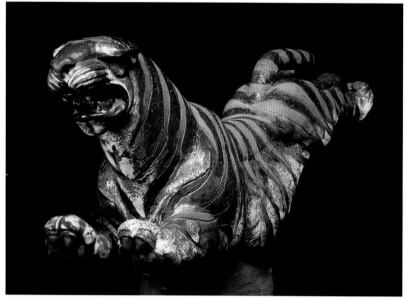

Tiger, 1951. H. 26.2 cm.

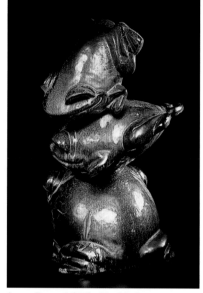

Leap-Frog, 1950. H. 53.3 cm.

lar purpose in mind. A tiger is designed to leap, a horse to run, a hippopotamus to wallow in the mud. As he has commented:

I've made hundreds of drawings of animals at the zoo—elephants, giraffes, and so forth. I became very interested in animals. No matter what it is, it always has a characteristic form of some sort that one recognizes. One animal is designed to carry a load, another

is sleek and speedy. A bear has back feet bigger than his front feet. If a bear ever chases you, don't ever run up a hill, he'll beat you. But if you run down a hill, he'll tumble if he tries to catch you! [2]

In his sculpture of animals, Viktor has tried to capture the essence of their design in clean, simplified forms. Often he has made interesting simplifications to focus on an animal's most es-

1 Henry Adams, interview with Viktor Schreckengost #8, June 21, 1999. Archives of the Cleveland Museum of Art. Typescript, page 26.

2 Henry Adams, interview with Viktor Schreckengost, June 21, 1999. Archives of the Cleveland Museum of Art. Typescript, pages 27–28.

sential aspect. In *Brahman*, for example, a study of a Brahman bull, the hooves of the beast are cut off at the ankles, in the interest of both structural strength and visual simplicity.

As with Viktor's other ceramics, the pieces he made in the 1930s tend to be more colorful, as is evident in the polychromatic effect of *Spring*. When he returned to animal sculpture after the war, he employed more muted glazes. In addition, the earlier sculptures are more irregular in shape—more like animated drawings. Many of the

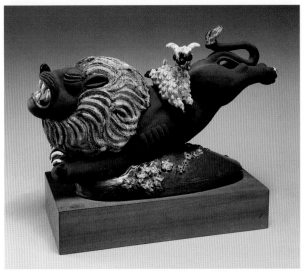

Spring, 1941. H. 38.1 cm.

later animal sculptures, such as *Kublai*, emphasize the massiveness of great lumps of clay. From some viewpoints, they are almost abstract—their resemblance to an animal may only be evident from certain angles.

Viktor's sculptures often contain humorous word play. For example, *Leap-Frog* actually consists of three frogs leaping on top of one another, i.e., playing leapfrog. *Spring* plays on several meanings of the word: the lamb is springing, a lamb jumps in delight at the mild season of spring, and the "lamb and the lion" biblical imagery also refers to a renewal of times, like spring itself.

Political Ceramics

Viktor's statue *Filibuster* recalls the work of the radical cartoonists of the 1930s, such as William Gropper, who often took aim at U. S. congressmen and senators. Curiously, Viktor's satire of an American politician seems to have stirred up little fuss, but this was not the case when he attacked fascist dictators.

Viktor's two most remarkable ceramic sculptures were *The Dictator* and *Apocalypse '42*. Po-

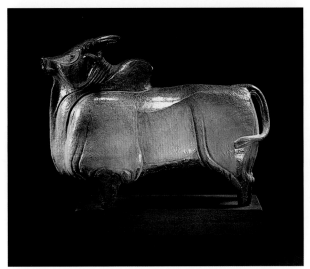

Brahman, 1951. H. 48.3 cm.

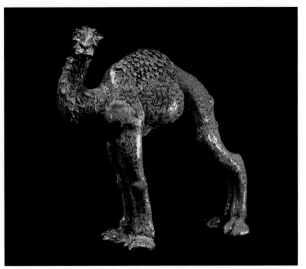

Naama, 1939. H. 45.7 cm.

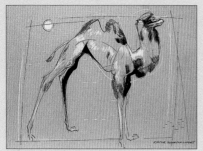

Camel, 1953. H. 17.8 cm.

Impalas, 1977. H. 27.9 cm.

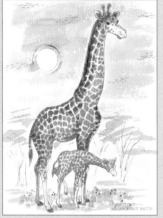

Giraffes #7, 1995. H. 35.6 cm.

These sketches show two ways that Viktor approached animal subjects. The first set (above and to the right) emphasizes movement, shape, or other qualities inherent to the animal. The second set (to the left and below) shows gentler, more childlike renderings of animal parents and children. These rounded, cartoonlike figures are consistent with a general style that can be discerned across media, from sculpture to pedal cars.

Ram, 1976. H. 35.6 cm.

Elephants #25, 1994. H. 27.9 cm.

Rhinos #10. H. 27.9 cm.

Polar Bears #8. H. 27.9 cm.

litical caricature was a vigorous art form during the 1930s, and was practiced by major figures such as Gropper and Hugo Gellert. Viktor's contribution was to translate this sort of commentary into ceramics, something that had never been done before. *The Dictator* (1939) showed the notoriously cruel Roman emperor Nero playing his lyre—a reference to the legend that he made music while Rome burned. The dictators Hitler, Mussolini, Stalin, and Hirohito—in the guise of cher-

ubs, but with evil, grown-up faces—crawl up his throne to rest on his lap. The British lion sleeps at his feet. At the time it was made, America was not yet at war, and many Italian-Americans openly supported Mussolini. Thus, when the piece was put on display at the Cleveland Museum of Art, it caused considerable controversy. The museum's director, William Milliken, who had many Italian friends and had recently received an award from the Italian government, took personal offense and

told Viktor, "Stay out of politics. It has nothing to do with art." In fact, the sculpture disappeared from its case for a time. Mr. Milliken's explanation was that it was "being photographed."

Apocalypse '42 was created a few years later, just after the bombing of Pearl Harbor. This showed the figure of Death, in a German uniform, riding on a horse in the company of Hitler, Hirohito, and Mussolini. Since Mussolini's military adventures had already gone awry, Viktor placed him in the back, about to be bounced off the horse. The horse has flames of destruction billowing from its body. In a happy accident, some of the red glaze of these flames dripped down the side of the piece, like streams of blood. As Viktor wrote at the time:

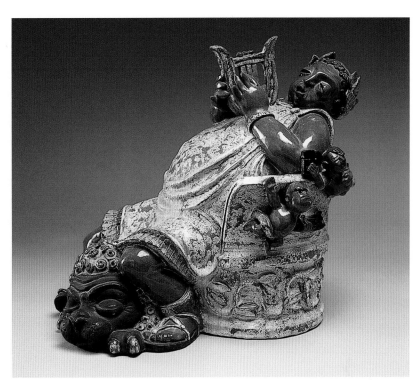

The Dictator, 1939. H. 33 cm.

In the Four Horsemen of the Apocalypse, I saw a strange resemblance to the four beasts that have been let loose on the world today. Certain liberties have been taken in my interpretation; for instance, I felt one horse was

Apocalypse '42, 1942. H. 40.6 cm.

Filibuster, 1949. H. 45.7 cm.

enough for the whole gang…
Perhaps it is humorous, but
I really believe that it tells a
true story.[3]

Religious Sculpture

Viktor's parents were deeply religious, and, when he attended the Cleveland Institute of Art, they expressed the hope that he would concentrate on religious art. As it happened, his career took a different course, but work with religious subject matter forms an interesting leitmotif of his career. Perhaps Schreckengost was responding to his parents' request when, rather early in his career, he created the cast sculpture *Madonna*, which depicts a moment of tranquility between mother and child, who gaze downward, cheek to cheek, oblivious of any audience. Simple, fluid lines and an all-over ivory glaze further the impression of peace and repose. Casts of this sculpture have been exhibited in various locations, most recently at a full exhibition of Viktor's religious works in 2004 and even a community holiday nativity display in 2005, where Viktor delightedly commented that the piece very much belonged.

One of his most ambitious ceramic pieces is *Peter the Fisherman* (1954), which shows St. Peter holding up a net full of fish—probably a reference

Madonna, 1931. H. 25.4 cm.

to the miraculous bounty of fishes. The sweeping lines and simplified forms of the piece recall the work of the great central European sculptor, Ivan Mestrovic, whom Viktor met during this period. At one point Mestrovic discussed with Viktor the kinds of simplifications necessary when working on a monumental scale to make sure that the features of a figure would read properly. Essentially, Viktor used such simplified forms on a small scale, seeing this as a way to increase the dramatic impact of the design.

Technically the piece is remarkable for its use of multicolored clays to represent the different fish and for the way that this use of color is combined with varied surface textures to create

3 Typescript statement by Viktor Schrekengost, 1941, in Schreckengost scrapbook #2 (unpaginated). Schreckengost Archives.

almost the effect of a watercolor or drawing. With wonderfully economical means, Viktor creates a vivid illusion of fish squirming in a net. This piece was featured in a poster advertising a one-man retrospective of Viktor's work at the Cleveland Institute of Art in 1976.

While *Peter the Fisherman* is wonderfully exuberant, Viktor also fashioned a likeness of Peter that is almost opposite in its emotional character—a piece that was redis-

Poster for the 1976 Viktor Schreckengost Retrospective Exhibition at the Cleveland Institute of Art.

covered recently in Viktor's attic, where it had languished for thirty or forty years. Featuring Peter and a rooster, it depicts the disciple's moment of awareness that he had thrice denied knowing Jesus, just as Jesus had predicted he would. Viktor reduces this episode to the minimal elements necessary to communicate the story: a cock and the head of St. Peter. The very simplicity and reductiveness of this approach has a startling effect since noth-

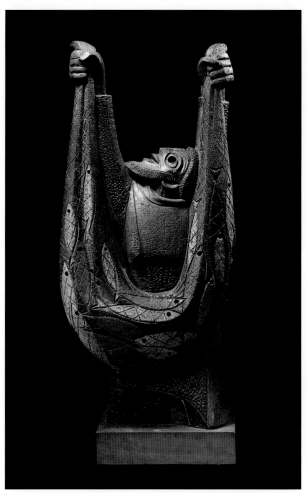

Peter the Fisherman, 1954. H. 78.2 cm.

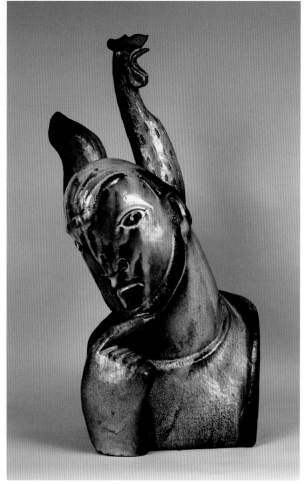

St. Peter, 1951. H. 76.2 cm.

ing detracts from the terrible message of the sto-ry—Peter's guilt that he has betrayed his Master. While not so visually dramatic as the rendering of Peter as a fisherman, it is in some ways even more powerful in its emotional impact.

Architectural Sculpture

Throughout Viktor's career, one success-ful project always led to new commissions. His charming animal sculptures, though small in scale, led to one of his most ambitious commis-sions: a monumental group of polychrome relief sculptures for the bird building of the Cleveland Zoo, which then led to an assignment to create a full wall relief for the zoo's pachyderm house. In between these two projects, he was asked to take on a monumental outdoor sculpture for a high school auditorium in a Cleveland suburb.

A major technical challenge for all of these projects was to find a way to produce ceram-ics that would be sufficiently sturdy to endure Cleveland winters. Previous efforts of this sort

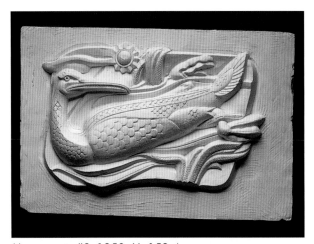

Hesperornis #2, 1950. H. 152.4 cm.

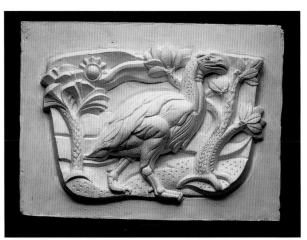

Diatryma, 1950. H. 152.4 cm.

These plaster cast models for the Cleveland Zoo's Bird Building represent final sculpture panels that are brilliantly colored and generously sized, at five feet high by eight feet wide. The details on each bird—feathers, beak, talons—were meticulously examined by ornithologist (and Viktor's nephew) Don Eckelberry and researchers from the Audubon Society.

Dodo, 1950. H. 152.4 cm.

American Bald Eagle #5, 1950. H. 152.4 cm.

had failed. For example, all of the ceramic sculpture that was done during the WPA period has disappeared because it was fired at too low a temperature. Before starting work on the zoo project, Viktor signed a contract with the city that his sculpture would last for twenty-five years. He noted at one point:

> I was scared about what I would have to do in twenty-five years if they weren't still up there. But if you go over now you'll find that the sandstone is crumbling and that the ceramics are as hard and bright as the day we put them up.

Bird Building Relief Sculptures, 1950

The bird building project required consultation with the zoo architect, J. Byers Hays, then one of Cleveland's most forward-looking architects, and with Viktor's nephew Don Eckelberry, a distinguished ornithologist and Audubon guide illustrator. As part of his master plan for the zoo,

Hays required a sixty-foot ventilation tower outside the bird building. He and Viktor decided to face it with large, colorful relief panels of birds, almost in the style of a totem pole. Viktor and Don decided on a series that would trace the evolution of birds from their dinosaur predecessors. The 140-million-year-old, carnivorous *Archaeopteryx* came first, followed by the 100-million-year-old *Hesperornis*, an amphibious bird. Next came *Diatryma*, a 60-million-year-old creature with hairlike feathers, and then the more recently extinct dodo bird. The final bird, a soaring bald eagle, was seriously endangered at the time. These five 5' × 8' panels, each weighing a ton, remained on display at the zoo for half a century, along with two dozen smaller plaques representing recently extinct American birds. They were removed in 2004 as part of a larger renovation, and have already been pulled from storage at least once for exhibition.

Early Settler (Johnny Appleseed), 1954. H. 533.4 cm.

 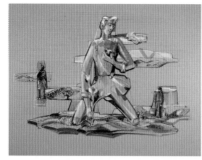 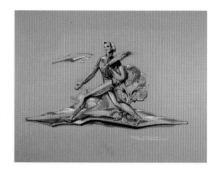

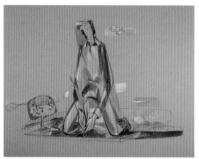 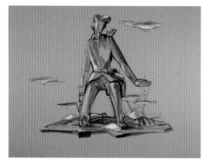

Sketches for *Early Settler*
(*Johnny Appleseed*). H. 55.9 cm.

Early Settler (*Johnny Appleseed*), 1954

After the bird building project, Viktor was asked to design a monumental sculpture for Lakewood High School. He began with an image of Johnny Appleseed but transformed it into a more general representation of a pioneer after those who approved his design expressed concern that Johnny Appleseed was too much of a "hippie" and would be a bad influence for children. Viktor later recalled:

> When they cleared the site for Lakewood High School, there was a big apple tree on the property and they were almost sure that Johnny Appleseed had planted the seeds of it as he came through Pennsylvania and up

through the Ohio Valley. When I started, I made quite a few drawings of Johnny skipping through the woods with his apple seeds. They decided that maybe it wasn't the best image for kids, so the images of Johnny Appleseed are still in it, but instead of planting an apple tree he's planting the tree of knowledge. You'll still see apple trees in the background and the symbol of the rising sun that is on the Ohio seal.

The architect of the building, again Byers Hays, kept many of the best drawings of *Early Settler* (their present location is not known), but Viktor also kept a portfolio of early sketches that explore alternative solutions to the design. They

are confidently executed on tinted paper, with the highlights in gouache. One sketch shows him skipping through the woods; another holding an apple to his chest; another holding a tree; another planting a tree. The tree-planting sketch contains the essentials of the final design.

The relief is huge in scale—eighteen-and-a-half feet high, kneeling, from his knees to the top of his head. Creating it presented technical challenges. For the sake of visual drama, Viktor decided to make the sculpture a relief up to his waist and then to have the upper part of the body lean forward and become completely three-dimensional. The projecting upper body is supported by a steel I-beam to which the relief is attached by bronze hooks. The cement that holds the ceramic pieces together is not rigid but rubbery since, as the sun passes over the relief during the day, the heated

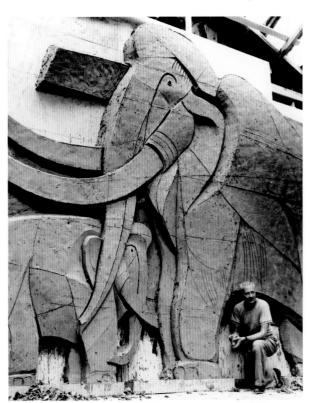

Mammoths and Mastodons, 1956. H. 381 cm.

parts expand. If he had not allowed for this swelling, the relief would have popped off years ago. Because he did, it remains in good condition.

Mammoths and Mastodons, 1956

When Viktor received a second commission from the Cleveland Zoo—to produce sculptures for the pachyderm building—he simplified his earlier "evolutionary timeline" into two wall-size panels of mammoths and mastodons, the extinct ancestors of modern elephants. But while Viktor's theme was similar in the two projects, his mode of treatment was quite different. In his bird reliefs he employed brightly colored glazes. For his renderings of mammoths and mastodons, he used only earth tones, eliminating glazes altogether and creating variations in color by employing four different kinds of clay. For the bird building he produced designs that are highly realistic in style. For the pachyderm building he made renderings

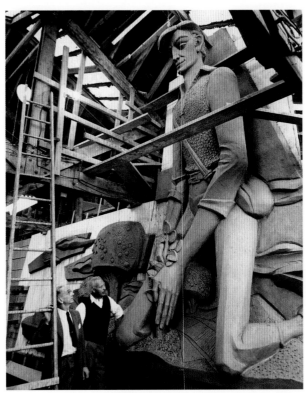

Viktor at work on Early Settler, *1954.*

that are highly simplified in keeping with his general tendency in this period to move towards more simplified, abstract effects.

In key respects, however, his prehistoric pachyderms are very engaging. While Viktor's mammoths and mastodons are simplified, even cartoonlike, he made them exactly the size of the actual creatures; and he also designed them to come down right to the ground so that children can go up and measure themselves against them. The spot has become the most popular place for snapshots in the whole zoo.

The project is huge: the mammoth relief is twenty-five feet wide and thirteen-and-a-half feet high; the mastodon is twenty-five feet wide and twelve feet high. Producing sculptures so large presented notable technical challenges. Thirty-two tons of clay went into the project. After making a small clay model, Viktor executed the sculptures at Federal Seaboard in Perth Amboy, New Jersey, the only place in the United States with kilns large enough to handle the project. He worked against a plywood wall, from which cleats extended to hold the clay. During the process, the plywood framework began to buckle, but he propped it back into place with telephone poles and reinforced it with steel rods with tighteners. So that they would fit into the kilns, the animals were divided into sections weighing about 600 pounds apiece. After the buckling plywood was fixed, everything else about the work went smoothly, and the project was ready in time for the dedication, which took place on May 13, 1956.

Eagle Pulpit Breastwork

When Viktor's architect friend J. Byers Hays renovated St. Paul's Episcopal Church, Viktor proposed making a huge ceramic relief of St. Paul that would take up most of the face of the church's tower. Like his relief sculptures at the Cleveland Zoo, this would have been imbedded right into the surface of the wall, essentially becoming part of the fabric of the building. Unfortunately, this dramatic proposal was never realized, but Viktor did design a striking eagle for the breastwork of the pulpit. This commission illustrates Viktor's ability to reapply expertise (like bird relief sculpture) and leverage his friendships and contacts (like Byers Hays) into future commissions. It also illustrates his ability to adapt one subject or theme to multiple contexts without hesitation: his bird is equally at home on a church pulpit or on a zoo tower.

Zodiac Mural

Viktor's interest in abstract shapes, which is evident in his slab forms, is also apparent in his *Zodiac* mural, created for the Cleveland Hopkins International Airport in 1955. Rather than anthropomorphizing the signs of the zodiac, he reduces them to alphabet-like shapes. This technique is reminiscent of the paintings of primitive, imaginary forms of writing produced by painters such as Adolph Gottlieb in the same period. Viktor's studies for the Hopkins Airport mural show that he began by sketching a globe with different time zones and also sketched the moon in its various phases. He finally settled for stylized representations of the signs of the Zodiac. His final renderings, in gouache on dark paper, carefully show the dimensions and the materials.

The task of translating the design into metal was carried out by the illustrious Cleveland firm of Rose Ironworks. Established by the Hungar-

Polar Map, Zodiac Mural sketch, 1955. H. 55.9 cm.

Time Zones, Zodiac Mural sketch, 1955. H. 55.9 cm.

Libra, Zodiac Mural sketch, 1955. H. 55.9 cm.

Gemini, Zodiac Mural sketch, 1955. H. 55.9 cm.

Moon, Zodiac Mural sketch, 1955. H. 55.9 cm.

Sun, Zodiac Mural sketch, 1955. H. 55.9 cm.

Series of sketches made for *Zodiac* mural at the Cleveland Hopkins International Airport.

ian ironworker Martin Rose in 1904, it is still in business today—the oldest maker of ornamental ironwork in the United States. Martin Rose's son Melvin, who studied under Viktor at the Cleveland Institute of Art, supervised the execution of the project.

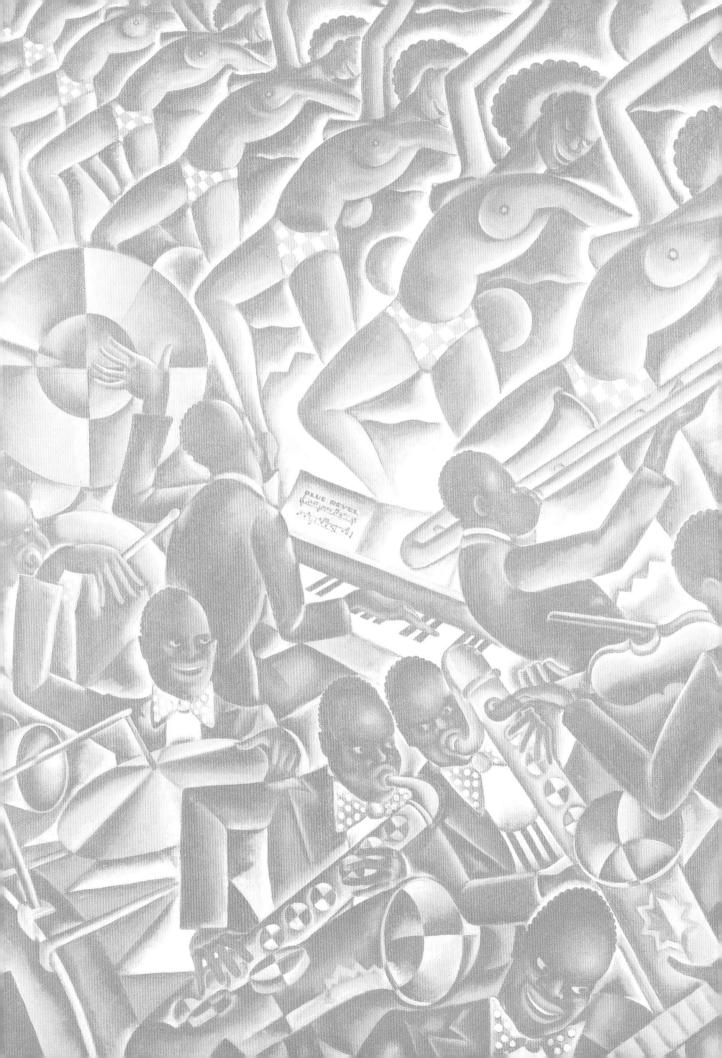

TWO-DIMENSIONAL WORKS

Student Drawings

Recently many of Viktor's student drawings from the Cleveland Institute of Art have surfaced in his attic, along with his grade sheets. They reveal that his training was systematic and thorough. He explored textures in pen-and-ink, both in little boxes that he filled with linear patterns, and in a still-life of books. He drew twenty-five figures in black silhouette, lining up men and women to explore variations in contour and different effects of body-fat levels. He drew a horse in zebralike contour lines. One set of drawings shows seven color variations for the same design of a parrot on a branch: dark on light, light on dark, and different combinations of complimentary colors.

Under Jules Mihalik he designed decorative objects such as radiator grilles and lighting sconces in a somewhat fussy, old-fashioned style. He even designed a caryatid for a balcony and made a sketch for a mural of a godlike figure surrounded by a host of flying horses and classical deities.

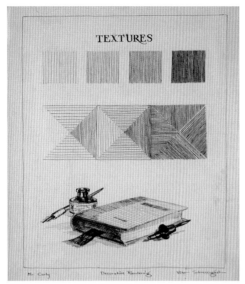

Textures, 1920s. H. 35.6 cm.

Ceiling Light, 1920s. H. 35.6 cm.

God with Book and Angels, 1920s. H. 46.5 cm.

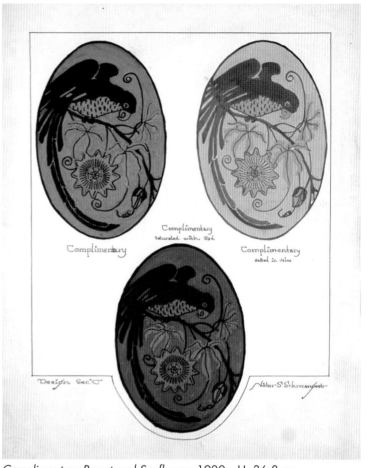

Complimentary Parrot and Sunflower, 1920s. H. 36.8 cm.

He also made numerous drawings from the nude model, and in them his distinctive personality as an artist is already evident. They show great confidence in the massing of large shapes: they often seem less like life drawings than like renderings of earthenware vases or of figures that had been cast in bronze. Fairly frequently he included side sketches that analyzed the pose in terms of simplified geometric forms;

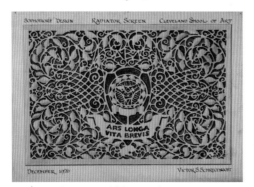

Radiator Screen, 1920s. H. 40.1 cm.

Merry Christmas with Candles, 1920s. H. 17.1 cm.

Cactus in Pink and Purple, 1920s. H. 50.8 cm.

Female Nude Sitting,
1920s. H. 63.5 cm.

Male from Side,
1920s. H. 63.5 cm.

Female Nude Sr. Concour,
1920s. H. 63.5 cm.

Female Nude (Back) Small Sketch
Beside, 1920s. H. 63.5 cm.

Male Nude, 1920s. H. 45.7 cm.

Female Nude Torso (Front),
1920s. H. 63.5 cm.

Male Holding Pole,
1920s. H. 63.5 cm.

Male Sitting (Back),
1920s. H. 63.5 cm.

Female Nude Sitting with Hand on
Hip (Front), 1920s. H. 63.5 cm.

Border Design Butterflies on Black,
1920s. H. 58.4 cm.

Nude Supporting Building,
1920s. H. 33 cm.

Basic Forms Sr. Design,
1920s. H. 35.6 cm.

Viktor S. Schreckengost logo, 1920s.

once, for example, transforming a back view of a woman into a collection of cubes.

Finally, many of Viktor's student drawings anticipate his later career in industrial design. There are renderings of vases, bookends, lace, an automobile logo, a Christmas card design, a personal "VS" logo, a repeating graphic design of a cactus, and an intricate border with a butterfly motif.

Batiks

A fascinating and little-known side of Viktor's art is his work in batik. For years he taught how to make batiks in his classes at the Cleveland Institute of Art. In 1929 he made eight batiks, which played a prominent role in the one-man show he held in Akron in 1931. But Viktor did not exhibit any of his batiks after 1933, and his work in this medium was essentially forgotten until last year, when two of his batiks, *Mycenean*, an im-

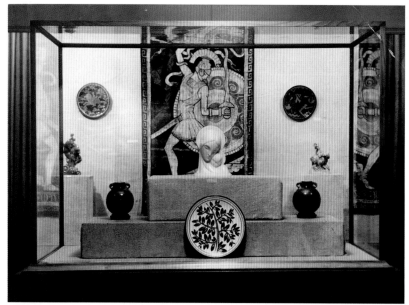

Akron Art Institute exhibition, 1931.
Perseus and the Gorgon batik hangs on wall.

age of a standing woman, and *Perseus and the Gorgon*, showing Perseus with the Gorgon's head, were discovered in his attic. Both are striking decorative designs, rendered with a flatness that brings to mind both Greek vase painting and Art Nouveau poster design. These batiks have not yet been restored; shown are photographs of these works at the 1931 exhibition.

Not only are these pieces important artistic discoveries in their own right, but they bear an interesting relationship to Viktor's work in other media, particularly to his pottery. In batik the artist paints the design with removable wax, then dips the fabric in dye. The dye colors the fabric everywhere except where it was painted with wax. By its nature, the method encourages the artist to

Akron Art Institute exhibition, 1931. *Mycenean* batik on display.

think in strong patterns of figure and ground. In short, the batiks trained Viktor to make paintings that were also ornamental, and thus helped him develop the very decorative style of painting that he began applying to bowls and vases shortly afterwards—often in pieces that, like the batiks, portray mythological scenes, such as *Leda and the Swan*. In addition, batik encouraged Viktor to think about the properties of wax. This influenced his work in pottery, for in 1930 he began mixing wax with glazes so that he could draw designs on the clay surface.

Oils

While Viktor's long career focused chiefly on ceramics and industrial design, during the 1930s he produced a few quite impressive oil paintings. Two untitled early works show the influence of Cubism. The first shows a woman with a white cat and a plant. It was painted circa 1930–1931 and hung in Viktor's home for several years. A second, a still life of a fish dinner on a table in front of

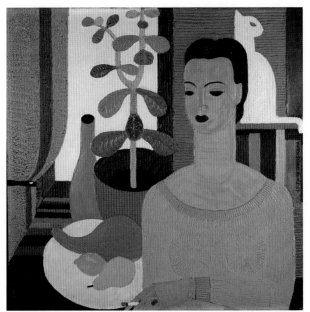

Morning Light, 1930s.

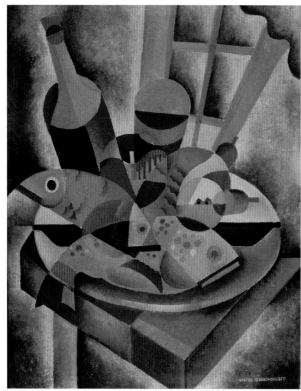

Still Life, 1930. H. 55. 9 cm.

a window, prefigures Viktor's later still-life watercolors. This piece was exhibited in Cleveland's 1931 May Show.

The most ambitious of Viktor's oil paintings was *Blue Revel* (1931), which featured a jazz band and a series of black topless dancers, all rendered in a style somewhat reminiscent of Mexican cartoonist Miguel Covarrubias, whose book *Negro Drawings*, recording the nightlife of Harlem, had been published a few years before. A sketch of *Blue Revel* was recently unearthed in the Schreckengost archives. The general imagery of the painting is quite similar to that of Viktor's famous *Jazz Bowl*, although the inclusion of stereotyped African figures makes it more problematic to display today, when such stereotypes are often considered demeaning. The painting was based on actual performances of topless dancers that Viktor witnessed at the Globe Theater in Cleve-

land. Viktor was not the only artist who visited the Globe Theater's performances to gain inspiration—other faculty from the Cleveland Institute of Art, such as Paul Travis, liked to go there to sketch the figures as they danced.

Moroccan Lutes (1934) portrays a group of instruments that Viktor had acquired during a long trip through North Africa with his best friend, chemist and photographer Fred Stross. The instruments on which it was based are still hanging on a wall in Viktor's attic. The Cubist style of the painting pays tribute to the work of Picasso, an artist whom Stross greatly admired. In the same year, Viktor painted another Cubist

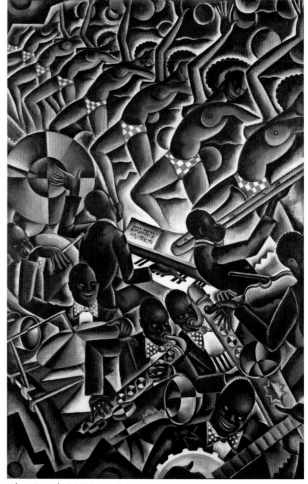

Blue Revel, 1931. H. 127 cm.

still-life composition on his *Still Life* plaque (see Chapter 3), which now belongs to the Cleveland Museum of Art.

November Morning

Viktor executed so few oil paintings that when archivist Craig Bara discovered a 5' × 5' oil painting in Viktor's attic in late 2005, he first assumed it was someone else's work. But it bore the artist's bold signature. A quick check through the artist's card files confirmed that this was *November Morning*, painted in 1937. Several sketches of the piece were found as well. Craig described his response to the painting of a barren country road.

Moroccan Lutes, 1934. H. 101.6 cm.

"I could hear the sounds of a cold autumn day, especially the wind. It seems to be the after-autumn season before the snow, but with winter quickly approaching. All is barren, no leaves, no animals, no people." He noted fierce-looking black clouds and tree branches bent unnaturally by the wind. Yet sunlight pours through one section of clouds, silhouetting the last of three crosses receding in a line down the road. When asked to explain the meaning of the newly discovered painting, Viktor gave the same evasive answer he often does when asked about his more thoughtful works: "What do you think it means?" On more than one occasion he has resisted telling "the meaning" of a work, preferring instead to allow viewers to think through the questions or ideas he proposes.

World events may offer a hint to Viktor's feelings during this time period. A letter written by

Blue Revel sketch, ca 1931.

November Morning, 1937. H. 142.4 cm.

Viktor to his friend Edgar Kaufmann, Jr.[1], a fellow student at the Kunstgewerbeschule in Vienna, described a trip to Europe during the summer of 1937. Viktor expressed extreme disappointment in the condition of his old school there, saying, "It was quite a disappointment to go back to the school and find it completely changed. They seem to be worse off than ever."

Kaufmann responded: "I imagine there are many such changes now that the Social Democratic government has been gone for so many years." Perhaps the storm clouds in *November*

1 Edgar was a member of the family that owned Kaufmann's department store, through which he also knew Viktor (from dinnerware sales). The Kaufmann family commissioned Frank Lloyd Wright to build their famous home, Fallingwater, in Pennsylvania.

November Morning Sketch #1,
ca 1937.

November Morning Sketch #2,
ca 1937.

November Morning Sketch #3,
ca 1937.

November Morning Sketch #4,
ca 1937

November Morning Sketch #5,
ca 1937.

November Morning Sketch #6,
ca 1937.

November Morning Sketch #7,
ca 1937.

November Morning Sketch #8,
ca 1937.

Series of sketches for
November Morning.

Morning forebode the gathering storm of war in Europe and the rays of the sun breaking through, a sense of hope for the outcome. An explanation along this vein would be consistent with the deep interest and concern over world events expressed in Viktor's prewar political sculptures.

Watercolors

As a student at the Cleveland Institute of Art, Viktor received instruction in watercolor from two virtuosos of the medium, Frank Wilcox and Paul Travis. However, he did not seriously explore watercolor until he served in World War II, when he found that constant travel made it difficult to work in clay or create oil paintings. He executed a number of watercolors during World War II—after the war he began to use watercolor studies to explore themes and subjects that appear in his sculptures. In later years, Viktor created a number of watercolors for commercial projects. After he retired from working in clay as a result of back surgery in the late 1950s, watercolor became Vik-

Looking Down, ca 1945. H. 55.9 cm.

Low Ceiling, ca 1945. H. 55.9 cm.

Closing In, ca 1945. H. 55.9 cm.

Scattered to Clearing, ca 1945. H. 55.9 cm.

tor's primary medium, and during his later years he produced brilliantly colored, museum-quality paintings.

World War II Watercolors

In June 2005, more than forty watercolors painted during and immediately after World War II were found in Viktor's attic, hidden behind a stack of empty frames. These canvases, most of which have never been framed or exhibited, were previously assumed by Viktor to have been lost or sold. The works are signed, some with Viktor's military rank and position, and almost all appear to have been untitled. Those painted during the war may represent the only significant chunk of Viktor's work that he did not catalog in his card

Banking Left, ca 1945.

files since he was away at war while they were created.

Three subjects are repeated throughout the series: a pilot's perspective from the clouds, images of war devastation in Europe, and, curiously enough, orchids. Perhaps the most original of

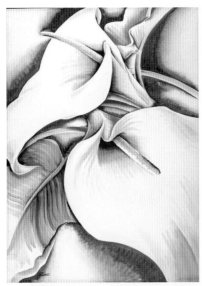

Orchid (Blue), 1940s. H. 76.2 cm.

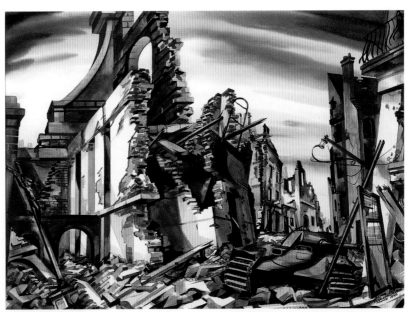

All Quiet (France), 1946. H. 48.3 cm.

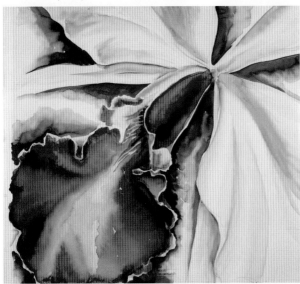

Orchid (Pink), 1940s. H. 50.8 cm.

these pieces are the series of aerial views, based on Viktor's flying experiences. These perspectives transform the familiar landscape into strangely abstract patterns. Of the second subject, one of the most masterful is *All Quiet (France)*, inspired by the ruins of French villages encountered after the 1945 Battle of the Bulge. The work is obviously based on motifs combined from different places, which he probably sketched from life: a wrecked car; a tall building, half shattered; a

crumbling wall seen in silhouette. Organizing all these motifs into a unified composition proved a challenge. "I found… that one of the most difficult things in the world is to paint rubble and destruction," Viktor later commented. "Even the illusion of chaos must be carefully planned." The third subject, which fills several slightly smaller canvases, are bright, beautiful single orchid blooms. One extraordinary example shows a close-up of orchids, reminiscent of Georgia O'Keeffe's florals but perhaps more unexpected in pattern. The handling of pigment is confident and decisive. With wonderful skill, Viktor used the white paper to indicate the tendrils.

The paintings fulfilled his need to express himself, especially his horror at the devastation of France. Unfortunately, Viktor commented, "People were not interested. When they reacted at all, it was with a shrug that seemed to imply: all that is over now, so let's forget about it."

After he returned to Cleveland, he continued in a melancholy vein with paintings of demolished buildings in a group of moody studies of decaying

Wild Dream, late 1940s. H. 55.9 cm.

ceramics; others explore the patterns of bottles or musical instruments. From 1946 to 1958, the last year for which prizes were given, Viktor received an award of some sort in the May Show every year.

Still life forms a constant theme in Viktor's watercolors although his treatment of the theme

Dried Fruit, 1946. H. 54.6 cm.

old Victorian structures, reminiscent of the work of Charles Burchfield. One of his most curious watercolors during this period, *Wild Dream*, executed just after the war, combines several of his war-era interests—an aerial view, a Cubist perspective, and an exploding building. The painting shows a building in odd perspective from an aerial viewpoint. In the foreground, a discombobulated statue seems to be jumping off its pedestal in response to the disturbing strangeness of the scene.

Still-Life

During the late 1940s, when he was working on his slab forms, Viktor made many watercolors of still-life themes. Some of these feature his own

Studio Window, 1947. H. 55.9 cm.

Floral #5, 1973. H. 101.6 cm.

Hewn Forms, 1947. H. 55.9 cm.

Composition, Pottery Forms, 1952. H. 55.9 cm.

altered considerably over the course of his career. Early still-life paintings, such as *Dried Fruit* (1946), while organized in strong patterns, are essentially representational. By the late 1940s, however, he was beginning to experiment with a more stylized approach, as in *Studio Window* (circa 1947), which organizes plants in front of a window into a semiabstract arrangement of forms. By the 1950s, he had begun to fracture the forms in a fashion reminiscent of stained glass although occasionally he would employ a very different approach, with wet, bleeding forms, as in *Floral* (1973).

By the 1960s and 1970s, Viktor began painting still lifes of his own three-dimensional works and those of other artists. *Hewn Forms* is a painting of some of his slab form sculptures. *Composition, Pottery Forms* is another example that was recently discovered in the permanent collection at the Nora Eccles Harrison Museum of Art at Utah State University.

High Fire, painted around 1979 after fellow artist Claude Conover requested that Viktor paint some of his clay works, recently sold at auction for several thousand dollars.

Watercolor Studies

Viktor often worked back and forth between different media, and many of his clay renderings of animals relate closely to watercolors. His watercolor *From the East*, for example, is closely related to his sculpture *Brahman* (1951), and also stresses the massiveness of the bull's body. But

From the East. H. 55.9 cm.

Aaron with Serpent, 1976. H. 101.6 cm.

Viktor transforms the motif by showing two bulls superimposed on each other as well as by the intensity of the red color of the piece. In some of his animal sketches of the 1950s, he simplified the patterns in a way that resembles prehistoric cave drawings. This, in turn, seems to have influenced his use of designs reminiscent of cave paintings in the Primitive pattern he devised for his Free Form dinnerware shape in 1955.

Religious-Themed Watercolors

Viktor's religious watercolors are just as thought-provoking as his religious sculptures and

often as ambiguous, preferring only to present a question or theme and leave the interpretation of meaning to the individual observer.

Perhaps his most ambitious religious-theme watercolor is *The Apostles*, a panel depicting the faces of the twelve disciples chosen by Jesus. Their faces might be described as masklike in their stylization and opaque expressions. Such a presentation differs markedly from the expressive faces of Viktor's sculpted St. Peters. Instead the faces take on an almost mythological feeling, removed from the human experience. Each apostle may be identified by traditional iconography: for example, Peter has a key, Simon a hook, Judas three silver pieces, Philip a fish.

Aaron with Serpent refers to the story that Moses's brother Aaron performed a miracle before Pharaoh by turning his staff into a snake. Pharaoh's sorcerers responded by turning their own staffs into snakes, but Aaron's serpent triumphed by eating the other serpents. Aaron's expression

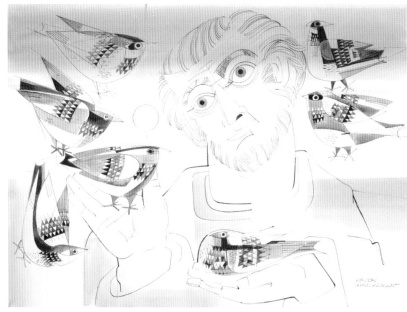

St. Francis, 1976. H. 76.2 cm.

The Apostles, 1951. H. 76.2 cm. *The Apostles* depicts these disciples, from top left: Peter, James (brother of John), John, Simon, Andrew, Matthew, Thomas, Judas, Matthias, James the lesser, Philip, and Bartholomew.

is somewhat enigmatic; he may be troubled or sobered by the power he wields. His arm is raised with serpent in hand, a gesture typical of a conqueror, yet the composition of the snake is sinuous, perhaps connoting a far from straightforward feeling of triumph. *St. Francis*, with a pale saint and colorful birds, puts the focus on the birds rather than the man feeding them.

Viktor used watercolor to explore the religious themes that also appeared in his sculptures. For example, he produced a number of watercolors that almost seem to be studies of his religious sculptures Judas and St. Peter.

Commercial Projects and Later Watercolors

In the late 1950s, Viktor underwent surgery because of a serious back injury. As a result, he could no longer handle large slabs of clay and watercolor became his primary means of artistic expression. He continued taking commercial commissions, which had begun after winning a prize in a New York watercolor show many years earlier. Since that time, he had been doing paintings for Christmas cards for the American Artist's Group, producing such cards annually for nearly fifty years, from 1947 to 1996.

His work was often reproduced in programs for Cleveland cultural events and benefits: in 1958 he even designed a little burro carrying a backpack for Roxboro Elementary School in Cleveland Heights. Very likely, his increasing involvement with commercial projects had an influence on his overall style, which grew progressively bolder, more stylized, and more brilliant in color.

Cityscapes and Musical Instruments

Some of Viktor's most interesting later watercolors are two similarly styled series: cityscapes and musical instruments. Vivid colors and small geometric blocks characterize these canvases, painted mostly in the 1960s and 1970s. Several of the cityscapes feature views of the pre-9/11 New York City skyline. These resemble blueprints or technical drawings, and a modern viewer might

Roxboro Elementary mascot logo, 1958.

Cover of *Today's Art* (August 1962) featuring Viktor's painting, *Morning Light on the Riverfront*.

Afterglow in the City, 1974. H. 76.2 cm.

Uptown, 1989. H. 101.6 cm.

compare them to low-resolution digitized images; either way, the style may be perceived as Viktor's reference to the role of technology in urban life and development. *Morning Light on the Riverfront* was featured on the cover of *Today's Art* in 1962 as the winner of a purchase prize in the American Watercolor Society's annual show. Vik-

New York Buildings, Blue Background. H. 97.5 cm.

tor relies on color to evoke different moods in, for example, *Afterglow in the City* and *New York Buildings, Blue Background*. He captures a cold, hazy light with paler tones in *Bridge in Winter* and the businesslike energy of daylight hours in *Tapestry of a City*.

From his youngest days, Viktor was a musician; in fact, he almost pursued a professional music career instead of art. That interest is reflected in earlier works, including the *Jazz Bowl* series (beginning in 1930) and *Moroccan Lutes* (1934), as well

as a series of watercolors done later in life. Viktor uses bright colors and resonating patterns to communicate a sense of music and rhythm. The saxophone, which Viktor played, recurs in multiple works, including the vibrant *In the Mood: Rhapsody*. This piece and *Baritone in Brass* give a sense of Viktor's "musical spectrum": in the first, purples and blues evoke a much more mellow tone than the brassy

Bridge in Winter, 1976. H. 55.9 cm.

golds of *Baritone in Brass* and the upbeat reds and yellows of *Lute*. Viktor even embraced the en- ergy of electronic instruments and sounds in *Rock Jazz Bass*, completed in 1994 for the opening of

Tapestry of a City, 1973. H. 55.9 cm.

In the Mood, 1995. H. 101.6 cm.

Baritone in Brass, 1958. H. 76.2 cm.

Lute, 1968. H. 73.7 cm.

the Rock and Roll Hall of Fame in Cleveland when Viktor was eighty-eight years old!

In 1979 Viktor produced a series of fourteen watercolors of notable buildings, such as the West Side Market, the Terminal Tower, Little Italy, and the Art Museum, for a 1980 Cleveland calendar produced by International Printing. In preparation for the series, he shot twenty-four rolls of

Rock Jazz Bass, 1994. H. 101.6 cm.

Severance Hall, 1979. H. 55.9 cm.

Little Italy, 1979. H. 55.9 cm.

Bend in the Cuyahoga.

Entrance to the City, 1979. H. 55.8 cm.

Engine Number 21, 1979. H. 55.9 cm.

Liberty Boulevard, 1979. H. 55.9 cm.

Beginning with *Severance Hall* in January and concluding with *Shaker Square* in December,
the 1979 Cleveland calendar's oversize images—big enough for framing—celebrated local landmarks.

film. He and close friend Gene Nowacek (later his second wife), took a ride across Cleveland's lakefront and up the Cuyahoga River on the Goodtime, a popular touring cruise, to capture several famous views of the city. When the cruise captain discovered their mission, he took them

Over the Bridge, 1972. H. 55.9 cm.

Sacred Landmark, 1964. H. 76.2 cm.

West Side Market, 1979. H. 55.9 cm.

Garfield's Monument, 1979. H. 55.9 cm.

Lakeside Northeast, 1979. H. 55.9 cm.

Shaker Square, 1979. H. 55.9 cm.

out onto Lake Erie to photograph a lighthouse and to capture better images of the city's skyline. Gene also drove onto sidewalks along what is now Martin Luther King, Jr., Boulevard to allow Viktor to photograph the bridge that appears in one of the watercolors.

The calendar was the second in a series of calendars featuring Cleveland-area artists that was produced for several years by International Printing. For twelve years, individual artists' work made up each year's calendar; for the thirteenth year, the company invited all participating artists to vote for their favorite images among the others' previous works. A final calendar featured the most popular image by each artist.

The calendar made it possible for those who could not afford Viktor's full-size paintings to enjoy his work. According to Craig Bara, even today pages from those calendars are to be found, framed and hanging in Cleveland area offices. Though Viktor created fourteen canvases, only twelve were used. The printer then created prints of the fourteen canvases, one hundred of each which Viktor signed as a series. Gene Schreckengost, Viktor's wife, remembers that during the process of signing those 1,400 prints, Viktor commented that he wished his name was Roy Hess, a former student and business partner who apparently had the shortest name he could think of. Those prints were sold by Bonfoey, a Cleveland gallery.

In the late 1980s and early 1990s, Viktor produced the Guerreros, a large series of around twenty-six watercolors featuring wooden fish carved in Mexico. During a trip to Mexico, Viktor observed fishermen using carved fish-shape rattles as good-luck charms. Mask makers subsequently painted these as folk art. Upon his return to Cleveland, he found some of these fish in a folk art shop in Little Italy. He used these as a recurring motif in several canvases, likening his work

Guerrero XXI, 1990. H. 101.6 cm.

to a jazz musician doing variations on a theme. The paintings are anchored visually by these fish, which are surrounded by images taken from the fish themselves: stylized suns, waves, and other tropical themes. Delightful, bright ornamental patterns emerge.

The Guerreros were exhibited in the spring of 1991 to an enthusiastic audience. A number of the paintings sold before the show even opened; by the end of the exhibition, only two were left unsold. The Guerreros represent the last series of pieces Viktor created, but in his mind they also coincide with a new chapter in his life. When his nephew Gary Schreckengost, a minister, came to town for the closing of the show, Viktor asked him to be the officiant for his wedding to longtime friend and neighbor Gene Nowacek. Gene, a pedi-

Guerrero Still Life III, 1989. H. 55.9 cm.

Guerrero Still Life VII, 1989. H. 55.9 cm.

Guerrero Still Life X, 1989. H. 55.9 cm.

Guerrero Still Life XIIB, 1990. H. 55.9 cm.

Guerrero Still Life XXVI, 1995. H. 55.9 cm.

Guerrero Still Life XXV, 1991. H. 76.2 cm.

atrician, retired that year as the medical director of a hospital and, though several years his junior, signed on as wife, companion, and caregiver to Viktor on April 27, 1991.

THEATER AND COSTUME DESIGN

When he first enrolled at the Cleveland Institute of Art, Viktor expressed interest in becoming a cartoonist. While his career ultimately took him elsewhere, Viktor's "side" work in costume and set design shows a canny ability to grasp and reflect the larger sentiment or meaning of a theatrical project. In addition, his various projects in this arena—from puppet heads to rubber masquerade costumes to full theatrical sets—illustrate the sometimes tangential path of an industrial designer. Viktor's puppetry project might be attributed to his background as a sculptor and potter; from this and other introductions to figures in theater, other projects in costume and set design followed.

Helen Joseph Puppets

In the early 1930s, working in partnership with Guy Cowan, Viktor began designing puppets for Helen Haiman Joseph, who ran her own puppetry company out of Shaker Heights, Ohio. In the early 1920s, Helen Joseph had written a book on the history of marionettes that became standard reference for marionette makers and puppeteers. By the 1930s, she headed the children's theater program at Cain Park in Cleveland Heights, Ohio, near Viktor's home. Not surprisingly, Helen and Viktor crossed paths. Her company, Playfellows, Inc., was in need of someone to create puppet heads

Pinocchio marionette, Helen Joseph Puppets, 1934.

Sambo marionette, Helen Joseph Puppets, 1934.

for children's create-your-own-puppet kits. Viktor designed the heads in clay and arranged to have thousands of them fired at Gem Clay Forming Co. in his native Sebring, Ohio, where he was active in the pottery industry. He also devised costumes for the figures and designed packaging and advertising. Recently a variety of these puppet materials have surfaced in Viktor's attic, including puppet heads, packaging, and complete puppet figures of Pinocchio, a sailor, Sambo, and Topsy.

These marionette heads were not Viktor's only foray into children's theatrical toys. He was recently discovered to have created the backdrop for a small set of figurines portraying Hal Roach's "Our Gang" (aka "The Little Rascals"), and may

Topsy marionette, Helen Joseph Puppets, 1934.

have designed backdrops for similar sets, including an early and now very rare Tarzan set.[1]

Theatrical Design

From 1937 until 1943 Viktor designed three or four stage productions a year for his close friend Barclay Leathem, who headed the theater department at Case Western Reserve University in Cleveland. The two had known each other in Vienna, when Viktor was at the Kunstgewerbeschule and Leathem was studying with the great theatrical impresario Max Reinhardt.

Many of Viktor's efforts along this line were clearly a labor of love. Leathem's productions were often performed by undergraduates in the university's Eldred Theater, a modest facility that seated only 200. Still, Leathem staged many more ambitious summer productions, including a world premiere of William Saroyan's play *Jim Dandy* in 1941 and plays at Cain Park that featured Marta Abba, a remarkable Italian actress who had performed in Rome with the theater troupe of the famous playwright Luigi Pirandello. Abba performed both in a comedy, Victorien Sarou's *Divorcons*, and in a more thought-provoking Pirandello play, *Right You Are! If You Think So!*

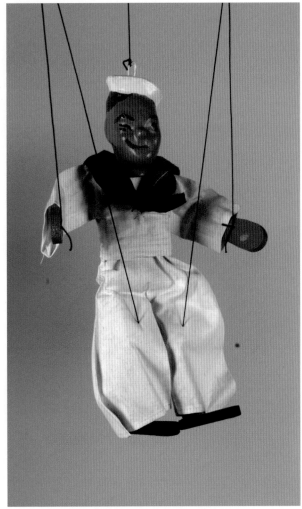

Sailor marionette, Helen Joseph Puppets, 1934.

1 One of the "Our Gang" sets was recently offered for sale on eBay (November 28, 2005).

Murder in the Red Barn

Among the fascinating items that have emerged in recent years from Viktor's attic are sketches for one of his first major theatrical projects, a Victorian set piece. Around 1937 the Dunham Tavern—the oldest building in Cleveland—was badly in need of renovation. As a fund-raiser, Barclay Leathem agreed to stage *Murder in the Red Barn*, a melodrama written in 1840. The play was filled with wonderfully stereotypical characters such as dastardly villains and helpless women. The

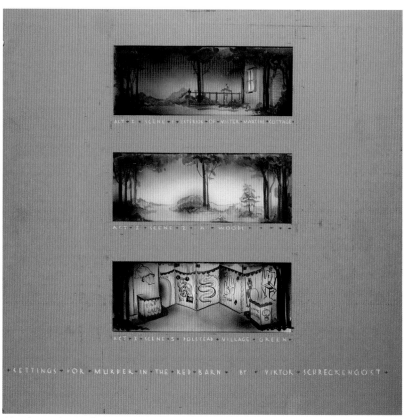

Murder in the Red Barn: Act 1 Scene 3, ca 1937. H. 76.2 cm.

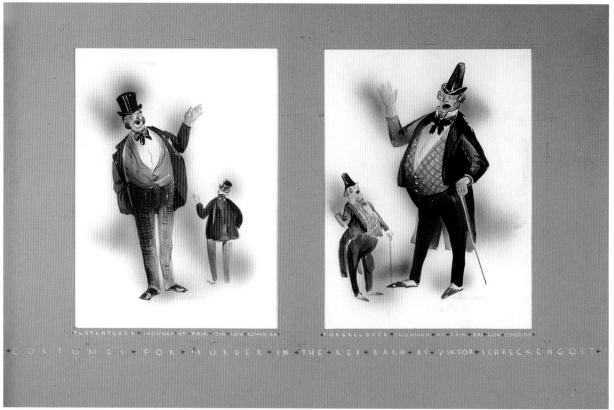

Murder in the Red Barn: Flat Catcher, ca 1937. H. 55.9 cm.

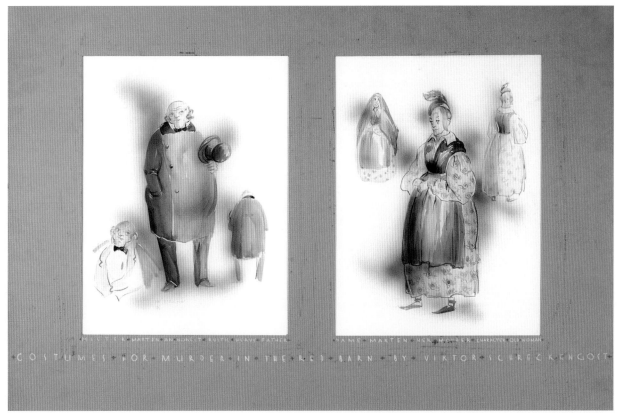

COSTUMES · FOR · MURDER · IN · THE · RED · BARN · BY · VIKTOR · SCHRECKENGOST

Murder in the Red Barn: Dame Marten, ca 1937. H. 55.9 cm.

audience was encouraged to participate in the fun by cheering the hero and heroine and hissing at the villain. The play featured innumerable scene changes, which Viktor evoked with roll-down backdrops.

Victorian melodrama became one of Viktor's specialties. In addition to *Murder in the Red Barn*, he also designed sets for Thornton Wilder's *The Merchant of Yonkers*, which spoofed the Victorian theatrical conventions of the 1880s, and for Augustin Daly's *Under the Gaslight*. The latter featured eleven different scenes, including a bridge from which the heroine was thrown and a railroad track to which the hero was bound.

Spook Sonata

One of Viktor's most ambitious projects was a group of costume and set designs for August Strindberg's unconventional play *Spook Sonata*, a tale of unhappy, haunted characters whose meaning, one theater critic complained, was as difficult to grasp as "trying to nail jelly to a wall." While optimistic by nature, Viktor seems to have reveled in the Gothic gloom of this strange story.

Viktor set the play in a forest of green columns and arches that receded into a seemingly infinite distance. The set had a panel in front that gradually moved aside to transform the scene from the outside of a building to the interior of a room. With a humorous exaggeration reminiscent of a Disney cartoonist, he also sketched costumes for the characters of the piece, which included

a ghost, a student, a mummy, and a milkmaid. Like the stage designs, his costumes perfectly capture the strange mood of the play. One rendering contrasts the colonel, who has an impressive uniform with epaulets, and the bandaged mummy of his murdered wife; another pairs the blowsy cook, who wears bilious yellow, with Bengtsson, the colonel's manservant, looking stiffly formal in mossy green.

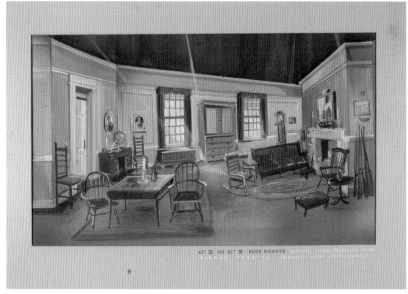

Poor Richard: Acts 3 and 4. H. 55.9 cm.

Poor Richard

Viktor's gift for creating different moods is illustrated by two set drawings for *Poor Richard*—one the musty interior of a shop with books, the other a palatial white-and-gold interior with elaborately decorated doorways. Both drawings concentrate on the illusion without making it exactly clear how Viktor intended to handle the physical

change from one to another. But even from the drawing, one suspects that the walls of the palace were simply curtains and that Viktor may have used lighting and a few doorways or other props to suggest a complete imaginary realm.

Murder in the Cathedral

Viktor's costume designs for *Murder in the Cathedral* illustrate a canny ability to suggest contrast or relationships between characters. He used costumes in the same way a cartoonist uses caricature: for both illustration and commentary. A dull monk's attire forms a stark contrast to the splendid paraphernalia of a bishop. Similarly, drawings for the costumes of two knights share an essential pattern but use contrasting colors and patterns to indicate differences.

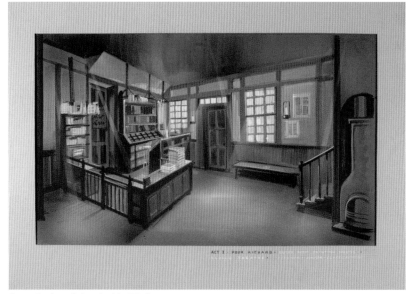

Poor Richard Act 1. H. 55.9 cm.

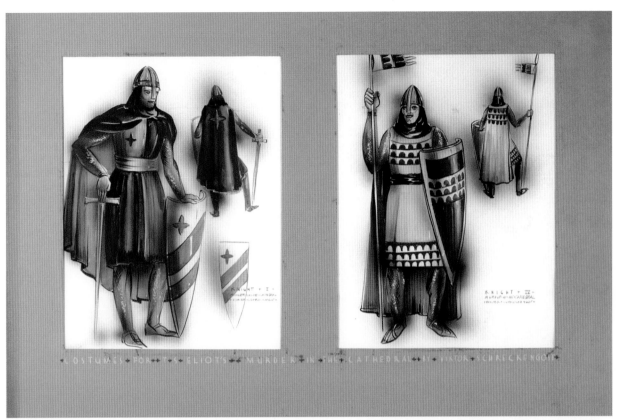

Murder in the Cathedral: Knight 4. H. 55.8 cm.

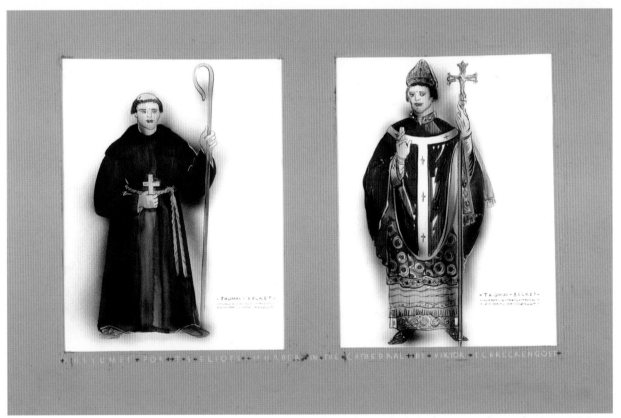

Murder in the Cathedral: Thomas Becket (Bishop). H. 55.9 cm.

The Akron Rubber Ball, 1939

One of Viktor's most ambitious forays into costume design occurred in 1939 when he was commissioned to create costumes for the Akron Rubber Ball. This lavish social affair, sponsored by Akron-based tire companies Firestone and Goodyear, was intended to draw attention to the city's preeminence

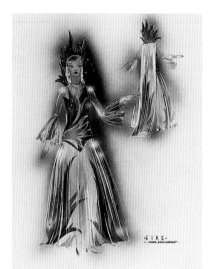

Fire-Female costume sketch, Akron Rubber Ball, 1939.

in the production of rubber products. The event included a contest for the most creative rubber costumes, though freakish costumes such as gigantic hot water bottles were discouraged. The significance of the occasion is suggested by the fact that three nationally celebrated painters—Charles Burchfield, Rockwell Kent, and John

Sloan—were brought in to serve as judges for the event.

Viktor was commissioned to design attire for the king and queen of the court and their eighteen attendants (nine men and nine women), all of whom were major executives in the rubber industry or their consorts. The costumes were fabricated entirely from rubber fabrics and rubber products, some of which had never been shown in public before, such as Corasheen, Lioflim, Koroseal, and Controlastic—new materi-

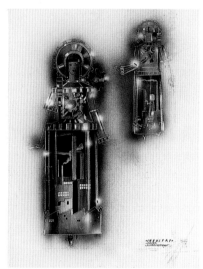

Industry-Female costume sketch, Akron Rubber Ball, 1939.

als that had just been developed for use in raincoats, corsets, and other forms of clothing. Many of the fabrics were transparent or semitransparent, and Viktor exploited this effect by layering one over another, creating vari-

ations in color, light values, and transparency that must have been fascinating at night, with shimmering artificial light.

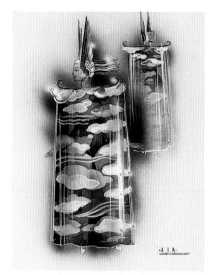

Air-Female costume sketch, Akron Rubber Ball, 1939.

The elongated forms of the female figures in Viktor's drawings reflect a new type of female beauty that was beginning to replace the slightly chubbier "flapper girls" of the 1920s. Viktor's costume designs are an interesting combination of various genres. Some, such as one depicting Industry, explored machine-age themes; others, as with Fire, bring to mind book illustrations for fairy tales by figures such as Kay Nielsen; still others, such as Air, explore decorative effects that recall Japanese prints (in this case, the pattern of clouds recalls Hokusai's prints of Mount Fuji).

INDUSTRIAL DESIGN

Viktor began to apply his concepts of design to mass production early in his career. Interestingly, while Powolny had occasionally designed for mass production, his teaching at the Kunstgewerbeschule focused entirely on handicraft. While in Europe, however, Viktor must have been aware of movements that applied modern design to mass production, such as the Wiener Werkstätte or the Bauhaus, and throughout the 1930s Viktor regularly made trips to Europe during which he visited schools, stores, museums, and factories, looking for things that were new and different in their approach. When he turned to industrial design Viktor used two principles that had precedents in Europe: the use of clean, simple, powerful shapes, and a machine-made look. Viktor's designs, however, are not just reproductions of what was being done in Europe. He had a gift for making designs that

> "If they sold 600,000 of something I felt I was on the right track."
>
> —Viktor Schreckengost

101

looked friendly rather than austere and that met the specific needs of the American market. In addition, he often made technical innovations that improved performance or lowered the cost of an item. Indeed, in nearly every field he touched, his designs shook the industry.

In 1932 Viktor made breakthroughs in two very different product areas: trucks and dinnerware. Following these successes was an evolving chain of products that, broken only by his service in World War II, continually branched into new projects well into the 1970s.

The theme for the 2006 Viktor Schreckengost National Exhibition Series, during which more than one hundred venues across the United States will display Schreckengost creations in honor of his one-hundredth birthday, offers a fitting summary of Viktor's influence on the world of twentieth-century design and consumer culture:

Almost every adult living in America has ridden in, ridden on, drunk out of, stored their things in, eaten off, been costumed in, mowed their lawn with, played on, lit the night with, viewed in a museum, cooled their room with, read about, printed with, sat on, plac ed a call with, enjoyed in a theater, hid their hooch in, collected, been awarded with, seen at a zoo, put their flowers in, hung on their wall, served punch from, delivered milk in, read something printed on, seen at the World's Fair, detected enemy combatants with, written about, had an arm or leg replaced with, graduated from,

protected by, or seen at the White House something created by Viktor Schreckengost.

The Cab-Over-Engine Truck, 1933

Viktor's involvement with trucks came about through his friendship with Paul Travis, the gifted draftsman and watercolorist whose yearlong trek across Africa, from Capetown to Cairo, had inspired Schreckengost's bust *Jeddu* (1931). Travis was teaching an art class for professional women at the Church of the Covenant and found that his students, tired of making paintings, wanted to work in crafts. Viktor took over a few classes and taught the women to make pottery, batiks, lamp shades, and other items. In the course of his teaching, he became friendly with one of the women in the class, Madge Spiller.

> "Perhaps the greatest single innovation in truck design occurred when Viktor Schreckengost placed the cab over the engine in 1933 for the White Motor Company."
> –Hugh Greenlee, *The Art of Car Design*

At the time, Viktor was designing a double-decker bus for the city of New York. The idea was that the bus would run on steam, which would cause less pollution. In the end, however, the project was shelved since it would have cost too much to build a factory to produce the engines.

One Saturday morning when Viktor was working on the double-decker, there was a knock on the studio door. When he opened it, there was Madge. "I want you to meet hus," she said. "Hus" was Ray Spiller, the chief engineer for White Motor Company. Viktor invited them in, and Spiller looked

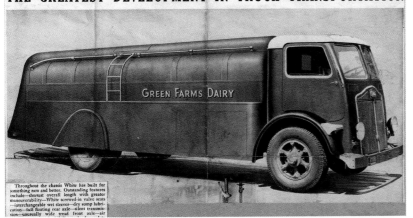

Advertisement for White Motors truck with cab-over-engine design by Viktor Schreckengost.

over the sketches for the bus with great interest. "When you're done, I've got a project I'd like to discuss with you," Spiller told him. Six weeks later Viktor had finished his bus; he gave Ray Spiller a call and arranged to visit White Motor.

An outgrowth of the White Sewing Machine Company, which was founded by Thomas White in 1886, White Motor Company was established when White's three sons became interested in making trucks and produced their first vehicle in 1906. The business was hit hard in 1929 when Walter White, who was running the business, was killed in a car accident. The onset of the Great Depression further compounded the company's problems. By 1931 sales had dropped 75 percent from the previous decade and the company desperately needed to come up with a new product.

Spiller had come up with an idea for one: The length of a truck on the road was limited by law

to forty-two feet. As a consequence, anything you could do to reduce the length of the cab would add to the profit-making hauling space in the trailer. Spiller's idea was to put the engine right under the cab, which would allow five more feet of cargo space. But he was having trouble working things out.

During Viktor's first visit, Spiller showed him a mock-up that he had crafted from plywood and asked him what he thought. "It's the worst-looking chicken coop I've ever seen," was Viktor's response. Spill-

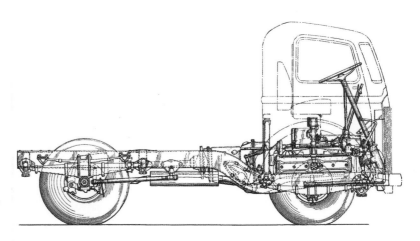

Cab-over-engine design sketch, ca 1933.

er asked if he could do better, and Viktor replied that he thought he could.

It took several months to work the glitches out of the design: the windshield needed to be tipped back to accommodate for the driver's higher sightlines once the cab was raised; a hole had to be cut into the fender and a headlight put behind it to avoid treading on a patent by Pierce Arrow for a headlight that was part of the fender; and

the door design had to be altered after the company realized that drivers disliked the original back-hinged door that allowed them to use the front fender as a step for getting into the cab.

Interestingly, while it was a major step forward in truck design, the cab-over-engine concept was difficult to patent. Patent law is based on the concept of adding an object or innovation of some sort to an existing product. But adding extra space by taking away the front end of the truck was not viewed as an invention. While Viktor did register a design patent, the fundamental principle he had introduced, that of putting the engine under the cab, was not patentable. As patent law stands, the placement of an object is not something that can be patented, even in a case such as this when it had dramatic financial and practical implications. Thus competitors were able to use the cab-over-engine idea by making a few superficial changes in styling. The principle has been widely imitated and is arguably the single most significant innovation in the history of truck design. Many trucks and buses in the United States and most models in Europe use the cab-over-engine design.

Toys and Pedal Cars

The manner by which Viktor was introduced to toy, pedal car, and bicycle design was surprising but not inconsistent with the pattern of his overall career. He often moved from one project to the next through strings of not-quite coincidences, as previous projects or employers brought him into contact with new opportunities. Viktor was never one to turn down an opportunity. When asked to do something he'd never done before, his typical response was, "That sounds interesting. I could

do that." And he'd learn it. In that context, the route he took from set design to bicycle design was totally reasonable.

One night Viktor brought his *Murder in the Red Barn* sketches over to Barclay Leathem's apartment, where they were joined by Leathem's upstairs neighbor, Ralph O'Brien, a vice-president at the Murray Company. After each of them had downed several mint juleps, the conversation turned to bicycles. Murray was looking for someone to replace their current designer, Count Alexis de Sakhnoffsky, who was proving difficult to work with. Had Viktor ever designed a bicycle? No. Would he like to? Of course.

They arranged to meet at the Murray Company the following Monday, but when Monday came, Viktor didn't know whether the appointment was real or the spin-off of mint juleps. Fortunately,

Count Alexis de Sakhnoffsky, *Esquire* magazine photo.

O'Brien called him to remind him of the engagement, so he rushed down to the Murray Company to meet with the president, C. W. Hannon. By the time the meeting was over, Viktor had received a commission to design a new bicycle for Murray to display at the 1939 World's Fair.

The Murray Ohio Manufacturing Company, 1937–38

Founded in 1919, Murray Ohio started as an extension of a Detroit company that did metal stamping for the automotive industry. In 1925 the president of the company, C. W. Hannon, purchased the factory complex in Cleveland and made it an independent company. In its early years Murray focused on stamping out fenders and other parts for Cleveland car manufacturers, such as Jordon, Peerless, Franklin, Rolland,

Hupmobile, Cleveland, and Sheridan. But as these companies folded, one after another, during the early years of the Great Depression, Murray turned increasingly to manufacturing bicycles and toys. In the mid-1930s Murray purchased a large building on Euclid Avenue near University Circle to manufacture bicycles. (This is now the McCullough Building of the Cleveland Institute of Art.) As Viktor was already teaching at the Institute of Art, this was a fortuitous development—the new location made it easy for Viktor to stroll back and forth between classroom and factory.

Murray began making toys as early as 1923, but they remained a sideline until 1936, when Murray landed a large contract from Sears, then the nation's leading retailer. Over the next few

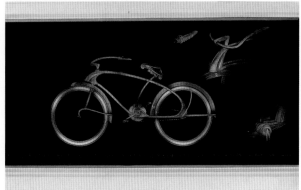

These concept drawings for bicycles were found recently in the Schreckengost archives. His dramatic technique of using colorful metallic forms on black paper was learned from previous Murray designer Count Alexis de Sakhnoffsky.

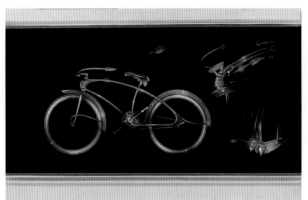
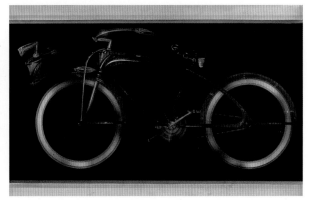

years the company shifted almost entirely to the manufacture of bicycles, pedal cars, and toys, a trend that continued until 1941, when it became heavily involved with producing canister shells and other munitions for the war effort.

In the early 1930s many of Murray's designs were produced by Count Alexis de Sakhnoffsky,

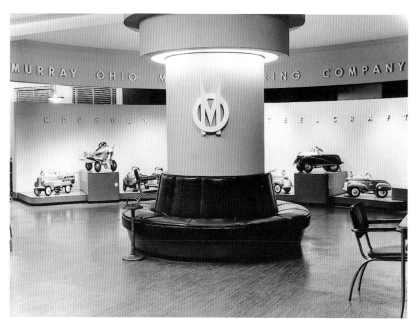

Murray showroom, designed by Viktor Schreckengost.

a now nearly forgotten figure based in New York who enjoyed a great reputation at the time since his drawings were regularly published in *Esquire* magazine. Sakhnoffsky seems to have been an important figure in developing the streamlined aesthetic, and he produced striking drawings that dramatically contrasted shimmering streamlined metallic forms against a dark background. He liked to work in pencil or gouache on black paper, a technique that Viktor adopted as well.

The problem was that Sakhnoffsky had little interest in mechanics or in the cost factors involved in making molds for complicated shapes. When Viktor first began working for Murray, his role seems to have been as a kind of adjunct designer who would help translate Sakhnoffsky's striking but complicated drawings into something that could be manufactured at reasonable expense. Viktor's archive contains a number of pedal car drawings by Sakhnoffsky that he was apparently asked to rework into something simpler to produce. He did so with such success that Sakhnoffsky seems to have dropped out of the picture within a year.

Very quickly it became apparent that Viktor could do drawings as striking as those of any outside designer and that there were great advantages to having him at the factory site, where he could confer with Murray's engineers to work out practical details. The genius of Viktor's designs lies not only in their overall look but in schemes he devised to cut down on the cost of the product. For example, he would reduce the number of parts, pack products in a way that reduced shipping and mailing charges, and develop product lines with interchangeable parts.

Initially Viktor seems to have been hired as an outside consultant to work with Murray project by project. By 1940, however, he had become for all intents and purposes the chief designer for the company, responsible for overseeing the entire product line and often taking on other assignments as well. In 1940, for example, he redesigned the company's logo, interlocking the M and the O in a more dynamic fashion; shortly af-

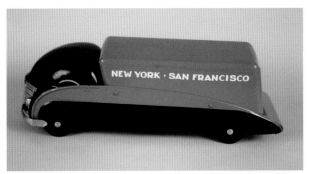

Steelcraft Toy City Delivery Truck.

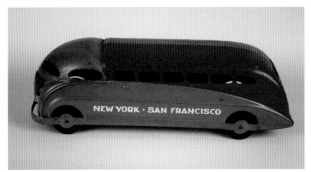

Steelcraft Toy World's Fair Bus.

ter the war, he redesigned the Murray showroom in New York. Good manners and personal charm played as much a role in his success as his design skill. One gathers that the Count had been imperious and high-strung and that everyone, from top down, much preferred working with Viktor. He quickly became a close personal friend of the president of the company; C. W. Hannon would confide his latest brainstorms and Viktor would diligently find ways to execute them.

When Viktor started working for Murray the company produced about $1 million worth of products a year, most of which were parts for the declining Cleveland automotive industry. By the time he retired, the company did a volume of about $40 million a year, consisting entirely of products that Viktor had designed.

Viktor's first work for Murray Ohio seems to have been a group of toy vehicles that were marketed under the name Steelcraft. The dimensions

of these toys were dictated by very specific restraints since the metal for them came from the scrap produced by stamping out fenders for automobiles. Sakhnoffsky had designed an earlier line of such toys, but they were expensive to produce since they had many small details that were difficult to cast, such as exhaust pipes and hood ornaments. Viktor eliminated these details and reduced the body to a sweeping arc-like shape. In other words, rather than literally copying existing vehicles produced by Ford and General Motors, he created a kind of generalized cartoon of an automotive shape. The bold curves he employed are distinctly reminiscent of the clean sweeping shapes he had used in the design of the first cab-over-engine truck. One of the most ingenious aspects of the design was that he created a product line with interchangeable parts. All the vehicles have the same chassis, but with the addition of a second piece they become a specific kind of vehicle, such as a car, bus, truck, or fire engine.

Red Wagon

Viktor's red wagon design quickly became so popular and widely imitated that we forget how innovative it was at the time it was produced. Re-

Super De Luxe 4-Ball Bearing Wagon, 1961. H. 61 cm.

Wagon concept drawing #1.

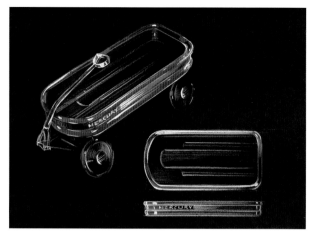

Wagon concept drawing #2.

cently, two concept sketches for his red wagon have been discovered that show the first phase of the design. His original model was based on the wooden wagons used in the countryside, the dimensions of which were established by the need to hold two milk cans—which, handily, was also the right size to hold two small children. Such wagons were traditionally made of wood. When Viktor created his model out of steel, however, he added a number of new features, such as rolled edges—still a novelty at the time—so that a child would not cut his hand, and a delicately curved shape that gave the wagon a dramatic streamlined look. He also added two mechanical improvements. The first was wheels with ball bearings, which provide a smoother and more cushioned ride. The second was a curved front handle that could be used, not only to pull the wagon from in front, but to steer the wagon from the inside. A coat of bright red lacquer paint with white accents gave the product a jazzy quality, evoking the image of a flashy roadster of the period.

Champion Pedal Car

Viktor's Champion, first issued in 1940, revolutionized pedal car design. To be sure, the design was modeled in part on earlier drawings by Sakhnoffsky—Viktor, however, not only made significant changes in styling, but thought through the process of making the product in a way that changed the whole

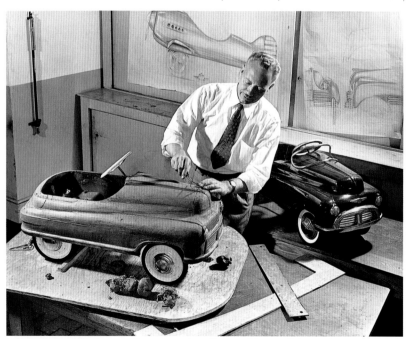

Viktor's expertise as a sculptor heavily influenced his pedal car designs. In this photograph from about 1940, Viktor is shown rendering a pedal car prototype in clay. The clay model was an interim step that transferred an initial two-dimensional rendering, like the concept drawing on the wall behind him, into a three-dimensional product, like the finished car on the floor.

pedal car industry. Earlier model pedal cars were constructed using the same method as a real automobile, with a chassis that was welded to an underlying frame. The Champion was stamped out in a single, flat piece that was then folded into the shape of a car: the body also served as the frame. Inserts at the front and back completed the ensemble. These inserts could be changed to create different models or types of vehicles—a particular car model, a station wagon, or a fire truck. The cost savings produced by reducing the steps of manufacture transformed pedal cars

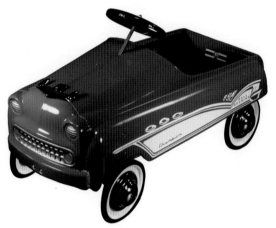

Murray Champion pedal car, first issued 1938.

from a rich boy's toy into something that nearly everyone could afford.

Interestingly, the contours of the shape do not closely resemble any full-scale automobile. Rather the vehicle has a teardrop shape, slightly higher and wider at the front, which gives it a pleasing streamlined look. The most popular version of the Champion had a streamlined bulge, roughly shaped like an airplane fuselage, which ran along the side and contributed to the forward-moving effect. The front of the car also does not closely resemble an actual automobile but rather is sim-

plified to have a face-like quality, with the grille forming a mouth and the headlights, two eyes. By playing with these elements, it was possible to give the pedal car an emotional expression: for example, one popular version of the design, which had a downward-turning grille, was known as the "Sad Face." In developing his shapes, Viktor was clearly influenced by the "concept cars" of the period. The streamlined look of the Champion, for example, recalls the concept cars that Raymond Loewy produced in this period for Hupmobile. Also, a child could, in his imagination, turn a more generic design into a car just like dad's.

Pedal Pursuit Plane, 1941

The most visually stunning of Viktor's children's vehicles was his Pursuit Plane, produced in 1941, just as America was about to enter World War II. While earlier pedal planes resembled orange crates held together with baling wire, Viktor simplified this confusion into a simple ovoid shape, reminiscent of the egg-like creations of the great modernist sculptor Constantin Brancusi. To save costs, Viktor made the pedals by simply bending the front axle. This also produced the turning of the propeller. The wings were short enough to fit through a standard household doorway, and the propeller turned as the vehicle moved forward. The steering wheel connects with cables to the rear wheel, causing the rear wheel to turn in the opposite direction from the path of the vehicle. Since this could be confusing to a child, Viktor placed a cross-member at the back of the fuselage to keep the rear wheel hidden. Viktor did not want to mount a gun to the fuselage, which would have been costly and would have seemed too violent. But a series of tubular shapes in front of the

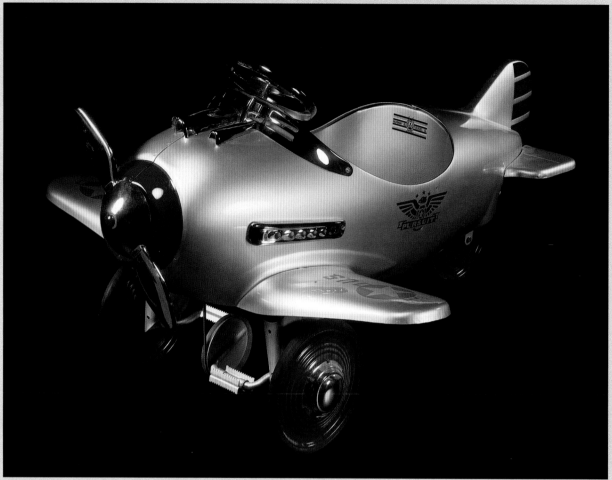

Murray Pursuit Plane, first issued 1941. H. 66 cm.

The Pursuit Plane enjoys an enduring popularity. Its snub-nosed, friendly outline shows up in pedal car books and collections; nostalgic art prints; Hallmark Christmas tree ornaments; and, judging by the prices commanded by restored originals and modern reproductions, in the fondest memories of yesterday's children.

Recently, an exhibition at the Decorative Arts Center of Ohio featured Viktor's Pursuit Plane pedal car as one of the magical toys of Christmas Past. "Christmas Morning Toys: Trains, Dolls and Miniatures" celebrated the 2005 holiday season with displays of nineteenth- and twentieth-century American dolls, miniatures, and toys.

Barbara Hunzicker, Exhibitions Chair at the Decorative Arts Center, described her first encounter with Viktor's work. A few years ago she made what was intended to be a brief stop at an exhibition before attending a play. Viktor's toys were on display. "I fell in love with Viktor and missed the play," she recalled. "His toys ... were streamlined and sculptural: little works of art. I had never seen anything like them. I spent two hours making sketches of the toys, marveling that such incredible design skills could be lavished on toys. I'm thrilled to have his spunky little Pursuit Plane in our exhibit at the Decorative Arts Center. [It] is one of the most popular objects we have ever displayed. ... I absolutely love it, as do our visitors."

steering wheel convey the feeling of a gun in a way that appeals to the imagination of a child. The design was an instant hit, and in 1941 the busiest section of the Murray factory was the one devoted to the Pedal Pursuit Plane and a closely related product, the R.A.F. Spitfire.

Although the Pursuit Plane and Spitfire were "the real thing" to American children, America's need for real military metal products during World War II required Murray Ohio to discontinue its production of children's toys. The company's annual report of 1943 illustrated some of its most popular products, including Viktor's Murray Mercury and Pursuit Plane, with the following note: "We have illustrated above representative items in our prewar lines of Mercury Bicycles and Steelcraft Juvenile Wheelgoods. As soon as circumstances permit we intend to resume the manufacture of these or similar items." By 1946, Murray Ohio had resumed toy production, just in time for the "baby boom."

Postwar Pedal Car Design

After returning from World War II, Viktor returned to work at Murray Ohio, which rapidly became the country's leading producer of bicycles and pedal cars. This was the period when General

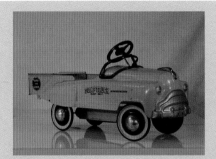
Murray Dump Truck pedal car, 1953.

Murray blue pedal car.

Murray Lincoln pedal car.

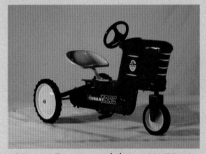
Murray Tractor pedal car. H. 51 cm.

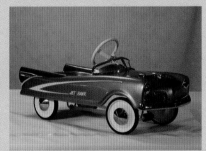
Murray Jet Hawk pedal car.

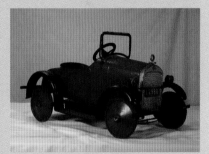
Murray Flint pedal car.

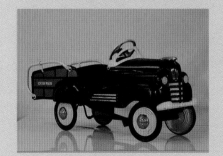
Murray Station Wagon pedal car.

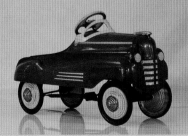
Murray green pedal car.

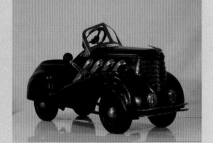
Murray Steelcraft pedal car.

A sample of classic pedal cars designed by Viktor Schreckengost. From the collection of the Museum of American Speed.

Motors and other car manufacturers organized their business around the concept of an annual "new model," which always had dramatically new and different styling and often new mechanical features as well. Similarly, Viktor tried to come up with a new feature or a new look every year. He also began modeling pedal cars more closely after their adult counterparts, even to the assign-

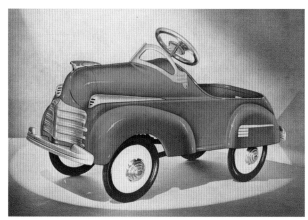

Murray Chrysler pedal car promotional drawing, 1947 Murray catalogue.

ing of real makes, like the Mercury, Chrysler, and Pontiac models from the 1947 catalogue.

Flat-face Pedal Cars

For years the Champion had dominated the market, but this uncontested success was challenged when a rival designer, Brooks Stevens, created a modern flat-face pedal car design for American Machine and Foundry. As the name suggests, this design featured a broader, flatter look

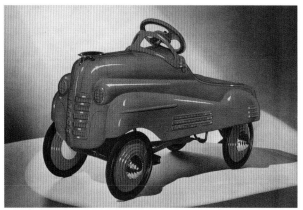

Murray Pontiac pedal car promotional drawing, 1947 Murray catalogue.

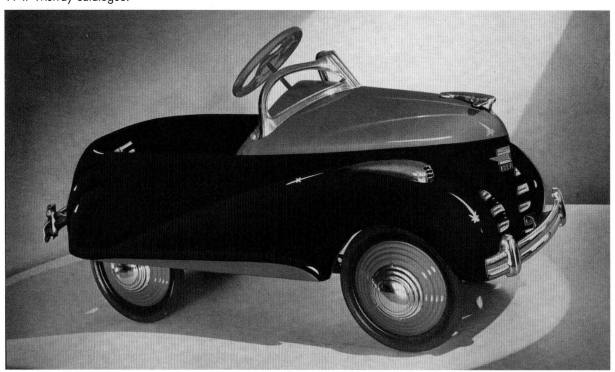

Murray Mercury pedal car promotional drawing, 1947 Murray catalogue.

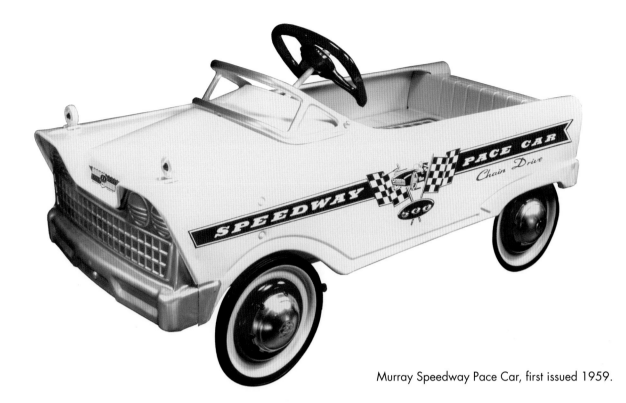

Murray Speedway Pace Car, first issued 1959.

Murray Good Humor Cart pedal car promotional drawing, 1955 Murray catalogue.

The sides of this new style of pedal car created a natural billboard, making it possible to update the look of the car each year by changing the paint treatment, which was obviously much cheaper than designing a whole new model. New graphic treatments were developed to update the car annually and to turn ordinary cars into pace cars and race cars, as well as to appeal to the different sexes—dark colors for boys and turquoise and pink for girls. Case in point: the Good Humor

that more closely resembled the wide and boxy American cars of the period being produced by firms such as Cadillac and Chrysler. In response, Murray Ohio completely retooled its entire factory to accommodate production of the flat-face design. The Speedway Pace Car is a classic example of the flat-face design.

Murray Police Cycle pedal car promotional drawing, 1955 Murray catalogue.

MURRAY *pleasure boats - A*

7-962

A popular version of the pedal car was the Jolly Roger Flagship. The model shown, from the 1967 Murray catalogue, had a dashboard compass and a pennant and bow staff, shown in these production close-up photos. The outboard motor (which also ran a small propeller) and flashing navigation lights were battery-powered. A tinted wraparound windshield sat low on the driver's horizon, not encumbering the view but furthering the illusion of being at the wheel of a racing boat. Red racing trim completed the nautical theme.

JOLLY ROGER FLAGSHIP*
Outboard Motor—Pedal Drive

The pacesetter of the Murray fleet has all the right features to keep pace. Hull with motor is 45" in length, 17" wide and 18" high. 8" front and rear wheels with moulded tires. Equipped with outboard motor (2 "D" type batteries not included), flashing navigation light (1 "C" type battery not included), chrome plated bow rail. Also features wrap around tinted windshield, bow staff and pennant. Motor actuates propeller. Finish is foam white with racing red trim and surf blue wheels. Shipping weight is 27 lbs. Packed one per carton.
*Patent Pending

Murray provides way ahead features for the youngsters. Flashing navigation light with port and starboard lens available on Model 7-962

Jolly Roger Flagship pedal car promotional drawing, 1967 Murray catalogue.

Murray has the power to please the young sailor. The big attraction for the boat fancier is the outboard motor available on Models 7-962 and 7-961

Jolly Roger dashboard compass detail. Undated promotional photograph.

Jolly Roger lamp and staff ornamentation. Undated promotional photograph.

Jolly Roger outboard motor detail, 1967 Murray catalogue.

cart and Police Cycle from the 1955 catalogue use the same body, despite their very different imaginary functions. Viktor also introduced unusual gimmicks, such as the music box that played *Whistle While You Work* that he had installed in a turquoise station wagon. The Disney tune, incidentally, came to Viktor's cars by way of a simple request: Viktor called Walt Disney personally and obtained verbal permission to use the melody. No written contract was even drawn up.

Additionally, Viktor's "updates" led to his creation of less traditional pieces such as boats, tractors, a dump truck, and even a nuclear missile. Most of the more novel forms seem to have been available only briefly, and some created problems—while the boat had no bottom, for instance, children sometimes rode it into the swimming pool, forcing the product to be discontinued for safety reasons.

Bicycles

For more than thirty years, Viktor was a leader—*the leader*—in American bicycle design. In this role he directly competed with some of the design geniuses of the twentieth century, many of whom moved from automotive to bicycle design. While many of these men were superbly gifted,

none rivaled Viktor either in the longevity of his career in bicycle design or in his economic impact. Except for a brief interruption during the war years, Viktor designed bicycles for Murray from 1939 until 1971: just over thirty years. Due to his innovations in engineering and styling, Murray Ohio grew from a pipsqueak in the market-

Numerous industrial designers got involved in bicycle design during the Machine Age. Many were famous auto stylists like Harley Earl (GM), Brooks Stevens (Studebaker and others), and Count Alexis de Sakhnoffsky (Packard and numerous others). *But when Viktor Schreckengost entered the scene, taking over at Murray Ohio's bicycle division from Sakhnoffsky, it was the dawn of an entirely new era.*

Schreckengost had the vision, creativity, and imaginative ability to create solid, real world designs that both worked and looked good. His stunning 1939 Mercury deluxe bicycle, which was featured at the New York World's Fair that year, is a perfect example. It was light in weight, visually appealing, tasteful, and full of modern features. And to top even those points, it was Art Deco to the max!

Viktor Schreckengost's bicycle designs or designs he supervised were unforgettable. Many of these bicycles have become top collector pieces today. Viktor had a rare set of abilities: he understood the minds of American youth and he had the skill and foresight to translate that understanding into reality. Viktor and those under his direction were actually able to design and produce the things that American boys and girls from the 1930s through the 1970s dreamed of. His skill and talent have been a kind of magic that only he possessed. In this regard, I believe that Viktor Schreckengost and his designs stand alone in the bicycle world as it once existed in America.

— Leon Dixon, curator, National Bicycle History Archive of America[1]

1 Personal communication from Leon Dixon to Sunny Morton, January 25, 2006. Copy in Schreckengost Archives.

place to the leading bicycle manufacturer in the world. Viktor also designed for other brands: at one point in his career, he was designing for 108 different labels. More than fifty million bicycles were manufactured to Viktor's designs.

Viktor's creative versatility—whether making a breathtakingly original design or mimicking the competition and then adding his own ingenious little improvements—is only one of his secrets to success. Viktor's understanding of the manufacturing process, his intuition of what appeals to children, and his grasp of marketing strategies were important factors as well. His innovative new method of blind welding dramatically cut costs, produced a far stronger frame, and shook up the whole bicycle industry. With shrewd understanding of children's fantasy lives, Viktor added extras like horns and headlights; some of his headlights are design masterpieces in their own right. Finally, he was quick to respond to changes in fashion or popular culture: over his career he shifted from the motorcycle look, to the supersonic look, to the kookie look. Some of his latest bicycles are the youngest in spirit.

One of Viktor's cleverest tricks was to produce designs that were varied on the outside, yet uniform in their basic understructure. Leon Dixon, curator of the National Bicycle History Archive of America, offers a case in point: the 1950s Murray Fleetline and Western Flyer X-53. "Both were based on similar construction, yet had a very distinctive individual appearance." Similarly, Viktor's Rocket Ray headlights (made for Delta Electric; see next section) "looked almost completely different for each bicycle, but were made from nearly identical parts. Schreckengost

achieved very distinct visual identities by making the bases of the lights identical but using different casting for the headlight top. Simple—yet brilliant!"[2]

Viktor also created entire product lines within the Murray brand—lines that cut across the whole bicycle market and in fact competed with each other—in a fashion rather similar to the way General Motors developed competing brands of cars. His product lines had examples of every basic type of bicycle, from tricycle to adult bike. So whatever kind of bicycle you needed, you could get it from Murray. His range of styles could be likened to car models that varied a bit from year to year as fashions changed. And like car models, some features were utilitarian but each model generally had a stylistically distinctive character. The Sears Spaceliner series was quite original, and reflects Viktor's innovations in creating a lighter and more stylish bicycle frame. Some of Viktor's designs, though, were meant to one-up the competition's popular models. His 1948 J. C. Higgins was modeled on Schwinn's Black Phantom, with some improvements in the detailing. If you were thinking of buying a Schwinn, Viktor had something quite similar, but a little better. On the other hand, if you wanted something radical and new, Viktor had a bicycle somewhere in his lineup that looked truly different from the competition.

As with General Motors, he was competing not only with other manufacturers but with himself. The bicycles in the line ranged in price in a way that made it always tempting to buy a bicycle just

2 Personal communication from Leon Dixon to Sunny Morton, January 25, 2006. Copy in Schreckengost Archives.

a little better and more expensive than the one you had walked into the store to purchase. There were also nifty accessories, such as streamers, headlights, bells, whistles, and so forth, which could be added on, again slightly raising the price.

Viktor was also adept at picking up themes from popular culture, although these bicycles are often the most difficult to document, since they were produced for a limited market and fol-

Murray Mercury bicycle, 1939.

lowed fads that often lasted only a year or two. For example, he might accessorize a bicycle to have a Gene Autry or Roy Rogers look. (To some extent he did the same thing with pedal cars—for example, with the car that had a music box that played *Whistle While You Work*.)

The full scope of Viktor's achievements in bicycle design has yet to be catalogued, since Viktor produced for so many labels for so many years. But additional evidence of his influence is now emerging in "new" bicycles themselves. Modern designers are once again copying Viktor's designs, only

now they are considered "retro." Consider this statement from a recent bicycle trade magazine:

"While it is hard to gauge Schreckengost's impact on the modern bicycle industry, it is clear that his work—both in his designs and his pioneering manufacturing techniques—was substantial. For evidence of his influence one need look no further than the waves of 'retro' designs being fielded by scores of modern-day bicycle companies trying to achieve the same shapes and lines that Schreckengost incorporated into his many original designs. Aside from his contributions in design, the sheer span of Schreckengost's career in the bicycle industry is seldom matched to this day." — Chris Lesser, associate editor, *Bicycle Retailer & Industry News*[3]

The Murray Mercury, 1939

When Viktor made his first bicycle for Murray in 1939, bicycle manufacture was enjoying a resurgence after a more-than-thirty-year slump. Though the bicycle was originally introduced in the early nineteenth century, it was poorly designed and unsteady. In the 1890s, English machinist James Starley made improvements to the design and, since the motor car was not yet perfected, the new version quickly became the principal form of adult short-distance transportation. Starley's principal impetus for design improvement was practicality and safety: high wheels were

3 Chris Lesser, "Schreckengost Inspires Many of Today's Retro-look Models: The Million Bike Man," *Bicycle Retailer & Industry News* (June 1, 2005). Vol 9, p.39.

eliminated and replaced with wheels of equal size, tires were improved, and brakes were developed. Cycling became a craze, and by 1895 bicycle sales soared to over two million a year. This rate of sales continued for about five years until automobiles began to make bicycles somewhat obsolete. Between 1900 and 1905, bicycle sales dropped to about a quarter of their former levels.

Oddly, sales improved again during the 1930s—the period of the Great Depression. At this point, the customer base for bicycles shifted. Rather than being viewed as transportation for adults, bicycles became a standard toy for children, and the demand for children's bicycles created a whole new market. This change somewhat altered the features that made a bicycle seem desirable. By this time the basic form of the bicycle had been perfected so there was no need for much change in this area. But children needed a rugged bicycle, one that was difficult to break. Children also have a strong sense of fantasy: they like dramatic styling, and they love gadgets and special features such as bells and headlights.

Viktor's first bicycle, the 1939 Murray Mercury, had all of these features. Solidly made, with heavy tires, its most unusual feature was the use of sculptural elements for the head, tank, and chain guard. Working first in clay, Viktor then created metal versions of his designs for these pieces with a skilled metalworker at the Murray plant, Tony Tucci.

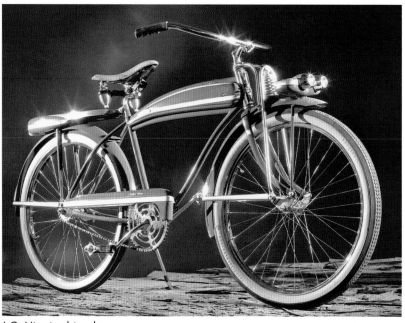
J.C. Higgins bicycle.

The head was then die cast, and the tank and chain guard were stamped from metal sheets: they were all chrome-plated and very shiny. All three elements had a dramatically aerodynamic look and were essentially abstract versions of the sleek planes, trains, and liners of the period. While a few earlier bicycles had made use of chrome-plating, it had primarily been used as an embellishment. Viktor integrated chrome-plating into the design of the frame itself so that it gave a futuristic, streamlined quality to the look of the whole machine. The first model was exhibited at the 1939 New York World's Fair.

Around the time that he designed the Mercury, Viktor persuaded Sears to make Murray its leading bicycle supplier by developing a group of interchangeable parts that could create forty-two different bicycle designs.

J. C. Higgins, 1946

Viktor's first postwar bicycle was the J. C. Higgins, which was originally created for Sears but

THE MURRAY STRATO-LINE: A COLLECTOR'S STORY

In 1992, Canadian bicycle enthusiast Mike Siewert found a "rough 1951" girls' Murray Strato-line bicycle while wandering around the swap meet area of the NSRA North West Street Rod Nationals. "The bike was a 'must have' due to its dual-spring front suspension and the fact that it was complete, fenders, rack, chain guard, tank... Everything was there," writes Siewer on his web site. He bought the bike for $100 CDN, dismantled it, and drove it home in a roadster. Then, during the spare time not spent at his job in the Department of Chemistry at the University of Calgary, he spent more than a year restoring it to what he calls "the original look with a 1999 ride."

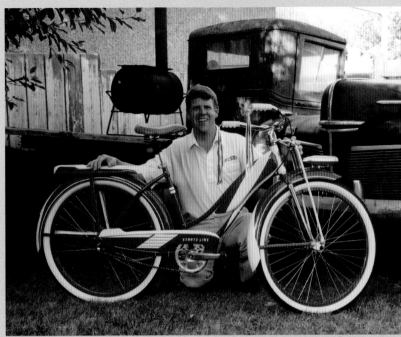

Canadian bicycle enthusiast Mike Siewert with his restored 1951 Murray Strato-line bicycle.

What appealed to him about the Strato-line? "The balloon tire coaster style. They're not very available in Canada. And there are fins on the carrier rack and on the chain guard. It's nonfunctional ornamentation, but it makes it kind of fun, like an old Cadillac. Most vintage Canadian bikes don't have any metalwork." Mike found out about his bike by calling the Murray headquarters, now in Tennessee. Although Murray doesn't make bicycles anymore, a helpful employee dug further and further into her files of production catalogues until she found a photo that matched his bicycle.

Mike's web site[5] documents his meticulous restoration of the bicycle and the Award of Excellence he received for his work from *BikeRod&Kustom*[6], a "WebZine" devoted to fans of custom, chopper, and hot-rod bicycles.

eventually sold by several department stores. According to an article on the history of this bicycle, "Sears had used the Higgins name on a line of sporting goods since at least the early 1900s, but by the end of World War II the name use was expanded. The giant retailer decided to retire the famous old Elgin brand bicycle and so the J.C. Higgins was born."[4]

The J.C. Higgins continued the so-called "motorcycle look" that was popular in the 1930s. The tires and frame were solid and massive, but the machine achieved a look of speed and strength through the use of sweeping, streamlined curves. With the J. C. Higgins, Viktor achieved an unusually pleasing composition, at once dynamic and visually balanced. Since the basic design of a bicycle had been standardized

4 Leon Dixon, "The 1956 J.C. Higgins Deluxe!" Article originally appeared in *CYCLIST* (July 1985), and is reproduced at http://nbhaa.com/index9.html. Quoted with permission.

5 http://www.acs.ucalgary.ca/~mdsiewer/cycle/murray.html
6 http://www.homestead.com/bikerodnkustom

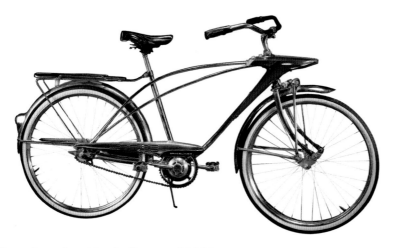

Sears Spaceliner bicycle, first issued 1965.

by this period, sales often depended on special "sales points"—extra features that differed from the competition. The design of the J. C. Higgins plays up two of the features, the smooth ride and the headlights. The front vertical member of a bicycle is known as the fork, since it is two-pronged with a tine on either side of the wheel. The J. C. Higgins dramatically features a spring fork—a large spring mechanism attached to the fork that cushions the ride. Rival bicycles, such as the Schwinn B Series Hollywood, also had a spring fork; however, Viktor's looks considerably more striking since the spring on the Schwinn model was horizontal whereas Viktor's stands vertically. Just in front of this spring, Viktor placed the other most enticing feature of the design, the headlights. Viktor made these look dramatic by having two headlights rather than just one and encasing them in a streamlined element with bat-like wings on either side.

Sears Spaceliner, 1965

During the 1960s, bicycles grew sleeker and thinner, a trend that was encouraged by two innovations: thinner tires and a better welded frame that made it possible to achieve strength with lighter framing members. Viktor's masterpiece of this type is the Sears Spaceliner of 1965, which dramatically lightened the appearance to create a kind of supersonic look. The design is worth close study for its innumerable refinements of detail. To lighten the effect, Viktor ran double bars past the seat, which creates a smooth, unbroken line and a thinner silhouette. Thus, he avoided the awkward "camelback effect" of most bicycles, where the seat interrupts the smoothness of the line. Rather than emphasizing the spring, as he had in the earlier J. C. Higgins, he minimized it, and he also brought the forks down not directly to the wheel hub, but just beside it, which creates a weightless effect. Finally, he concealed the headlight within the tank so that nothing interfered with the flow of the design.

Two recently discovered renderings, one of a green, the other of a red bicycle, explore the ideas that led to the Sears Spaceliner and Viktor's other supersonically streamlined bicycles. The drawings, however, feature a more curvaceous design in which the major elements—the handlebars, the seat, the support bars, and the pedals—all wiggle slightly. (See images on page 105)

The Murray Mark II Eliminator, circa 1969

During his final years for Murray, Viktor developed a "late style" of bicycle design that is the most whimsical and playful of his career. The change was initiated as a response to a teenage fad. In California, boys had begun to put small wheels, borrowed from tricycles, on the front of

their bikes so that they could do wheelies and other acrobatic tricks. This in turn encouraged the development of other odd-looking features that allowed the rider to shift his weight easily, such as enormous pretzel-like handlebars (sometimes known as "Texas Longhorns"); a seat the rider could slide on (popularly known as a "banana seat"); and a bar in the back to protect the rider if he tipped over backwards (known as a "sissy bar"). The most developed of Viktor's designs of this type was the Murray Mark II Eliminator, which contained all of the above elements, had the look of a dragster, and was billed as "the raciest machine yet to hook the surface." The massive gear mechanism and the ungainly springs behind the seat and on the front fork added to the sense of power and excitement. The logo on the tank featured a cobra burning rubber on asphalt.

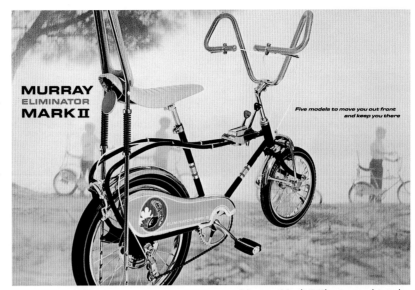

Murray Mark II Eliminator bicycle.

Western Flyer X-53

Bicycle historian Leon Dixon lists several Western Flyer bicycle designs (created for Western Auto Stores) among his list of Schreckengost designs. In a published tribute to the Western Flyer X-53 Super, Mr. Dixon writes: "For most of the decade of the 1950s, the fabulous X-53 Super was the top of the Western Flyer line. The Murray bicycle people built the X-53 according to exclusive Western Auto designs and it featured the usual luxocruiser gadgets (electric horn, headlight, etc.). The frame was hydrogen-brazed seamless-steel tubing and chrome abounded on the fenders, tank, and reflector housing. And colors? Whoa, did they have colors! Early models had painted and striped fenders and color schemes and hues changed every year. The most memorable was 'flamboyant black cherry and gold.'"[7] Dixon also lists several other "derivative" designs that Viktor created under different brand names, including the Hiawatha and Ranger. It may yet take some time, effort, and collaboration on the part of historians like Dixon and researchers at the Viktor Schreckengost Foundation to create a comprehensive list of Viktor's bicycle designs.

Lighting Design

Bicycle design brought Viktor into other areas of consumer products, including lighting fixtures and household furniture and appliances. His involvement with lighting started when he began designing streamlined "rocket ray" headlights for

7 Leon Dixon, "The Western Flyer X-53 Super!" Article originally appeared in CYCLIST (June 1986) and now appears at http://nbhaa.com/indexWESTERN.html. Quoted with permission.

bicycles. He worked for at least three different lighting manufacturers: Delta Electric, General Electric, and Holophane.

The "rocket ray" bicycle headlights were manufactured by Delta Electric, which later commissioned him to design flashlights. The most original of Viktor's flashlight designs was the Buddy Light, which was only just larger than the standard two batteries that powered it, but it emitted a much larger light from a reflector that was two and a half inches wide. For Delta Electric Viktor also designed the Flashing Powerlite, a six-volt "electric lantern" that had an optional flashing green or red top. Viktor designed flashlights for Delta well into the 1960s.

General Electric, which had an office in Cleveland, commissioned Viktor to produce home lighting fixtures. An undated promotional photo found recently in the Schreckengost archives features a fixture designed by Viktor, a similar model of which still hangs in his own home. Another General Electric

Delta Rocket Ray bicycle headlamp.

project also found in Viktor's archives is a ceiling panel with small pyramid-shaped grids meant to diffuse indirect lighting in an industrial setting.

Viktor's involvement with Delta led to work with Holophane, a company that produced prisms to control the diffusion of light from light fixtures. One of Viktor's Holophane fixtures, an exterior light, consists of a die-cast steel fixture and sturdy glass cover, which, despite its heavy materials, remains graceful due to its classic shape.

Other Household and Industrial Products

One of Viktor's most popular designs was the Beverly Hills Lawn Chair made for Sears, which consisted of three parts: a tubular support, a stamped metal seat, and the back of the chair. Devising a comfortable metal seat presented a challenge. Viktor's solution was to place a half-barrel filled with soft clay and covered in plastic outside the Murray cafeteria and offer the employees a chit for a cup of coffee to sit

Delta Buddy flashlight.

Holophane lighting fixture.

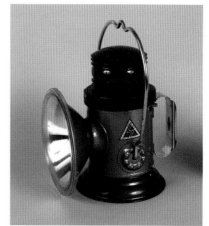
Power Lite flashlight.

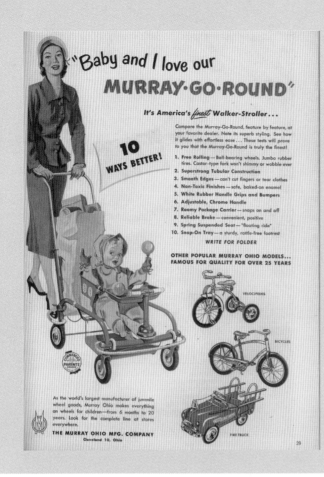

THE MURRAY-GO-ROUND BABY WALKER

This 1951 advertisement for the Murray-Go-Round Baby Walker shows yet another clever Schreckengost design. This baby walker doubled as an infant stroller that sat lower to the ground and was therefore safer than other strollers. It was called the "Murray-Go-Round" because it had a locking wheel that prevented a child from rolling away. As a promotional brochure for the walker boasted, "It's got everything!"

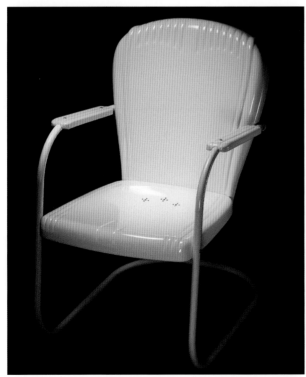

Beverly Hills lawn chair, first issued 1941.

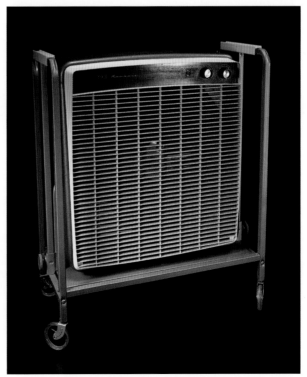

Sears Mobile Adjustable Fan, first issued 1963.

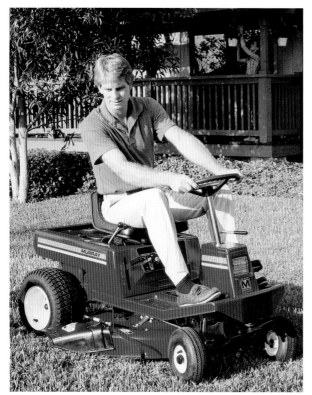

Promotional photo of Murray riding lawn mower.

it. One of his fans, an exhaust fan, was meant to cool the room by pulling air out the windows. One customer apparently didn't understand the concept: she complained that the fan was so powerful that it was blowing the covers off her bed!

Riding Lawn Mowers

In the late 1960s, Viktor designed some of the first riding lawn mowers to gain wide commercial success. He remembers conceptualizing a riding mower as a toy for grown-ups, a tractor for the suburban man, so to speak. His early designs appeared under both Murray and Craftsman (Sears) labels. Not only did his models look like fun to drive, but they housed dangerous blades beneath the driver instead of out in front of his toes (like some competing designs did).

Printing Presses

Perhaps one of the most important characteristics of a successful industrial designer is versatility: both the willingness to try new design projects and the ability to apply lessons learned from previous projects. That said, it may still be a little surprising that Viktor Schreckengost also made major advances in the field of printing press

on it. The impressions from several hundred fannies molded the clay into a comfortable contoured shape from which Viktor took the mold for the seat. Viktor also designed fans for Sears, simplifying their end panels to create a more modern look and introducing practical innovations, such as putting a fan on wheels so that women could move it around the house without needing to lift

Harris-Seybold presses, before Schreckengost redesigns.

Harris-Seybold presses, after Schreckengost redesigns.

Chandler Price press.

design. These advances have been written of in more detail elsewhere; here we just give a brief summary.

Viktor's first experience with printing press design was in the 1930s, when he produced a press for Cleveland company Chandler Price. Safety and aesthetic features of this press prefigured more extensive projects Viktor was to do for Harris-Seybold after World War II.

Early twentieth-century printing presses were notoriously unsafe. Press operators had scarred shins from variously sized and placed knobs and levels; their bodies, especially fingers, were vulnerable to the exposed, whirring rollers and other fast-moving parts. Viktor enclosed the working parts in metal sheaths, making the machines both safer and more attractive.

After his partner on the cab-over-engine project, Ray Spiller, became chief engineer for Harris-Seybold, Viktor was invited to work for the company. His first project, a sheet-fed printer redesign in 1948, led to Viktor's being put in charge of all Harris-Seybold's products. Viktor eventually created a company with two of his former students (Schreckengost, Greenlee, Hess) just to

handle the work from Harris-Seybold and the many companies it acquired. A number of Viktor's former students and younger colleagues at the Cleveland Institute of Art (CIA) gained valuable career experience at this company as well, including Dan Cuffaro, the current Chair of CIA's Industrial Design program—a program started by Viktor in the 1930s.

World War II Service

When World War II broke out, Viktor was thirty-seven and too old for the draft. He also had deferment because of his involvement with defense work. However, Viktor was anxious to do his part for the war effort, and, at the encouragement of a Navy captain who saw his work on a Murray project, applied for enlistment. Viktor was told it would take several months to process his application, but a phone call five days later asked him to report for duty immediately.

Radar

After basic training, Viktor was sent to the Special Devices Division, Bureau of Aeronautics, Navy Department, at a secret base in New Jer-

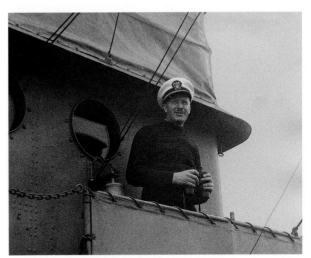
Lieutenant Viktor Schreckengost aboard the minesweeper USS *Kestrell* in October 1944, during a mission to test the range and accuracy of radar.

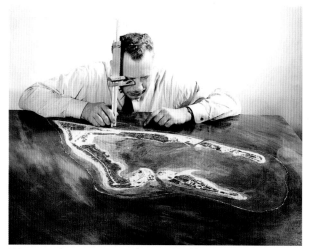
Viktor working on maps during World War II.

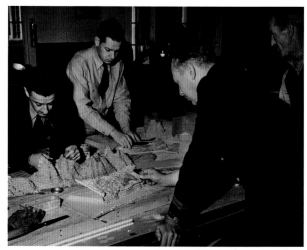
Viktor, in foreground, supervises creation of stick terrain model.

Plaster mold of mountainous terrain with wire mesh overlay.

Map section copies with their plaster molds.

sey. There multiple branches of the military were working on a top-secret project: the development of radar. Even the word "radar" was classified. At this time, Special Devices not yet deciphered the scattered feedback received on radar screens. Commanding officer Luis de Florez theorized that the pattern had something to do with the shape of the targets, and requested assistance from a sculptor, who would be sensitive to shapes. Enter Viktor Schreckengost.

Viktor joined the Special Devices Division's efforts to interpret radar. They created detailed scale models of plausible scenarios in real com-

bat locations and learned to interpret the radar feedback. Viktor assisted with radar difficulties in combat scenarios as well. Before the Battle of the Bulge, he was rushed to France to help troubleshoot problems with American radar. The radar returns were not reading properly and some of the radar installations themselves were malfunctioning. Viktor quickly discovered that the troops had camouflaged the radar installations *too* well; the tree screen formed a barrier to radar interpretation. He helped them reposition the equipment so that it was exposed enough to be useful but still protected from enemy discovery.

Mapmaking Advances

As radar became an operable technology, it became increasingly imperative to have highly accurate, three-dimensional terrain maps to inform radar-guided bombing missions. Under Viktor's guidance, a new system of dimensional mapmaking was developed. Formerly restricted instruction manuals found in Viktor's archives describe this work: "How to Build Terrain Models" and "The Development of Landfall Techniques and Landfall Recognition Models." A series of 8"×10" black-and-white glossy photographs also found in the archives clearly illustrates instructions in these manuals.

Viktor led a team that devised innovative techniques for creating consistently accurate contour maps from aerial photography. Cameras were mounted on airplanes to produce a stereometric pair. When these photographs were projected so that they matched, a technician could build up a 1/1000th-scale topographical mold of the scene with plaster of paris and wire mesh or sticks. Aerial photographs on the correct scale would then be glued on a wire mesh over the mold, with the photo paper pressed carefully into all the crevices. (The process would be akin to laying a photograph of a face over a mannequin's features and creating a photo-real, three-dimensional face.) When the wire mesh dried, the rigidly formed map and mesh would be removed from the mold.

The topographical maps—a feat in themselves in terms of accuracy, scale, and reproducibility—were not complete, Viktor decided, without

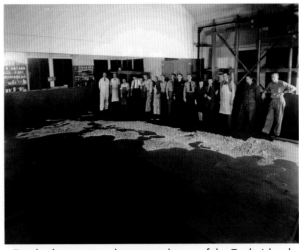

Finished room-size dimensional map of the Turtle Islands.

The largest ship in this photo is less than two inches long. Location unknown, but the back of the photo reads: "Invasion training board. October 28, 1943."

A box of models found in the Schreckengost archives.

accurate models of the ships and airplanes that were often a target of invasion. He created tiny scale models of several types of warplanes and battleships. He even created positionable gun turrets and lined up little planes on the flat surfaces of the ships that served as aircraft carriers. More than a thousand of these models have been found in Viktor's attic, carefully packed away after he returned from the war.

Compared to conventional techniques, Viktor's mapmaking method was quick, since it did not require measurements each time a map was made; the mapmakers simply matched the contours of the model with the photographic image and added the appropriate models. By the end

THE BATTLE OF REMAGEN BRIDGE

Remagen Bridge and surrounding area. A description attached to this photo reads: "Model created by Captain Elva D. Brown, Lt. Marvin L. Marchest, and four enlisted men who were trained [by Viktor Schreckengost] to do the work. The vertical scale is 1:5,000; the horizontal scale is 1:12,500."

Included in the archives are maps and tiny scale models of Remagen Bridge, immortalized in the 1969 film *The Bridge at Remagen*. Remagen was the last bridge standing over the Rhine, and American troops needed to capture and cross it in order to continue advancing into Germany. As explained by a web site devoted to the memory of those who fought there: "By seizing intact the old Ludendorff railroad bridge at Remagen and quickly crossing to the east bank of the Rhine, the Ninth Armored Division opened up immense military possibilities that were realized to the fullest when it came time for the Allied armies to drive farther into Germany. No other military event in Europe, excepting perhaps the D-Day landings in Normandy, so stirred the popular imagination. An avalanche of news stories and broadcasts poured out of the bridgehead area. The Ninth Armored soon became one of the most highly publicized American divisions in history."[8] Credit for this victory can certainly be laid at many doors, and one of them is Viktor's, for his painstaking work on the maps and models that trained the Ninth Armored for this critical success.

of the war, Viktor was preparing a large three-dimensional map of Honshu to prepare for the invasion of Japan, but the Japanese surrendered before such an invasion was launched.

Military Humor

Along with his more serious work, Viktor produced many cartoons during his service to lift his own spirits and those of others. Among the comical drawings recently discovered in the Schreckengost archives is a mock coat-of-arms featuring ribbons of paper and carrying the motto: "Chairborne—*Papyri Ad Nauseam*," apparently mocking the large amount of

Chairborne—*Papyri Ad Nauseam*, mid-1940s. H. 30.48 cm.

paperwork generated in the military. The word "snafu," featured in large script, means "a chaotic or confused situation."

Viktor also created a mock series of semaphore signaling cards along with illustrator Dudley Morris. Semaphore flags were used in the Navy during World War II as a kind of visual Morse code. Flags of certain colors and designs were flown to communicate with passing ships. The flags each stand for a letter of the alphabet if they are raised in a group, but have different meanings whey they are raised alone. Viktor created humorous illustrations that played on standard semaphore messages. For example, a group of male sailors ogling mili-

8 http://www.mindspring.com/~sgasque/army/bridge.htm

Semaphore Signaling Cartoon L,
mid-1940s. H. 30.48 cm.

Semaphore Signaling Cartoon Z,
mid-1940s. H. 30.48 cm.

Semaphore Signaling Cartoon U,
mid-1940s. H. 30.48 cm.

Semaphore Signaling Cartoon I,
mid-1940s. H. 30.48 cm.

Semaphore Signaling Cartoon C,
mid-1940s. H. 30.48 cm.

Semaphore Signaling Cartoon O,
mid-1940s. H. 30.48 cm.

Semaphore Signaling Cartoon R,
mid-1940s. H. 30.48 cm.

Semaphore Signaling Cartoon V,
mid-1940s. H. 30.48 cm.

Semaphore Signaling Cartoon W,
mid-1940s. H. 30.48 cm.

tary women illustrates the signal, "My engines are going full speed astern." "Look to port" is illustrated by an admiral, looking left as he strides past a line of beautiful women, his eyes at the level of their breasts. "I require medical assistance," shows a young man at a desk turning pale at the sight of the beautiful woman standing in front of him.

The racy, sexist humor of the sketches would be frowned upon today, but they made the meanings of the flags unforgettable. They also give insight into one aspect of the male response to an increased female presence in the military.

Postwar Research

After the fighting ended, Viktor was assigned to the Naval Research Center in Cleveland. He helped on a project to determine the best means of transmitting voices through static. He designed stackable steel body containers that could be easily labeled. And he assisted in a project to improve the fit of prosthetics for war amputees. In an experiment similar to modern medical research, Viktor and his team fitted able-bodied people of all shapes and sizes with lights on their joints to chart their patterns of movement. Then his team tried to duplicate those measurements on amputees in an attempt to approximate normal movement with prosthetics.

Stage Design

Viktor had originally joined the military after a Navy captain witnessed Viktor's success in staging an elaborate ceremony for the Army-Navy Excellence Award granted to Murray Ohio employees. In the military Viktor continued his work with stage design, making the most of the limited materials he had to work with. An elaborate drawing he made for the Pump Engineering Service Corps shows musicians arrayed upon a stage. Colorful flags adorn either side of the stage and the musicians are placed on tiers that rise up in the center to create a dramatic effect.

One of Viktor's final military assignments was to install an exhibition at the New York Hall of Science on naval training and naval science. The exhibition included Edward Steichen's action photographs and films of the Navy in action. To make an exhibit of an aircraft carrier runway seem more realistic, Viktor placed life-size human models near the viewer, in the foreground, and increasingly scaled-down models and figures along the runway, which ended with a tiny model airplane. Another exhibit featured a moving, walk-through model of an atom that measured twenty-two feet across. Visitors could get a three-dimensional perspective of how the spinning electrons worked.

Leaving the Military

Viktor finished his tour of duty with a commendation from the Secretary of the Navy. He returned to civilian life with new ideas and training, which he immediately applied to improve the manufacture of his industrial designs. But, rightly proud of his military service, Viktor kept the commendation from the Navy, which nicely summarizes this time in his career. It reads in part:

"The Secretary of the Navy takes pleasure in commending Lieutenant Viktor Schreckengost, United States Naval Reserve, for outstanding performance of duty as head of the design laboratory of the Special Devices Division of the Bureau of Aeronautics from November 1943 to May 1945. Carrying out his essential work with skill and ini-

tiative, Lieutenant Schreckengost expertly developed new and improved techniques to construct and utilize three-dimensional terrain models for use in briefing pilots and air crewmen and, in addition, rendered invaluable assistance in the operation of radar planning devices for the location and evasion of enemy radar installations in bombing and invasion tactics. By his leadership and ingenuity Lieutenant Schreckengost inspired a high quality of research, design, and workmanship in the production of models for specific operations against Japan and thereby contributed materially to the effectiveness of the Special Devices program and the successful prosecution of the war." It is signed by James Forrestal, Secretary of the Navy.

Dinnerware

It is hard to credit one person with inventing modern American dinnerware, just as it is hard to credit one performer with creating rock-and-roll. Modernism has many faces, such as Deco, biomorphic, and Moderne, and it slipped into dinnerware design in stages. But Viktor has a good claim to be credited as the principal figure in this development, as is attested both by contemporary tributes and by the assessment of recent scholars, such as Garth Clark. Schreckengost's early patterns, such as Americana, Diana, and Manhattan, were all breathtakingly different and stunningly successful in the marketplace. They fundamentally changed the course of the American dinnerware industry. But Viktor's dinnerware story begins even before he introduced these first patterns

"From the mid- to late 1930s and throughout the mid-century, a prescient group of America's leading industrial ceramic designers championed new 'American' production tableware that was not imitative, but innovative—not traditional, but original, distinctive, and modern. This period birthed a new American modern design aesthetic and ethic that found increasing acceptance in homes all across this country. America's good designs and modern style found a multipurpose use not only at home, but abroad as well, where 'good design' waged war on foreign imports.

Viktor Schreckengost, a leader in this charge, created and promoted world-class modern ceramic design along with other notables that included Russel Wright and Eva Zeisel. America's best creatives shared a collective vision during this period that went beyond Art Moderne's 'extravagances' to a timeless modern style that was honest, functional, and compelling. The new modern shapes were often simple yet dramatic, flowing with an aliveness and lightness that helped lift the mood at the family table during the Depression, war, and postwar downsizing."

—Michael Pratt, mid-century modern design researcher; author, Schiffer series on Mid-Century Modern Dinnerware; creator/owner of the MODish.net, a web site devoted to mid-century modern ceramic design

under his own name. Some of his earliest work, including designing Econo-Rim restaurant china for Onondaga Pottery, is like much of Viktor's work—unrecognized and unattributed.

Econo-Rim

After Cowan Pottery folded in 1931, Viktor and Guy Cowan established a small design firm together. They took on a variety of jobs, many of them related to dinnerware since Cowan's expertise with pottery was well known. After about a year, Cowan moved up to Syracuse, New York, where he became the director of design for Onondaga Pottery, the same firm where his father had worked as a decorator. Most of Onondaga's business was in hotel and restaurant ware; their business often depended on coming up with products to serve some specialized use. In a fast-service restaurant, for example, you wanted cups that would cool the coffee quickly, so that people would move on and someone else could take their seat. In a nightclub you wanted a cup that would keep the coffee warm, so that people would linger. Since he was more a manager than an artist, Cowan began passing on design projects of this sort to Viktor. One of the projects led to Econo-Rim, the first of Viktor's mass-produced designs that became a classic. While the patent for Econo-Rim was held by Guy Cowan, it was Viktor who produced the design, according to Viktor himself.[9] While only the artist's own testimony is available, further evidence for this claim lies in the character of the design itself. Its strong shape is very characteristic of Viktor and different from Guy Cowan's work. Most likely there was some inter-

action between the two—in other words, Cowan probably verbally indicated what he wanted and Viktor came up with a design. Many other projects claimed by Viktor during a series of interviews in 1998—and not documented elsewhere as his—have since been confirmed to be his by archival evidence (correspondence, design drawings, etc) that has emerged from his archives.

In Vienna, Viktor had absorbed two key concepts. The first was how to achieve a modern look by removing extraneous frills and simplifying shapes to their essentials. The second was to examine every aspect of how an object functions. If you are making dinnerware, for example, does the plate fit neatly on the shelf? Is it easy to wash? Does the cup balance when you hold it? Does the teapot drip?

Econo-Rim was inspired by the challenge of making a plate that could be used in an unusually small space, such as the dining car of a train. The solution was simple: make the rim smaller. Econo-Rim has a rim that is only about a quarter-inch wide and, consequently, is nearly two inches smaller in diameter than a regular plate. To make up for the reduced width, Viktor made the rim a fraction of an inch higher than usual, so food wouldn't spill in a fast-service restaurant or on a moving train. In addition to saving space, the small rim creates an interesting optical illusion: the food on the plate looks larger. Since it seems as if there is more food on the plate, customers feel they're getting more value for their money.

As could be expected with such an untraditional design, the plate looked a little odd to those accustomed to Victorian-style dinnerware. Viktor did not try to hide the plate's differences with Vic-

9 Interview with Viktor Schreckengost, by Henry Adams. Interview six, July 16, 1998, Archives of the Cleveland Museum of Art.

torian frills but expressed the shape simply and bluntly, with a clean, modern look. When you ate off the plate, you become part of the modern age. Or at least you did in the 1930s. (Today, the design has a retro look and evokes the age of diners, streamlined trains, and the 1939 World's Fair.) Customers loved it and Econo-Rim proved to be one of the most successful dinnerware designs of the twentieth century. Millions of plates were sold, and it is still in production today, more than seventy-five years after it was introduced.

Commercial Dinnerware, 1932–35

> "While best known for his Art Deco *Jazz Bowls*, Viktor's mid-century modern production tableware is also outstanding and includes numerous services such as the groundbreaking Manhattan (American Limoges, 1934) and Free Form (Salem China, 1955) lines."
>
> —Michael Pratt

On his return from Europe in the summer of 1932, Viktor and his brothers constructed a studio in Sebring behind his parents' home using the modern material of cast concrete. When he settled into the Sebring studio, Viktor began to focus intensely on industrial design, and in the fall of 1932 he presented a modern line of dinnerware to the executives at American Limoges.

Viktor's work in Vienna with Michael Powolny was largely devoted to hand-thrown vessels. His experience there gave him a great appreciation for two things: a hand-thrown look and extremely simple, bold forms. At American Limoges Viktor proposed a design that he called Peasant Ware, which was contemporary but friendly, and which achieved a look similar to that of the hand-thrown wares he had produced in Vienna. Like many of his designs, Peasant Ware featured a gimmick that set it apart from any other product on the market. In this case he devised a template for the jigger that slightly ridged the interiors of the cups and bowls, further giving them a hand-thrown look.

Up to that time, American Limoges had focused on Victorian nostalgia, such as the Heirloom pattern of 1926 or Briar Rose pattern of 1930. Sadly, the executives rejected the Peasant Ware design as "too adventurous" and "too modern" but were sufficiently impressed that they encouraged Viktor to give it another try.

In 1934 American Limoges finally agreed to produce two new designs, Americana and Diana, which were quite similar to Peasant Ware, but without the unusual ridging. Though both look rather sedate today, they were startling in their time since they were the first mass-produced

> "The dinnerware shapes and treatments that Schreckengost devised for several American manufacturers are among the most innovative designs in the history of American dinnerware from the 1930s, '40s, and '50s."
>
> —Jo Cunningham, American dinnerware expert; author, Schiffer dinnerware collecting series

American Limoges Peasant Ware, black and gold, 1932.

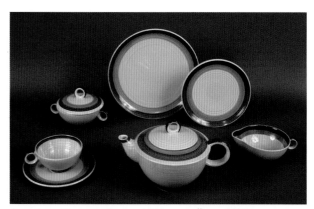
American Limoges Peasant Ware, yellow, 1932.

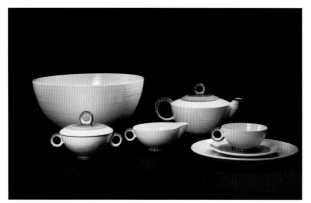
American Limoges Peasant Ware, white and brown, 1932.

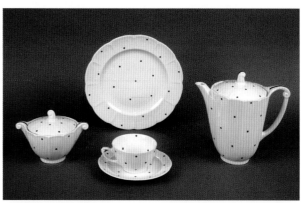
American Limoges Diana shape, Joan of Arc pattern.

American dinnerware to embrace a modern look. One journalist exclaimed that *"Americana . . . is a bit hard to describe . . . as it is so absolutely original."* Art critic Grace Kelly declared that the two patterns marked the beginning of "a new era in the production of household wares in America."[10]

The designs were also a commercial success. At a New York show in February 1934, American Limoges sold more of the Schreckengost patterns in the first day than it had sold of *all* its designs

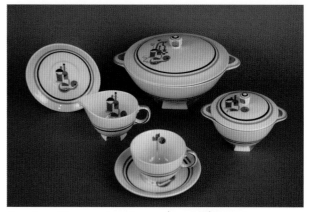
American Limoges Americana shape, Ultra pattern.

during the previous year's show. By the end of the show, the company had sold its full production and had to start up a new production line to meet the demand.

That fall Viktor produced a new design, Manhattan, which went into production early in 1935. Manhattan closely resembled Ameri-

American Limoges Americana advertisement.

10 Grace Kelly, "Limoges China Designed by Schreckengost and Made in Sebring, at Kroner & Woods," *Plain Dealer*, February 11, 1934, and untitled, undated article, circa February 1934, Schreckengost scrapbook #1, Viktor Schreckengost Foundation.

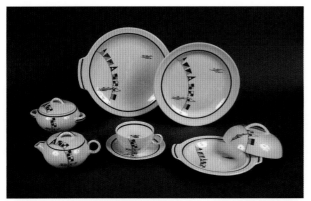
American Limoges Manhattan shape, Ship Ahoy pattern.

Design Magazine featured Manhattan in a double-page spread, while critics hailed it as "one of the smartest and most outstanding dinnerware shapes of the year." The executives at American Limoges were so pleased that they made Viktor the permanent chief designer for their plant. Several magazines featured the new shape over the next few years, including *Arts & Decoration* and *The American Home*.

The American Home features Manhattan dinnerware, July 1935.

Arts & Decoration magazine shows Manhattan dinnerware, April 1935.

One of the admirers of Manhattan was Frederick Rhead, the chief designer for the Homer Laughlin China Company in East Liverpool, Ohio. "In my humble opinion," Rhead wrote, "these two shapes constitute the most outstanding creative development by any American pottery within the last year." (Shortly after writing these words, Rhead called up Viktor to let him know that he had been fired for promoting the work of a competitor. Apparently, management rescinded this decision, for Rhead stayed on at Homer Laughlin, where he introduced one of the most popular dinnerware designs of the twentieth century, Fiesta Ware, in 1936. Fiesta Ware is closely modeled on Viktor's Manhattan pattern but with the addition of bright colors inspired by contemporary car design.) More recently, noted ceramic critic Garth Clark singled out Manhattan as one of the four most significant American dinnerware designs of the twentieth century.

Despite his successes with other patterns, Viktor was still disappointed by the rejection of his

cana in appearance but featured many small improvements. The shapes of the rims and the handles were simplified, and the saucers harmonized better with the cups.

The globular forms of Viktor's Manhattan pieces recall the work of Michael Powolny, who used similar simplified, circular forms in the Shape 68 porcelain service he designed in the late 1920s. The effect of the two designs, however, is entirely different. Powolny's service, in white porcelain, has a stiff, formal elegance. Viktor's design looks homey and has a comfortable feel that makes it appropriate for daily use.

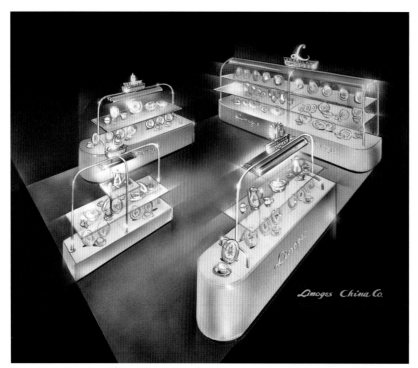

American Limoges China Company showroom concept drawing by Viktor Schreckengost. Viktor worked for American Limoges China Company from the early 1930s to the early 1940s. Shown is a drawing for a Deco-style American Limoges showroom Viktor designed to show off the company's wares. Viktor's work with the company brought about not just new trends in tableware but in the industry itself. Cleveland art critic Grace Kelly noted in 1935 that "when Schreckengost designed Americana and Diana last year for American Limoges, the retaining of an artist . . . to do such work was more or less of an experiment, but the success of the venture was so overwhelming that D. S. Albright, general manager, made him permanent chief designer for the plant." This successful experiment led other dinnerware manufacturers to begin hiring their own professionally trained designers, now a standard practice.

Cover of *Better Homes and Gardens* magazine, June 1939, with American Limoges Triumph shape, Bermuda pattern.

Triumph, 1937

In September 1937 Viktor introduced one of his finest designs, Triumph, which was produced by American Limoges. Like Manhattan, Triumph enjoyed a clean modern look, but the silhouettes of the shapes were somewhat bolder and more original. Both plates and hollowware pieces were decorated with close-set horizontal ridges: these were placed on the rims of the plates and on the base of the hollowware forms. While serving a decorative purpose in themselves, the ridges also provided guide marks for the decorators, making it possible to decorate the shapes more simply and at less expense. Most often, hand-painting was done on the lower part of the shapes, where the ridges helped guide the painter's brush. The flat surfaces on the upper parts of the shapes were suitable for decoration with decals.

Peasant Ware. Not one to give up easily, in 1934 Viktor persuaded the management at American Limoges to make a few sample sets, in gunmetal and oyster white, which were exhibited at a prestigious home design exhibition at the Metropolitan Museum of Art in a dining room designed by Donald Deskey. While the sets received very positive reviews, the executives at American Limoges remained unswayed, and the pattern was never put into production. Commercial dinnerware with the handmade look that Viktor proposed did not come into common use until the 1960s, when an interest in returning to nature made such forms popular.

As opposed to the essentially globular form of Viktor's earlier tea- and coffeepots, those of Triumph have a vertical effect and are visually more dramatic and modern-looking. Both teapot and sugar bowl have handles that sit on top of the shape like a chimney, creating an interesting play between curved and rectangular shapes.

As with Manhattan, Viktor devised a great range of decorative treatments, often with striking color combinations. One of the finest of these was the Havana pattern, examples of which can be found in the Dallas Museum of Art. The colorful Bermuda pattern, with a tropical floral center motif and broad yellow band, can be found on the cover of the June 1939 issue of *Better Homes and Gardens*. Triumph's banded colors can also be found in contemporary advertising material for other products, including Kellogg's Corn Flakes and Swift's Brookfield Butter.

Swift's Brookfield Butter ad with Triumph dinnerware.

Kellogg's Corn Flakes ad with Triumph bowl.

Victory, circa 1937

Shortly after creating Triumph, Viktor created a near variation of the design for Sa-

American Limoges Triumph shape, Silver Age pattern. This simple but glamorous banded pattern perfectly complements the streamlined details of the Triumph shape.

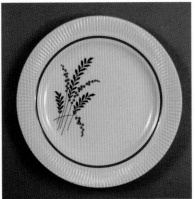

Salem China Victory shape, Parkway pattern.

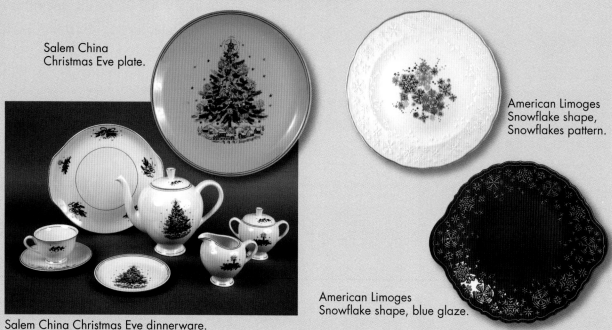

Salem China
Christmas Eve plate.

American Limoges
Snowflake shape,
Snowflakes pattern.

American Limoges
Snowflake shape, blue glaze.

Salem China Christmas Eve dinnerware.

One of Viktor's most widely produced dinnerware patterns, and one highly imitated, was Christmas Eve for Salem China. In production for nearly half a century (1950–1999), the pattern was made early enough that the name "Christmas Eve" was actually trademarked by Salem. This pattern is now very collectible: everything from plates to salt and pepper shakers to bells appear in online auctions in the months before each holiday season. This pattern is featured along with materials advertising its sale in a section on Viktor's work in Jo Cunningham's *The Best of Collectible Dinnerware* (1999, Schiffer Publishing). Both because of this exposure and because later backstamps carry his name, this design is one of the few patterns generally acknowledged as Viktor's.

It is not commonly known that Viktor produced a striking holiday design for American Limoges as early as 1935. Snowflake, both the name of a shape and a decorative treatment, was produced in both blue glaze and on a white background with a snowflake decoration. The blue glaze pattern shows the band of snowflakes sprinkled in relief around the rim around the plates; a similar relief covers the sides of the hollowware.

lem China, a company that also belonged to Frank Albert Sebring. In his Victory shape, the decorative grooves ran vertically, the sides of the hollowware shapes were nearly straight, and the handles did not echo the shape of the form itself but were circular. While very similar in concept, the overall effect was a little less successful. Moreover, for some reason, Sebring insisted on a less modern decorative treatment. Many of the pieces were decorated with nineteenth-century fashion prints, creating a disjunction between the Victorian quality of the decoration and the modern qualities of the design. The design shown, Parkway, represents one of the few Schreckengost decorations that appeared on this shape; note that its bold, simplified rendering, although of a traditional grass motif, is more modern and therefore appropriate to the shape. Another example of an appropriate decoration found in the Schreckengost archives, also typical to Viktor, is a version of

Concept drawing #1 for Jiffy Ware, yellow. H. 50.8 cm.

American Limoges Jiffy Ware, yellow.

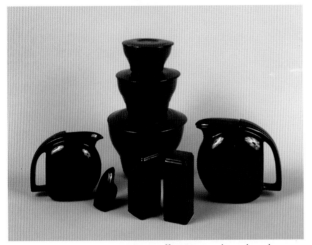

American Limoges Jiffy Ware, chocolate brown.

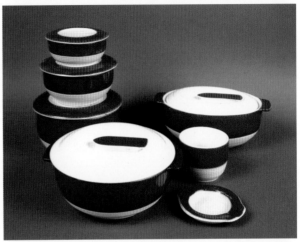

American Limoges Jiffy Ware, red and white, 1942.

the plate that appears with no center motif, only red and gray decorative bands around the inside of the rim.

Jiffy Ware

In 1942 Viktor designed Jiffy Ware, an inexpensive, ovenproof line of casserole dishes and containers that was designed with straight sides so as to take up a minimum amount of space on a shelf or counter or in the refrigerator. Many of the containers had recessed lids and were devised so that they could be stacked on top of each other. The lids could also be taken off and used independently as hot plates or ashtrays.

The bright colors of Jiffy Ware—as well as the practical shapes—contributed to Jiffy Ware's success. The dishes were available in solid green, yellow, chocolate, and turquoise; blue-and-white or red-and-white two-tone; and a variety of decals that matched other American Limoges dinnerware. The bold shape of Jiffy Ware is similar to designs found recently on dozens of concept drawings in Viktor's archives, many of which appear never to have been put in production. A similar design, Hotco, was made for Salem China

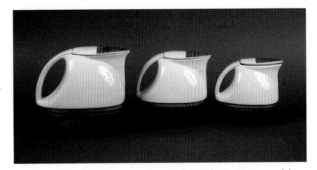

Salem China Hotco in blue.

Concept drawing: Blue Water Pitcher #2. H. 50.8 cm.

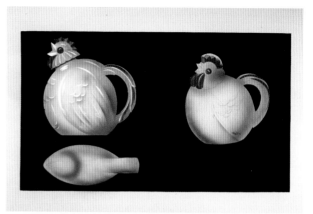
Concept drawing: Chicken Water Pitcher. H. 50.8 cm.

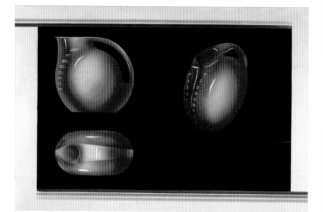
Concept drawing: OrangeWater Pitcher. H. 50.8 cm.

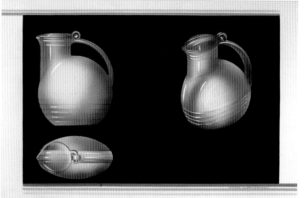
Concept drawing: Red Water Pitcher #3. H. 50.8 cm.

(shown here in blue and white). Shown also are undated concept drawings for water pitchers that bear marked resemblance not only to Viktor's own Jiffy Ware but to Homer Laughlin's now-famous Fiesta Ware disc pitcher.

Flair, 1951

Salem China's Flair shape (1951) has a purely modern look, enhanced by the rounded-off square shape of the plate. The plate well, which did not have a conventional rim but swept gently to a raised edge, had a surface area perfectly suited for larger designs. Viktor used this "canvas" effect to great advantage with larger-scale patterns like Fantasy, Peach and Clover, Woodhue, and his signed French Provincial design. Unusual as it is for a dinnerware designer to include a

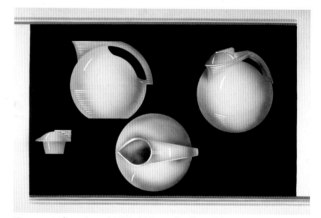
Concept drawing: WhiteWater Pitcher #1. H. 50.8 cm.

signature on the front side (or even as part of the underside mark), Viktor did so successfully; this piece is very collectible today because of its striking design and because the designer can easily be identified. Finally, although this is a very modern shape, the use of the front as a canvas

CONSTELLATION

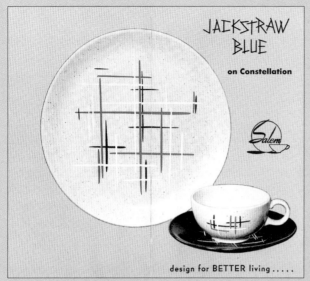

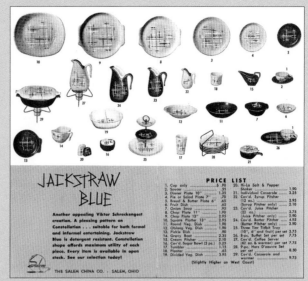

Brochure for Salem Constellation shape with Jackstraw blue pattern.

"The Constellation dinnerware line was introduced to the market in January 1954. This ware, designed by Viktor Schreckengost, was described as 'distinctively new' and was suitable for both formal and informal dinners. Artistic and functional, Constellation featured an 'appealing day and night art texture glaze... off-white flecked with dark grey-blue and charcoal grey which has the soft, dignified luster of rich ebony.' The line mixed round, rounded square, and tabbed shapes while exploiting high-color contrast to heighten the drama of modern dining. The pitchers were optionally lidded in contrasting colors and their handles were attached only at the top in an inverted 'U.' Handles on the covered casserole were strikingly similar to those on the Pebbleford service by Taylor Smith & Taylor, but the casserole body itself was shaped like a rounded rectangle. Items included a lidded pitcher with warmer and stand, round plates, tabbed plates, divided tab-handled vegetable, small single-handled covered casserole, a high- and low-rounded, rectangular salt & pepper, and a three-tiered tidbit. The line targeted young homemakers, as did many of the modern lines. The line was marketed as ovenproof. A forty-five piece service for eight ran $19.95."

—Michael Pratt, dinnerware expert, on web site www.MODish.net

Salem China Flair shape,
Fantasy pattern.

Salem China Flair shape,
French Provincial pattern. Unusual
in that Viktor signed the front.

Salem China Flair shape,
Woodhue pattern.

Royal Crest dinnerware, ca 1950.

Royal Crest dinnerware in multiple colors.

(more than simply a decorated surface) hearkens back to Viktor's earliest decorative wall plaques or plates.

Royal Crest, circa 1950

Viktor's 1950 tea set design for Royal Crest introduces forms that were far less geometrically regular and more biomorphic and sculptural than his earlier work. Several influences help explain this shift. For one thing, by this time both Russel Wright and Eva Zeisel had begun to produce more modernistic patterns, such as Russel Wright's American Modern, introduced by Steubenville Pottery in 1939, or Eva Zeisel's Museum, produced for the Castleton China Company in 1946. These innovative designs made Viktor's earlier designs for American Limoges, such as Manhattan and Triumph, which reflect the rigidly geometric streamlined sensibility of an earlier era, seem relatively conservative—even out of date. Equally significant, by this time, Viktor was exploring new directions in his own ceramic pieces, creating slab forms that avoided the regular shapes produced by the potter's wheel and treating ceramics as sculpture. In Royal Crest, Viktor took many of the ideas from his slab forms and translated them into a design for mass production.

Many of the slab forms loosely resembled botanical forms, and without being literally imita-

tive, Royal Crest explored this theme as well. The basic shape had the globular quality of a gourd; the sinuous handles recalled winding stems and tendrils. One of the most delightful aspects of the design was the way the walls of the shapes were indented in a fashion that recalled the work of the eccentric nineteenth-century potter George Ohr. This also served a practical purpose since the indentations functioned as finger grips and made the pieces less likely to slip when handling them. A notable practical innovation of this design was the slightly projecting underlip of the teapot. Unlike Viktor's earlier teapot designs, this one would not drip if there was a backflow. Another clever feature was the asymmetric shape of the saucer for the teacup, which curved out slightly on one side to hold a piece of cake. Sadly, this design was never put into production, but it stands as an important milestone in Viktor's career, marking the approach that he would follow in his later dinnerware designs.

Free Form, 1955

Viktor's Free Form shape (1955), his last major dinnerware design, was also one of his most notable design statements. As with Royal Crest, the pieces were influenced by his handmade slab forms although, in this case, the shapes were not so much gourd-like and biomorphic as canoe-like.

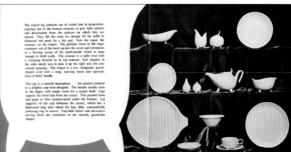

Salem China Free Form shape brochure.

Compared to his earlier dinnerware designs, the shapes were both simpler and more biomorphic. The plates, for example, had no rims: spilling was prevented by a high curving lip. The creamer had no handle but instead was held with indented thumb and finger grips.

The unique feature of the design was that all the hollowware pieces rested on tripod supports. The way that they seem almost to float weightlessly in the air brings to mind the modern architecture of the period. The French architect Le Corbusier, for example, liked to rest his buildings on concrete pillars so that they float above the ground. Frank Lloyd Wright often employed cantilevers so that solid masses seemingly defy gravity and soar.

This tripod innovation also improved the functionality of the teacup in a thoroughly practical way. Most teacups have a concave bottom, which creates suction between cup and saucer; if liquid spills into the saucer, the cup will inevitably pick up the liquid and spill it in the user's lap. The tripod feet of Viktor's cup, on the other hand, would not pick up the liquid even if the saucer were filled. To

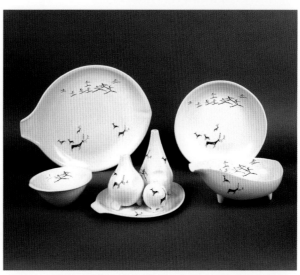

Salem China Free Form shape, Primitive pattern. First issued 1965.

Salem China Free Form shape, Aquaria pattern. First issued 1956.

Salem China Free Form shape, Southwind pattern.

demonstrate the value of this improvement, Viktor devised a machine that would lift the cup over a white tablecloth from one coffee-filled saucer to another. Over the course of the 1955 dinnerware show in New York, not a single drop spilled on the

tablecloth. Viktor's patent for this feature represented the first significant innovation in teacup design in more than a century.

This design also featured a teapot with a projecting lower lip, preventing dripping. While Viktor had introduced this feature into his Royal Crest design, it was the first time he was able to get it into production.

Finally, the salt cellar possessed an interesting feature. Its shape, which resembled that of a conical kiln with a vent at the top, created a natural air convection current that kept the salt dry. Salt would pour freely at levels of humidity that would cause most salt cellars to clog.

For once, Viktor was able to decorate his designs in a fashion that was suited to their modern aesthetic. Probably the most successful of the design schemes was Primitive, based on prehistoric cave paintings, with a theme of animals and hunters that, it was thought, would appeal to men. Unlike the relatively regular placement of Viktor's designs of the early 1930s, this one is scattered across the surface of the shape in a delightfully asymmetric fashion. Mid-century modern dinnerware expert Michael Pratt also lists Aquaria, Tepee, Hopscotch Pink, and Hopscotch Turquoise as the most collectible patterns on the Free Form shape. Southwind, a large pattern showing a branch with falling red and turquoise leaves, appears on the shape as well.

American Limoges Manhattan shape, Flower Shop pattern.

Decorative Patterns

Viktor seems to have originally hoped to produce modern dinnerware in simple glazes, such as the rich brown glaze known as Meerschaum, to create an effect reminiscent of the hand-thrown pots he had produced under Powolny in Vienna. Notably, the set of Manhattan that Viktor kept for his own collection has a Meerschaum glaze, although he also experimented with brilliant colors such as Mazarine blue (which was used with lemon coin gold to create a truly electric effect).

But the management at American Limoges was accustomed to selling wares that were decorated, and these varying schemes of ornament also served an important commercial function. To avoid price wars, the major department stores liked to sell wares that were unique. While it was too expensive to produce a new shape for every

chain, it was quite practical to devise different forms of decorative treatment. Adding new decorative treatments was also an inexpensive way to update a line of dinnerware for the next season. By February 1935, when Viktor first displayed his Manhattan set at the Ruth Coulter Gallery in Cleveland, he had already devised more than sixty different decorative treatments, and he seems to have devised many more over the course of the 1930s.

Viktor's decorative designs were as original as his shapes for, rather than using designs with shading and perspective in the Victorian fashion, he developed flat decorative treatments. The most successful of these, Flower Shop, was a response to a challenge that was presented to him in 1935. The management at American Limoges believed that American women wanted flowers on their dinnerware and insisted that he come up with a floral pattern. Viktor's response was to create a flat, almost childlike design that featured flowerpots placed upon very schematic ledges. These colorful elements were placed against a clean white background. In fact, Viktor's design was very reminiscent of the designs of the Wiener Werkstätte, but somehow transformed the rather stiff, modernist formality of his Viennese sources into a cheerful cartoonlike effect that appealed to a mass audience. At a time of economic depression, the cheerfulness of the design had enormous appeal. When Flower Shop was first released, American Limoges was running at one third of its capacity; within four months, the factory was at full capacity and had to rent kilns from Sebring Pottery to keep up with the demand. A single department store in Cleveland, Higbee's,

sold twenty-eight boxcars of the design. So much of the Flower Shop pattern was produced that the kilns became coated with selenium red, and the plates started to develop dark spots. The kilns had to be rebuilt with additional vents. Within a year, thirty-eight imitations of Flower Shop had appeared on the market, many of them made in places as distant as Czechoslovakia or Japan.

Like many of Viktor's designs, Flower Shop has recently been resurrected from obscurity. The famous doll series "American Girl" has a 1940s doll named Molly whose tea set is a miniature version of this design. As part of the 2006 Viktor Schreckengost National Centennial Exhibition, the American Girl regional headquarters in New York, Chicago, and Los Angeles are featuring displays of Viktor's original Flower Shop pieces alongside their own miniature look-alike tea sets.

In 1936 Viktor came up with another very striking design, Animal Kingdom. This featured bold silhouettes of elephants, cows, roosters, pigs, and goats accompanied by a star. It proved almost

American Limoges Manhattan shape,
Animal Kingdom pattern.

equally as popular as Flower Shop, and when Gimbels in Pittsburgh created a window featuring the pattern at the Pittsburgh Glass and Pottery exhibition in February 1936, it was constantly surrounded by interested spectators.

Both Flower Shop and Animal Kingdom employed decals, and, since these were produced in Germany, they added to the expense. (Fortunately, Viktor kept an uncut sheet of Animal Kingdom decals, whose crowded motifs make a striking pattern, like that of decorative wallpaper. Recently, another sheet of decals has been discovered as well, which features brilliantly colored bowls and plates of a Southwestern appearance.) Consequently, Viktor produced banded patterns of pure color that were less expensive, creating a dramatically modern effect reminiscent of the target paintings of Kenneth Noland. He also produced designs applied with rubber stamps, which printed designs in gold and platinum such as Joan of Arc and Evening Star.

American Limoges Diana shape, Evening Star pattern.

Viktor tended to develop his decorative treatments in related groups that explored a particular design approach. His decorations of the early 1930s tended to be more geometric in effect in keeping with the aesthetic of Art Deco. He liked solids (such as Meerschaum) or solid blocks as well as banded designs and stamped images. When he resorted to representational designs, he preferred strong, simple geometric shapes (Red Sails). When he employed floral patterns, he either gave them a strongly geometric character, as in Flower Shop, or placed them within a strongly defined circular or oval shape.

Under pressure from management, however, by the later 1930s he developed more flowing floral patterns such as Bermuda, and by the 1940s he was producing floral bouquets with a nostalgically Victorian character, such as Victorian Rose, Lansdowne, and Sheffield. He even produced representational scenes, such as Old Virginia, which featured six Schreckengost sketches of buildings in colonial Williamsburg.

After the war, he returned to floral motifs, such as Parsley, Strawberry Patch, Garden, Fantasy, and Windblown, but with a freer, less-symmetrical treatment that was more modern and often explored Asian or tropical themes. By the late 1950s, as modern design caught on with the general public, he was able to introduce a more contemporary decorative look, as in Primitive, based on cave paintings, which had a pictographic quality, or in geometric ray patterns, such as North Star or Jackstraw.

DECORATIVE THEMES

American Limoges
Manhattan shape,
Silver Elegance pattern.

American Limoges
Manhattan shape,
Meerschaum pattern.

Viktor preferred solid glazes, sometimes with additional bands of color, that showed off his artful shapes (like these two Manhattan patterns) and didn't require additional production expense.

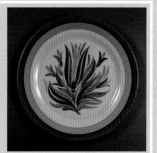

American Limoges
Triumph shape,
Bermuda pattern.

American Limoges
Triumph shape,
Jamaica pattern.

A tropically named series features bright, tropical florals, like Bermuda (left), Jamaica (right), Tahiti, and Yucatan (not shown).

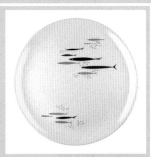

American Limoges
Manhattan shape,
Flower Shop pattern.

Salem China
Free Form shape, Aquaria
pattern. First issued 1956.

The tiny flowers in Flower Shop comprised one of Viktor's most popular patterns, but he also did additional motifs in this abstract-geometric style. Shown are Flower Shop on the Manhattan shape (left) and Aquaria on the Free Form shape (right).

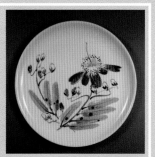

Salem China
Lotus Bud shape,
Cherry Blossom pattern.

Salem China
Lotus Bud shape,
Moonflower pattern.

Asian-inspired motifs make up at least two full dinnerware lines. Names like Cherry Blossom (left), Moonflower (right), Primrose, Woodhue, and Windblown evoked the theme.

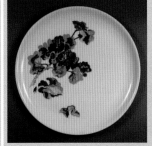
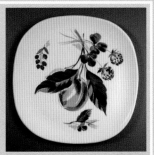

Salem China
Geranium pattern

Salem China
Flair shape,
Peach and Clover pattern.

Watercolor-style, larger-scale motifs dominated some later patterns, including Geranium (left) and Peach and Clover (right). These later patterns satisfied Viktor's employers' desires for more traditional floral motifs while still allowing him to portray them with a freer, less traditional style.

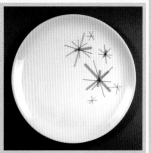

Salem China
Constellation shape,
Jackstraw yellow pattern.

Salem China
Contour shape,
North Star pattern.

Simple lines or hatch marks created uncomplicated motifs on pieces that have become more collectible in recent years, including Jackstraw (left), North Star (right), and Hopscotch (a pink version of North Star).

Don and Paul Schreckengost

Viktor's younger brother Don was also a gifted ceramic designer. In 1934 he took a job as chief designer for Salem Pottery in Salem, Ohio—the childhood home of the noted American watercolorist Charles Burchfield. Like American Limoges, Salem Pottery belonged to the Sebring family so Don and Viktor both reported to Frank Sebring, Jr., and seem to have worked in a loose partnership.

In 1935 Don created his most memorable design, the striking three-sided Tricorne shape. The impetus for the design came when a salesman

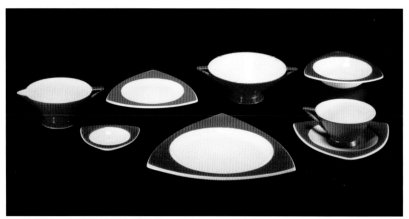

Salem China Tricorne Shape dinnerware set, 1933.

from the Henshaw Color Company in Cleveland brought him an unusual lustrous orange glaze made chiefly of uranium. The color suggested a shape that was forceful, unusual, and futuristic. After coming up with the idea of creating a three-sided model, Don then designed special jiggers that would fabricate it. Frank Sebring, Jr., was so impressed by the design that he insisted that Don patent it.

No doubt Don's play with geometric shapes was influenced by Viktor's earlier experiments, such as the Americana hollowware that sat on a hexagonal platform. At the time, all three broth-

ers were working together in the Sebring studio, and they must have freely exchanged ideas with each other. Viktor claims to have been involved with the designs, and in fact sketches of the hollowware have surfaced in his archives. The nature of Viktor's involvement is unclear—whether he contributed design ideas or simply comments—especially since Tricorne represents more than one partnership. The teacups and other hollowware that go with Don's plates and saucers are stamped with the name Streamline, the patent for which design is held by Vincent Broomhall for Salem China. Although Tricorne and Streamline are technically two separate designs, in practice they may be considered a set. Today, art and antiques auctions still sell lots of Tricorne and Streamline as sets.

Seventy years after it was created, the design still looks futuristic. Featured in many museum collections, it is undoubtedly the most striking instance of the streamlined look in American dinnerware design of the 1930s.

Paul Schreckengost (1908–1983), another of Viktor's younger brothers, was a gifted ceramist, designer, semiprofessional athlete, and father of eight children as well. During his day he was known as one of the most skilled mold-makers in the United States, and he often created freelance designs from his basement studio as well. His works are far more elusive than those of Don and Viktor, given their often unsigned nature, but his pieces command comparable attention at auc-

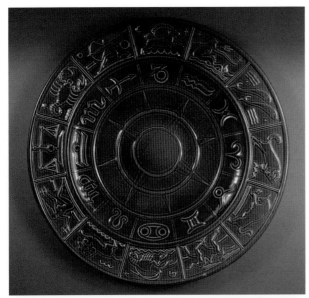

Paul Schreckengost. Zodiac plate, ca 1930s. This large plaque created by Paul in the 1930s features images from the horoscope, a popular Deco theme.

tion. For example, a dramatic, streamlined teapot Paul designed for Gem Clay Forming Company in 1938 sold at a West Hollywood LAMA auction in 2004 for $14,680, twice its estimated value.[11] This teapot, possibly his most recognized design, was featured at the Brooklyn Museum in The Machine Age, a 1986 exhibition. Another of his largely unattributed designs includes a panther-shaped lamp that even now crops up at flea markets and antique stores.

Paul also designed a "Tom and Jerry" set similar in style to his famous teapot, a full service of which was found in storage at the Schreckengost Archives in 2005. A "Tom and Jerry" is a creamy, brandy-based holiday drink—a bit like a milkshake—made with egg, cinnamon, cloves, allspice, sugar, hot milk or wa-

ter, brandy, and rum. Tom and Jerry sets used to be quite popular; even children were served nonalcoholic versions of this traditional favorite. Sets now appear at antiques auctions but are also kept as heirloom pieces by families who remember the conviviality of holiday gatherings around the Tom and Jerry bowl. A single teacup that appears to match the Tom and Jerry set—but would also match the teapot mentioned above—sold at auction in New York in 2005 for $2,800.[12]

Paul's designs not only evidence his own skills but the continuity of themes and products explored by the three ceramist brothers. According to family tradition, the brothers often worked together, sharing ideas, and many unsigned pieces in private Schreckengost family collections might easily be attributed to any of the three brothers.[13] Certainly the pieces shown here—dinnerware, drink bowls, and a plaque—absolutely share commonalities with the much more prolific ex-

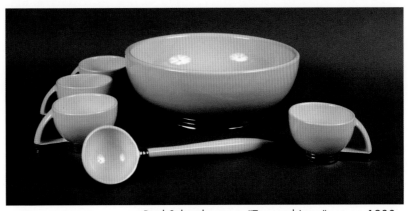

Paul Schreckengost. "Tom and Jerry" set, ca 1930s.

amples of surviving work by Viktor, to date the most famous brother but certainly not the only one with exceptional talent.

11 http://www.architonic.com/4105829

12 http://www.liveauctioneers.com/s/lot-1465371.html?q=Schreckengost&pq=&t=a

13 Interview with Paul Schreckengost (son of Paul Schreckengost), August 17, 2005.

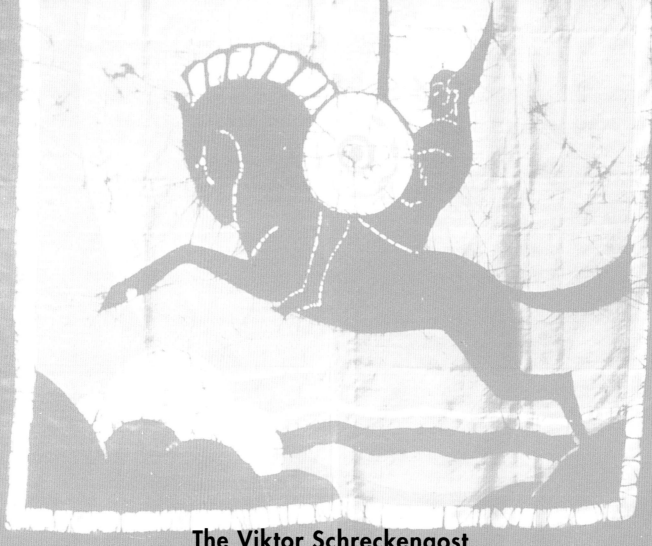

The Viktor Schreckengost
National Centennial Exhibition

100 SHOWS FOR A 100th BIRTHDAY

Reaching one hundred years of age is an impressive accomplishment—but then again, Viktor's life has been a series of impressive accomplishments. To commemorate this special occasion, Viktor will receive a gift that's just as magnificent. A gift he's never asked for but has deserved for more than seventy years: widespread national recognition for his life's work. During the hundred days before his birthday on June 26, 2006, more than one hundred venues across the United States are exhibiting Viktor's work. Perhaps the largest exhibition series ever launched, this grand tribute is a fitting size and scale for the work of a man who helped shape the course of twentieth-century design and consumer taste.

America will find Viktor Schreckengost works in a variety of venues, including art and ceramics museums; pedal car and bicycle collections; restaurants and libraries; historical societies and archives; military museums and a mounted police stable; parks and churches; and public schools and private homes. The diversity of participating venues illustrates not only Viktor's past influence in several

industries and art communities, but the new audiences that will be reached by his legacy. Art lovers will be exposed to his work, but so will those with interests in military history, children's toys, art pottery, vintage bicycles, dinnerware, and any other number of subjects.

Many venues participating in the National Centennial Exhibition have a personal connection to Viktor. Former students remember his legacy; they will hang his work in their offices. Businesses frequented by Viktor have gotten to know him, and will proudly display his designs. Institutions named for Viktor's contemporaries and friends (Vance Kirkland, Arthur Baggs, Guy Cowan) are acknowledging his role in the lives of their founding artists through their participation. Collectors are lending their own Schreckengost pieces to hometown museums that want to join the tribute. Charities that Viktor has supported for years are turning to offer their support for the exhibition as well.

His work was never meant to be enjoyed by elite or discrete groups. The same creed that guided Viktor's work for so many years—that good design should be available to everyone—now guides the invitation to all Americans to join the celebration of his one hundredth birthday.

The Viktor Schreckengost National Centennial Exhibition: PARTICIPATING VENUES

This list was current as of press time (January 2006). For an up-to-date list of participating venues (including several for whom details had not been finalized at press time), please go to www.viktorschreckengost.org.

Adam's Barber Shop (Cleveland, Ohio)
Adam Dedominico is Viktor's barber and a fan of his. Until recently, he lived just a block from Viktor's house. Adam used to walk by the house regularly so he could see the watercolor painting *Hewn Forms*, which hangs in an upper window in Viktor's house, in clear view from the sidewalk.

Albrecht-Kemper Museum of Art (St. Joseph, Missouri)
www.albrecht-kemper.org
The Albrecht-Kemper Museum of Art boasts a fine collection of American art dating back to the eighteenth century and serves as a cultural arts center for northwestern Missouri. The museum's collection features works by contemporary American artists. The museum is displaying several Schreckengost watercolors, three of which are owned by area resident Dr. Charles Nowacek.

American Girl Place *(Chicago, Los Angeles, New York)*

www.americangirlplace.com

The mission of American Girl is to educate and entertain, especially through dolls and books based on different times and places in American history. The 105 million books and 11 million dolls sold since 1986 attests to the success of the American Girl brand. American Girl's Molly doll represents the 1940s. An accessory sold with the doll is a china tea set that is a reproduction of Viktor Schreckengost's extremely popular Flower Shop pattern from this era.

American Watercolor Society *(New York, New York)*

www.americanwatercolorsociety.org

In 1866 in New York City, eleven people founded the American Society of Painters in Water Color, with the express purpose of advancing watercolor painting as an art form. Now the American Watercolor Society, the same organization hosts annual exhibitions and offers scholarships to art teachers. Viktor Schreckengost participated in exhibitions during the 1950s and '60s; he was awarded the Grumbacher Purchase Prize (1955), the Rudolf Lesch Purchase Prize (1962, 1964), and the Lena Newcastle Purchase Prize (1963).

Archie Bray Foundation for the Ceramic Arts *(Helena, Montana)*

www.archiebray.org

The Archie Bray Foundation for the Ceramic Arts is an educational organization in Helena, Montana, dedicated to creative work in ceramics. Archie Bray, a brick maker, founded "the Bray" in 1951, which he intended to be "a place to make available for all who are seriously and sincerely interested in any of the branches of the ceramic arts, a fine place to work." According to the web site, it is "internationally recognized as a gathering place for emerging and established ceramic artists" and draws artists from around the world.

Arkansas Arts Center *(Little Rock, Arkansas)*

www.arkarts.com

Located in Little Rock, Arkansas, the Arkansas Arts Center is the state's largest cultural center, housing acclaimed collections of artworks on paper, sculpture, and craft, by such artists as Van Gogh, O'Keeffe, Rembrandt, Whistler, and Rubens. Contemporary artists in the crafts collection include Dale Chihuly, Albert Paley, Peter Voulkos, and Dorothy Gill Barnes, with such items as baskets, turned wood objects, studio glass, ceramics, metalwork, and toys. New construction of 30,000 square feet and renovation of 12,000 square feet was completed in 2000.

Artefino Art Gallery Café *(Cleveland, Ohio)*
www.artefinogallery.com/index.htm#

Artefino is an art gallery where eating among the artworks is permissible, since the gallery is also a casual café. Artist-owner Hector Vega, born in Puerto Rico and raised in Cleveland, brings energetic, bold colors and patterns and a strong ethnic flavor to the café-gallery. Vega is also very involved in charitable, community, and art-related organizations. Artefino features Vega's work as well as the paintings, sculpture, and jewelry of other local artists. The gallery is showing several of Viktor's *Guerrero* series, known for their Mexican-inspired bright colors and tropical motifs.

Art Institute of Chicago *(Chicago, Illinois)*
www.artic.edu

While the Art Institute of Chicago was originally founded in 1879 as both art museum and art school, it now provides a foundation for the collection, preservation, and cultivation of the arts on a community, national, and international level. The museum's collection spans 5,000 years of human artistic endeavor from around the world. The Art Institute recently acquired one of Viktor Schreckengost's *Jazz Bowl*s, but the earliest known work by Viktor to be exhibited here is the sculpture *Jeddu*, which was displayed in the early 1930s.

Art on Wheels *(Cleveland, Ohio)*
www.aowinc.com

Multidisciplinary art classes are the focus of Art on Wheels, Inc., a Cleveland nonprofit company that develops hands-on traveling activities in visual art, music, movement, and drama. Art on Wheels developed a curriculum about Viktor Schreckengost at the request of Grant Elementary School in nearby Lakewood, Ohio. The company was already familiar with Viktor and his work, as he had previously visited with an Art on Wheels class for adults with mental disabilities.

Arthur Baggs Library *(Columbus, Ohio)*
www.library.osu.edu/sites/libinfo/BML.html

Located at the Ohio State University, the Baggs Collection includes an extensive library on ceramics and ceramics-related material, including a large collection of ceramic art objects and Ohio art pottery that is contemporary to Viktor's work. The Arthur E. Baggs Memorial Library, housed within the Department of Arts ceramic area, has a collection of books, objects, tools, glaze notebooks, and test tiles, primarily pertaining to the studio art movement in twentieth-century ceramics. Arthur Baggs, head of the Art Department at the Ohio State University, and Guy Cowan were of the same generation, and both were friends and mentors of young Viktor, whose first industrial job out of school was at Cowan Pottery.

Artists Archive of the Western Reserve *(Cleveland, Ohio)*
www.artistsarchives.org

The Artists Archives of the Western Reserve is an archives facility that preserves representative bodies of work created by Ohio visual artists and, through ongoing research, exhibition, and education programs, actively documents and promotes this cultural heritage for the benefit of the public. The Archive collects works by Viktor's contemporaries. Its sister organization, the Sculpture Center, did a show in 2004 that included Viktor's *Jeddu* and *Mangbettu Child*.

Attleboro Arts Museum *(Attleboro, Massachusetts)*
www.attleboromuseum.com

At the Attleboro Arts Museum, the visual and performing arts are used to promote creativity, education, and cultural awareness. Exhibits at the museum and in the community, a wide range of classes, youth outreach programs, workshops, and special events aid in accomplishing the museum's mission. Chuck Tramontana, a board member of the museum, is a former student and avid fan of Viktor Schreckengost. The museum's participation in the Viktor Schreckengost National Centennial Exhibition reflects Chuck's great admiration for his former teacher.

Baldwin-Wallace College *(Berea, Ohio)*
www.bw.edu

Founded in 1845, Baldwin-Wallace College in Berea, Ohio, is a fully accredited institution that offers liberal arts–based undergraduate, graduate, and preprofessional programs. The college's participation in the National Centennial Exhibition was initiated by Joe Kisvardai, an expert on the Cleveland School of artists. Joe is a longtime personal friend and admirer of Viktor.

Baltimore Museum of Art *(Baltimore, Maryland)*
www.artbma.org

One of the Baltimore Museum of Art's fortes is modern art, and the core of this strong collection is formed by some 3,000 works, including many early-twentieth-century European paintings. Distinguished works by Picasso, Cezanne, and van Gogh are owned by the museum, which is also one of the great Matisse repositories in the world. More than 500 of the French painter's works, including at least one painting per year from his productive period between 1917 and 1940, are housed here. The museum also owns a *Poor Man's Jazz Bowl* by Schreckengost, which is on permanent display because of its importance to Art Deco history.

Big Arts *(Sanibel, Florida)*

www.bigarts.org

Big Arts's mission statement is simple: "to provide cultural programs of high quality to the residents and visitors of Sanibel and Captiva (Florida)." Big Arts began modestly in 1979 when a small group of artists opened a gallery in a donated cottage and held concerts under a tent in the garden. The present modern facility boasts a concert hall, classrooms, and studios for visual and performing arts where workshops by well-known artists are held. Big Arts has evolved into a prominent cultural center through the dedication of a strong volunteer force and enthusiastic support of the area's residents. The Annual Art Fair features more than one hundred artists. Viktor's *Lazy Flamingos* will be on the island for the National Centennial Exhibition.

Bicycle Museum of America *(New Bremen, Ohio)*

www.bicyclemuseum.com

This museum houses the largest bicycle collection in the country. The original collection was a donation from the Schwinn family. Elegant antique bicycles of the 1800s, balloon tire classics of the 1940s and 1950s, and even the banana seat high-rise handlebar bikes of the 1960s are part of the museum's holdings. Viktor was a leading designer of bicycles for Murray Ohio, beginning with his 1939 Murray Mercury design for the New York World's Fair, and continuing through the 1960s Mark II Eliminator. The Bicycle Museum's participation in the National Centennial Exhibition is a natural, since they own many examples of Viktor's work.

Bonfoey Gallery *(Cleveland, Ohio)*

www.bonfoey.com

Established in 1893 as the Bonfoey Company by Asher D. Bonfoey, the Bonfoey Gallery in Cleveland, Ohio, quickly became a reputable picture framing establishment. Over the years, it has shifted its concentration more and more to fine art. The Bonfoey Gallery and Viktor have a relationship that spans many years, as this gallery has been the principal venue to offer his work.

Bubble Room *(Captiva Island, Florida)*

www.bubbleroomrestaurant.com

This fascinating American-cuisine restaurant is composed of eye-catching memorabilia from the 1930s, 1940s, and 1950s. Toy trains, twinkling colored lights, and more than 2,000 movie stills and glossies of stage and screen legends "draw people in with old memories and send them home with new ones of a fantastic dining spot." This is predictably a favorite winter haunt for Viktor, his wife Gene, and their grandchildren. The decor includes one of Viktor's pedal cars hanging above the door!

Butler Institute of American Art *(Youngstown, Ohio)*
www.butlerart.com

Founded in 1919 by Joseph G. Butler, Jr., the Butler was the first building specifically constructed for the purpose of housing our nation's art. Since its construction, the original building has been expanded and renovated countless times. The institute has two branch museums located in Salem, Ohio, and Howland, Ohio. Clyde Singer, the curator and an artist himself, has a long relationship with Viktor. For many years, the Butler's annual New Year's show featured Viktor's work. The Butler owns four Schreckengost pieces.

Cain Park *(Cleveland Heights, Ohio)*
www.cainpark.com

Cain Park was established in the mid-1930s. Owned and operated by the City of Cleveland Heights, Cain Park is known for its summer theater program, as well as its three-day Arts Festival in mid-July. Featuring gallery- and art museum–quality pieces, the top-rated Arts Festival matches 60,000 to 65,000 art patrons with 160 professional artists in a beautiful park setting. For many years, Viktor was a local, active participant at Cain Park. He designed theater sets for a production featuring noted Italian actress Marta Abba in the 1940s. The graphic for the 2004 Arts Festival was a Schreckengost design.

Canton Museum of Art *(Canton, Ohio)*
www.cantonart.org

The Canton Museum of Art was founded in a second-floor room of the Canton Public Library in 1935 as an art gallery. By 1941, its exhibits and art classes were moved to a new home and renamed the Canton Art Institute. Over the next thirty years, the Institute became a home for Canton's visual and performing arts. In 1970, the Institute became the Cultural Center for the Arts, and in 1995, the Canton Museum of Art. The museum holds year-round exhibits, classes, and events. Viktor participated in two or three of the museum's annual shows in the 1940s and early 1950s.

Center for Therapy Through the Arts—The Art Studio *(Cleveland, Ohio)*
www.therapythruart.org/prgm.html

CTTA is known for its innovative art therapy programs, especially for people who have had strokes and spinal cord and brain injuries. The center's focus is on the healing power of art through personal expression and image making. Mickey McGraw, a Cleveland Institute of Art graduate, is the retired director. Viktor has always been a supporter of the program. An original Schreckengost artwork is used as a perpetual annual fund-raiser. The artwork hangs in the home of the winning donor for a year.

Chicago Antique Toy Show *(St. Charles, Illinois)*

www.chicagotoyshow.com

An international event known as the Chicago Antique Toy Show is held three times a year at the Kane County Fairgrounds in St. Charles, Illinois, 35 miles west of Chicago. More than 1,000 exhibitors fill six buildings with vintage dolls and toys for the big shows in April and October. Toy enthusiasts from around the world come to the Chicago Antique Toy Show, the largest specialty event of its type, looking for that special piece. Since Viktor designed many toys over his long career, finding his Steelcraft toy trucks, red wagons, or ride-on locomotives is natural at this event.

Church of the Saviour *(Cleveland Heights, Ohio)*

www.chsaviour.org

Church of the Saviour United Methodist Church in Cleveland Heights, Ohio, was established in 1875, when it met in a one-room schoolhouse. Over the years, as the congregation grew, a number of name and location changes led up to the construction of the present sanctuary on Lee Road in 1928. It was designated a landmark by the City of Cleveland Heights in 1975. The church owns Viktor's *From the East*.

Cleveland Artists Foundation *(Cleveland, Ohio)*

www.clevelandartists.org/page2.shtml

The Cleveland Artists Foundation (CAF) is a nonprofit organization dedicated to collecting and exhibiting the works of Northeast Ohio artists; researching and publishing the art history of the area; and providing the community with lectures and programs on the topic. The heritage that connects contemporary Northeast Ohio artists to the old Cleveland School artists is often noted in the exhibitions. Viktor Schreckengost, himself one of the Cleveland School artists, is an honorary trustee, and his wife, Gene Schreckengost, is on the board of trustees. Viktor donated his oil painting *Moroccan Lutes* to the CAF collection.

Cleveland Botanical Garden *(Cleveland, Ohio)*

www.cbgarden.org

The Cleveland Botanical Garden, founded seventy-five years ago, was the first urban botanical garden established in the United States. The Botanical Garden's ten landscaped acres, off-site gardens and classrooms, programs, and events help people of all ages learn about and better appreciate the "interdependence of plants, people, and the environment." The Botanical Garden is located in Cleveland's University Circle, across from Viktor's alma mater, the Cleveland Institute of Art. Not surprisingly, the eighteen Schreckengost artworks shown at the Botanical Garden will focus on a mutually satisfying theme: florals, tree prints, and other botanicals and the positive role plants play in our lives.

Cleveland Clinic *(Cleveland, Ohio and surrounding area)*
www.cchs.net/about/partners/ccf.htm

The Cleveland Clinic, founded in 1921, is one of the world's largest hospitals and is consistently ranked as one of the nation's best. The clinic's physicians and scientists number more than 1,700, in 120 specialties. Patients come from all over the world, resulting in 2.5 million outpatient visits, 52,000 admissions, and 68,000 surgical procedures. The Cleveland Clinic Heart Center is the best in America, according to the *U.S. News and World Report*'s annual survey. The Heart Center doctors invented cardiac angiography and developed the coronary artery bypass. The clinic owns Viktor's watercolor *City in Red*.

Cleveland Heights Library—Taylor Academy Site *(Cleveland Heights, Ohio)*
www.heightslibrary.org

The Cleveland Heights-University Heights Public Library, with its award-winning online services, is one of the top-rated U. S. public libraries. Originally opened to the public in 1921, Cleveland Heights Library now has four locations and a circulation of over two million. The main library is temporarily located at the Taylor Academy on Superior Road. Always a friend to his local library, Viktor served on the council that recommended sculpture for the exterior. One of his watercolors hangs in the lobby.

Cleveland Hopkins International Airport *(Cleveland, Ohio)*
www.clevelandairport.com

Cleveland Hopkins International Airport, the first municipally owned commercial airport in the United States, celebrated its eightieth anniversary in 2005. Hopkins is the largest commercial airport in northeast Ohio, serving almost twelve million passengers annually. The airport owns a Schreckengost mural of the sun, moon, and zodiac, an appropriate theme for the world travelers who pace its concourses.

Cleveland Institute of Art *(Cleveland, Ohio)*
www.cia.edu

Established in 1882, CIA has come to be known as one the top ten professional colleges of art and design in the country. Viktor attended CIA from 1925–1929. He was a straight-A student and the highest ranked in his class. He also taught at the Institute for many years, mentoring some of the greatest designers of the twentieth century. In 1933, CIA opened its design program under Viktor's supervision. CIA will, appropriately, be showcasing some of Viktor's earliest work—his student design pieces and nude figures.

Cleveland Institute of Music *(Cleveland, Ohio)*
www.cim.edu

In 1920, a small group of founders each contributed $1,000 to open a school of music in Cleveland, which has since graduated 3,000 students from its bachelors through doctoral programs. The Cleveland Institute of Music, in Cleveland's University Circle, has become a well-known international conservatory. Twenty-four hundred CIM alumni perform in national and international orchestras and opera companies or enjoy teaching careers around the world. CIM also provides rigorous musical training programs for Cleveland residents of all ages and abilities. The proximity of CIM to Viktor's alma mater, the Cleveland Institute of Art, is a good metaphor for Victor's double gift of music and art. His love of music, in general, and especially of the saxophone and clarinet, which he played, is manifest in many of his watercolors. The Cleveland Institute of Music will feature several of Viktor's musically themed artworks.

Cleveland Metroparks Zoo *(Cleveland, Ohio)*
www.clemetzoo.com

The Cleveland Metroparks Zoo began in 1882 with a seventy-three-acre land donation for a deer park. Originally, only native animals were exhibited at the zoo, but with the expansion of vision, facilities, and management over the years came the acquisition of animals from around the world. Viktor's reputation as an artist expanded with the zoo. In 1948, Viktor designed and created a brightly colored ceramic relief facing for the birdhouse tower, presenting the natural history of birds, totem pole fashion, from their first appearance to present day. The complexity, success, and beauty of the project resulted in national attention, with an article in *Newsweek* and a medal for Viktor. In 1956, after elephants, hippos, and rhinos came to the zoo, Viktor produced *Mammoths and Mastodons*, a huge wall relief for the pachyderm building that housed the new arrivals. The new animals at the zoo provided living models for many of Viktor's later watercolor and clay renditions of animals of the world.

Cleveland Museum of Natural History *(Cleveland, Ohio)*
www.cmnh.org

Since 1920, the Cleveland Museum of Natural History has educated people of all ages about our natural environment and encouraged them to conserve and protect natural diversity. Four million specimens, science research labs, a planetarium, observatory, natural science and history exhibits, educational programs, an outdoor pond, and a live animal area all combine to inform, to inspire, and to engage people in the natural world. Viktor Schreckengost's love of animals was apparent in his many watercolors, sculptures, and line drawings, many of which will be on display at the museum.

Columbia Museum of Art *(Columbia, South Carolina)*
www.colmusart.org

The Columbia Museum of Art seeks to inspire, educate, and enrich the lives of the community, South Carolinians, tourists, and visitors by collecting and preserving fine and decorative art from around the world, exhibiting highly regarded work from a broad range of cultures, and providing dynamic educational and cultural programs. The museum's web site provides online commentary and selected images for each of seventeen galleries, which extends the museum's reach to patrons across the world.

Columbus Museum of Art *(Columbus, Ohio)*
www.columbusmuseum.org

On the cutting edge as an organization, the Columbus Museum of Art often hosts shows on little-known artists, which requires much original research and work and later results in showings of these artists at larger museums. The Columbus Museum of Art, like Viktor, is very engaged in what's new and innovative in the world of art. In the past, the museum hosted *Bringing Design Home*, featuring Viktor's *Jazz Bowl* and other items, as well as pieces by Don and Paul Schreckengost. The museum will be hosting a full exhibition of Viktor's work in 2007. Viktor's elephant sculpture *Kublai* will be on display for the centennial celebration.

Corcoran Fine Arts Limited *(Cleveland, Ohio)*
www.corcoranfinearts.com

Corcoran Fine Arts Ltd., Inc., owned by James Corcoran, offers appraisal services as well as works of art for sale. Located in the historic Shaker Square area of Cleveland, which was featured in a watercolor by Viktor Schreckengost, Corcoran Fine Arts has a history of dealing in Schreckengost works; for the National Centennial Exhibition it is exhibiting pieces from its gallery and owned by some of its clients.

Cowan Pottery Museum *(Rocky River, Ohio)*
www.cowanpottery.org

The Cowan Pottery Studio, Viktor's first employer, developed a full commercial line of high-quality, artistic pottery in the 1920s. This small forward-thinking group produced modern ceramic sculptures and Art Deco that gained international recognition for American ceramic art. Some of their art forms and glazes have never been reproduced. Viktor created his most famous piece, the *Jazz Bowl*, while at Cowan Pottery. He is the last living artist who is associated with Cowan Pottery. Cowan Pottery was located in the Cleveland suburb of Rocky River when it closed in 1931. The Cowan Pottery Museum made its permanent home in the Rocky River Public Library after the library acquired more than 800 pieces of Cowan pottery. About 15 to 20 percent of the collection, which has grown to more

than 1,100 pieces, are on display and rotated periodically. The Cowan Pottery Museum Associates, established in 1996, offers assistance to the museum and its activities.

Cranbrook Art Museum *(Bloomfield Hills, Michigan)*
www.cranbrook.edu/art/museum/

Cranbrook Art Museum, part of the Cranbrook Educational Community of Bloomfield Hills, Michigan, is a nonprofit contemporary art museum. Cranbrook Educational Community is a private college preparatory school system; its architectural setting was designated a National Historic Landmark in 1989. The museum's permanent collection focuses on the work of some of its own, such as Finnish-American Eliel Saarinen, Cranbrook's resident architect from 1925 to 1950. Viktor Schreckengost's connection to the Cranbrook Community is his *Young Pegasus* sculpture, bought by Loja Saarinen for the Saarinen House, where Viktor visited the Saarinens. *Young Pegasus* is now displayed courtesy of owners Robert Saarinen Swanson and Ronald Saarinen Swanson.

Crocker Art Museum *(Sacramento, California)*
www.crockerartmuseum.org

The Crocker Art Museum was founded in 1885 and continues to be the leading art institution for the Capital Region and Central Valley. The museum offers a diverse spectrum of special exhibitions, events, and programs to augment its collections of Californian, European, and Asian artworks. The Crocker Art Museum's interest in Viktor Schreckengost stems from its own region's importance to the contemporary ceramics movement; it will be featuring examples of Viktor's achievements in clay from the private collection of Jerry and Wynne Maschino.

Cycle Smithy *(Chicago, Illinois)*
www.cyclesmithy.com

Cycle Smithy, a high-end bike shop in the Lincoln Park area of Chicago, was started by owner Mark Mattei in 1973 and has operated from its present location since 1978. The shop sells and services road, mountain, triathalon, and leisure model bikes, in addition to parts and clothing. Mark began collecting vintage bikes—200 so far—in 1983 after a customer came in to the shop looking for parts for an old bike. His collection includes a wide range of bikes from the Victorian era to the highly ornamented Sears balloon tire bike models of the 1930s to 1960s. Usually about fifty bikes are on display in the shop, including a pair of Viktor's deluxe early 1950 J. C. Higgins balloon tire bikes. One is a girl's model, the other a boy's, both with fancy twin headlights and spring fork.

Dallas Museum of Art *(Dallas, Texas)*
www.dallasmuseumofart.org

In 1930, when membership of the Dallas Museum of Art numbered approximately 700, then-director John Ankeney stated, "Nature made Dallas rich, Time will make her powerful, but only Art can make her great." In 2003, the museum celebrated its one-hundredth birthday with about 20,000 members and a fabulous collection of high-quality art representing many time periods. An entire wing of the museum is devoted to decorative arts, including Deco design, and dinnerware in particular. Among the dinnerware pieces owned by the DMA are designs by Viktor Schreckengost, some of which will be on display for the National Centennial Exhibition, such as Free Form Primitive and Royal Crest. The Culver Trophy, designed by Schreckengost, is owned by the DMA and is currently in a traveling silver design show.

Decorative Arts Center of Ohio *(Lancaster, Ohio)*
www.decartsohio.org

The Decorative Arts Center of Ohio is located in Lancaster, Ohio, just southeast of Columbus. It is a statewide organization that fosters knowledge, enjoyment, and appreciation of the decorative arts, defined by the center as "functional art, a term that embraces all artistic works created for both use and decoration. Any and all art works with a sense of design fall under the decorative arts and are the wonderful things that we live with and look at every day." The Decorative Arts Center will feature one of Viktor's many dinnerware patterns, Twinkle, Twinkle on the Triumph shape, for the NCE. For the 2005 Christmas season, the center's toy show included a J. C. Higgins bicycle designed by Viktor and his Pursuit Plane pedal car. Of the pedal car, Barbara Hunzicker, exhibitions chair at the center, commented, "It is one of the most popular objects we have ever displayed."

Delaware Art Museum *(Wilmington, Delaware)*
www.delart.org

The Delaware Art Museum is famous for its pre-Raphaelite collection as well as outstanding American art and illustration from the nineteenth to the twenty-first century. The museum opened its newly renovated building in June 2005 on beautifully landscaped grounds that include a nine-acre sculpture park. The $30 million dollar expansion—from 60,000 to 100,000 square feet—provided seventeen gallery spaces capable of displaying 6 percent of the 12,000 works in the museum's collection. Viktor's ceramic heads *The Seasons* will be shown next to mounted Art Deco elevator doors.

Dunham Tavern Museum *(Cleveland, Ohio)*
www.dunhamtavern.org

The Dunham Tavern is the oldest building in Cleveland that still stands on its original site. It was built on the Buffalo-Cleveland-Detroit post road in 1824 by early settlers Rufus and Jane Dunham. It served as a stagecoach stop and inn until 1857, then became a private home. A group of WPA artists and printmakers used the building as a studio in the 1930s. Afterwards, it was taken over by the Society of Collectors and opened to the public in 1941 as a nonprofit museum filled with nineteenth-century antiques. It is now listed on the Register of National Historic Places and is a designated Cleveland Landmark. In 1938, Barclay Leathem, head of the theater program at Case Western Reserve University, and a friend of Viktor, wanted to restore the building. He suggested staging a theatrical production in the back barn on the property as a fund-raiser. Viktor designed the sets for the production, *Murder in the Red Barn*, a display for which will honor Viktor for the National Centennial Exhibition. The play indeed raised enough money to refurbish the tavern.

Elmer's Auto and Toy Museum *(Fountain City, Wisconsin)*
www.elmersautoandtoymuseum.com

Located on Eagle Bluff overlooking the Mississippi River Valley, Elmer's Auto and Toy Museum features vintage transportation (cars, trucks, bikes, and motorcycles) and thousands of antique toys. These nostalgic collections are spread out over five buildings. Of particular interest to Schreckengost fans are the 500 to 600 pedals cars, one of the world's largest such collections. On display for the NCE will be two of Viktor's pedal cars, the Chrysler Fire Engine and the Murray Sad Face General, and a Steelcraft toy bus. Viktor's pedal car designs revolutionized the production of these toys, making them mass marketable and affordable to the general public.

Erie Art Museum *(Erie, Pennsylvania)*
www.erieartmuseum.org

The Erie Art Museum provides year-round exhibition and education programs for all ages and hosts renowned musicians for their Contemporary Music Series. During the 1980s, John Vanko purchased a *Jazz Bowl* for the museum's collection, recognizing it even then as a classic. Although the acquisition met with some resistance then, partly because Schreckengost was not a household name, his intuition about the piece has since been validated.

Everson Museum of Art *(Syracuse, New York)*
www.everson.org

The Everson Museum of Art had its beginnings as the Syracuse Museum of Fine Arts, founded in 1896. In 1968, the museum opened as the Everson in its present building, designed by I. M. Pei. The Everson

was one of the first museums to collect specifically American art. The Syracuse China Center for the Study of Ceramics at the Everson, with more than 3,500 works, is one of the most comprehensive displays of American ceramics, as well as ceramics from around the world. The Ceramic National Exhibition, begun by the third director of the Everson, Anna Olmstead, was an important venue for Viktor's work in the 1930s. Viktor's former employer, Guy Cowan, organized some of the Ceramic National Exhibitions and worked at Onondaga Pottery in Syracuse after Cowan Pottery closed in Cleveland in 1931. Everson Museum owns the large slab-form ceramic piece *Oblongata* by Viktor, which can be seen online at http://www.fmhs.cnyric.org/community/everson/syrchina/Schrekengost.html.

Fine Arts Association *(Willoughby, Ohio)*
www.fineartsassociation.org

For almost fifty years, the Fine Arts Association of Willoughby, Ohio, has been a gathering place for individuals to learn, create, enjoy, and appreciate the arts. From ballet and watercolor classes to piano lessons and live performances, concerts, and exhibits, the Fine Arts Association educates thousands of students in the arts each year and seeks to create an environment wherein individuals will be motivated and inspired, allowing themselves to be transformed by the arts.

Flashbacks Bicycle Shop *(Lorain, Ohio)*
www.flashbacksbicycles.com

Flashbacks Bicycle Shop in downtown Lorain, Ohio, is a reminder of yesterday and owner Steve Keppler is a "lover of simpler times." He sells and restores vintage bicycles, pedal cars, wagons, and other toys. Steve's connection to Viktor Schreckengost can easily be ascertained by a look at his "before and after" restorations on his web site, which include a Murray wagon and a Murray Fire Chief pedal car. Flashbacks loaned a Murray Eliminator bicycle and a J. C. Higgins Color Flow bicycle to the November 2000 Cleveland Museum of Art's Schreckengost exhibition. A short article about Viktor can be found on the shop's web site. Flashbacks has a collection of Schreckengost bicycles and pedal cars that will be shown for the National Centennial Exhibition.

Francis Lehman Loeb Art Center—Vassar College *(Poughkeepsie, New York)*
www.fllac.vassar.edu

The Vassar College Art Gallery was formed along with Vassar College in 1864 in Poughkeepsie, New York, with a donation by Matthew Vassar of the Warburg Collection of Old Master prints. In 1995, the new building designed by Cesar Pelli to house the Vassar College Art Gallery was named the Francis Lehman Loeb Art Center in honor of its primary donor. The permanent collection contains more than 15,000 works representing the history of art in various media from paintings to sculptures to ceramic

ware, and is known as one of the finest teaching collections in the nation. For the NCE, the Loeb Art Center will be showing Viktor's watercolor *Bottles* owned by Franny Taft.

Gates Mills Community House *(Gates Mills, Ohio)*
www.gatesmillsvillage.com

The picturesque town of Gates Mills, Ohio, nestled in the Chagrin River Valley, is the setting for the April Art Show, held for two weeks each April in the Gates Mills Community House. Artists from area communities are invited to participate in this prestigious event, with a panel of professionals from the Cleveland Institute of Art selecting the works to be displayed. Viktor's work has appeared in the April Art Show. On display during the National Centennial Exhibition will be Viktor's pastoral watercolor *Ohio Valley #2*, which evokes the scenic vistas of Gates Mills itself.

Gatsby Gallery Antiques *(Cleveland Heights, Ohio)*
www.markbassett.com/pottery.htm

A small, multidealer fine-art gallery and antiques shop near the Schreckengost home, Gatsby Gallery Antiques specializes in nineteenth- and twentieth-century design. One of the dealers affiliated with the shop is Mark Bassett, author of *Cowan Pottery and the Cleveland School*. The shop owner, Chuck Bojack, is a big fan of Viktor and owns some of his watercolors, which will be on display.

Geauga West Library *(Chesterland, Ohio)*
www.geauga.lib.oh.us/GCPL/libinfo/GeaugaWest/GWinfo.htm

The Geauga West Library is part of the Geauga County, Ohio, public library system, which was recently rated in the "Top 10" by Hennen's American Public Library Rankings, an annual evaluation of libraries. The Geauga West library is located in Chesterland, Ohio, and in 2005 circulated 400,000 materials. Two staff members of the Viktor Schreckengost Foundation are graduates of West Geauga High School (located near the library); they arranged for the library's participation in the NCE and loaned pieces from their own Schreckengost dinnerware collections for the exhibit.

Grant Elementary School *(Lakewood, Ohio)*

Grant Elementary School in Lakewood, Ohio, is home to perhaps the only foundation created and run by elementary school children. Dina Bluemel, a gifted-education teacher at Grant Elementary, introduced the school to Viktor Schreckengost's legacy after attending the Cleveland Museum of Art's Schreckengost show in 2000. Inspired by Viktor's example as an artist, entrepreneur, and humanitarian, the students designed their own paper versions of Viktor's famous *Jazz Bowl*. They exhibited their designs at the Beck Center for the Arts in Lakewood, produced note cards featuring their artwork, then used the proceeds from the sale of the note cards to start their own foundation. Cowan Pottery

Museum and the Schreckengost Foundation provided assistance with the project, as did the Mandel Center for Non-Profit Organizations at Case Western Reserve University.
(See http://www.viktorschreckengost.org/Archives/News/smallthatjazzupdate605 for an article about the Grant Elementary project.)

Hand Artes Gallery *(Truchas, New Mexico)*
www.highroadnewmexico.com/handartes.html

Not far from the home of the late Georgia O'Keeffe in the Sangre de Cristo foothills is Hand Artes Gallery. The gallery, owned by Bill Franke, specializes in contemporary southwestern and Spanish-American art. Paintings, sculpture, furniture, textiles, folk art, and clay and glass works by established artists can be found outdoors in the Sculpture Garden or inside in the gallery.

Hagley Museum and Library *(Wilmington, Delaware)*
www.hagley.lib.de.us

The Hagley Museum and Library collects, preserves, and interprets the unfolding history of American enterprise. Hagley is located on 235 acres by the Brandywine River in Wilmington, Delaware, and houses an important collection of manuscripts, photographs, books, and pamphlets documenting the history of American business and technology. The library and museum will be exhibiting four of Viktor's industrial design sketches.

High Museum of Art *(Atlanta, Georgia)*
www.high.org

The High Museum of Art in midtown Atlanta, Georgia, began in 1905 as the Atlanta Art Association. In 1926, the museum moved to the former Joseph M. High residence. Considered the leading art museum in the southeastern United States, the High has more than 11,000 works of art in its permanent collection and the country's eighth-largest museum membership. Nearly 500,000 visitors annually are attracted to the exhibitions and educational programs. The High's extensive collections include African, American, and European art, folk art, modern and contemporary art, decorative arts, and photography. A *Jazz Bowl* and a blue *Fish Vase*, owned by the High, will be on display for the National Centennial Exhibition.

Historic Kirtland Visitor's Center *(Kirtland, Ohio)*
www.visithistorickirtland.org

Historic Kirtland is a small village of original, reconstructed, and restored buildings representing 1830s Kirtland, Ohio. A working sawmill, the only reconstructed ashery in the country, an original 1830s general store, a rebuilt 1819 red schoolhouse, and other buildings are open for tours. The

Newel K. Whitney Store restoration received the President's Historic Preservation Award in 1988 for its historical authenticity. Historic Kirtland hosted an exhibition of many of Viktor's religious themed artworks in 2004 and an antique toy show in January 2006. *St. Peter the Fisherman* will be on display in the visitors' center for the National Centennial Exhibition.

Hood Museum of Art—Dartmouth College *(Hanover, New Hampshire)*
www.hoodmuseum.dartmouth.edu

The Hood Museum of Art, located at Dartmouth College in Hanover, New Hampshire, is one of the oldest college museums in the country, dating back to at least 1772. With more than 60,000 objects of art and artifacts, the Hood is also one of the country's largest college museums. Important holdings include an ethnographic collection of 30,000 Native American, African, and Melanesian objects along with artworks representing diverse traditions of Europe, Asia, and the United States. American portraits and landscape paintings, as well as American and European prints, drawings, and watercolors are a part of this enormous collection. Most of Viktor's watercolors are in private collections rather than museums, but one of the watercolors owned by the Hood is Viktor's *Hurricane Still-life*.

Huntington Museum of Art *(Huntington, West Virginia)*
www.hmoa.org

The Huntington Museum of Art began fifty years ago with a gift of fifty acres of land from a prominent Huntington citizen, Herbert Fitzpatrick. Since then, the museum has become the finest in West Virginia, with glass from the Ohio Valley, Appalachian folk art, American and European nineteenth- and twentieth-century furniture, sculpture, and firearms added to its collections. Educational programs for every age level are offered as well as a variety of exhibitions. The museum will be showing three of Viktor's ceramic sculptures during the National Centennial Exhibition.

Juvenile Automobile Pedal Car Co.

Juvenile Automobile Pedal Car Co. features hundreds of toys, including a Steelcraft Fire Truck designed by Viktor.

Kelvin Smith Library—Case Western Reserve University *(Cleveland, Ohio)*
http://library.case.edu/ksl/index.html

Case Western Reserve University, located in University Circle, the cultural hub of Cleveland, is a well-known center of education for health care, law, science, and business. It shares an urban park setting with Cleveland Institute of Art and other important Cleveland institutions in University Circle. Case is

a major research university, ranked twelfth among private universities in federal funding for research. The Kelvin Smith Library, at the heart of campus, strives to be "the world's most innovative research library system." Case often partners with Cleveland Institute of Art, Viktor's alma mater. Henry Adams, Ph.D., is a professor of American Art at Case. He is author of this book and previous publications about Viktor Schreckengost, including the catalogue for the 2000–2001 exhibition he curated at the neighboring Cleveland Museum of Art, *Viktor Schreckengost and 20th-Century Design*.

Kenneth Paul Lesko's Gallery

www.kennethpaullesko.com/index.htm

Kenneth Paul Lesko is a well-known dealer in twentieth-century art from Rocky River, Ohio. He exhibits at some of the better venues, such as the MIAMI MODERNISM art show, and offers quality material in established twentieth-century collection fields. Modern art paintings, sculpture, and Art Nouveau lamps are among his previous sales. Viktor's *Hunt Plate* is among his collection.

Kent State University Museum *(Kent, Ohio)*

http://dept.kent.edu/museum/

Kent State University Museum on the campus of Kent State University in Kent, Ohio, is home to "one of the most comprehensive teaching collections of fashionable design from the eighteenth century to the present." The museum was opened in 1985 after Kent State was offered the largest and most valuable contribution since its founding. New York dress manufacturers Jerry Silverman and Shannon Rodgers bequeathed 4,000 costumes and accessories, 1,000 pieces of decorative art, and a 5,000-volume reference library in return for which the university created a museum and developed a curriculum in fashion design and merchandising. The costume collection is one of the best in the nation. Viktor's interest in costume design and scenery is a natural fit with the museum's mission.

King Otis Mounted Police Stables *(Cleveland, Ohio)*

www.clevelandmountedpolice.com

Popularly known as the Black Horse Troop, the Cleveland Mounted Police unit traces its history to the Cleveland Cavalry, formed in 1877. At its peak in 1932, the CMP had eighty-five horsemen and patrolmen. For decades they were known as the best precision unit of cavalrymen in the United States. In 1933 they won the International Drill Team Championship at the Chicago World's Fair. Over the course of their history, they have been invited to march in four presidential inaugural parades. Viktor created the O'Neill Memorial in 1949 to honor the role played by Hugh M. O'Neill in establishing the unit. The sculpture of a heroic horse's head was placed near the Troop A stables at East 38th Street.

Kirkland Museum *(Denver, Colorado)*
www.vancekirkland.org

Kirkland Museum was founded in 1996 to preserve the legacy of twentieth-century artist Vance Kirkland and the work of his contemporaries. Kirkland founded the School of Art at the University of Denver in 1929 and became a distinguished artist, producing 1,100 paintings over a fifty-four-year career. Kirkland's original studio is preserved as part of the museum. The Kirkland Museum collection includes more than 3,000 decorative artworks, focusing on the first seventy-five years of the twentieth century, including Arts & Crafts, Art Nouveau, Art Deco, Modern, and Pop Art. Kirkland was a classmate of Viktor at the Cleveland Institute of Art and threw ceramics with him at Cowan Pottery. Kirkland's art career in Denver as a painter, educator, and lifelong supporter of the music arts paralleled Viktor's career in Cleveland in many ways. Vance was a recipient of Viktor's annual ceramic Christmas cards. The museum owns several Schreckengost pieces, which will be displayed for the National Centennial Exhibition. At the top of the list are a *Poor Man's Jazz Bowl* and a *Danse Moderne Jazz Plate*. Several pieces of Free Form Primitive dinnerware, a Flower Shop platter, a nice selection of Jiffy Ware, and two small plates from American Limoges inscribed on the back "Greetings from Nadine and Victor Schreckengost" are also part of the collection.

L. E. and Thelma E. Stephens Performing Arts Center—Idaho State University *(Pocatello, Idaho)*
www.isu.edu/departments/theadanc/

The L.E. and Thelma E. Stephens Performing Arts Center, on the campus of Idaho State University in Pocatello, Idaho, is a new 11,000-square-foot facility. Three main performance areas in the center include an acoustically perfect grand concert hall, a drama theater, and an experimental theater. Viktor's lifelong interest in the performing arts makes this a perfect venue for his work.

Lake Erie Artists, Tower City Center *(Cleveland, Ohio)*
www.lakeerieartists.com

Cleveland's terminal tower was the second-tallest building in the world when it was completed in 1930. The building originally served as the Cleveland Union Terminal project, and now is home to a prominent shopping district known as Tower City Center. Lake Erie Artists is a new art gallery that has opened in Tower City.

Lakewood High School/Civic Auditorium *(Lakewood, Ohio)*
www.lakewoodcityschools.org

Since the first class graduated in 1885 from a small building on Warren Road, Lakewood High School has grown to become one of the finest high schools in Ohio. In 1954, when architect J. Byers Hays built an extension to the school, he asked Viktor to produce an appropriate sculpture to add visual

interest to the building. The original idea, apparent in the sculpture, was a likeness of Johnny Appleseed. However, the final result is an early settler planting trees of knowledge with the rising sun of the Ohio State seal and red cardinals, the state bird, in the background. The kneeling figure is 17½ feet tall, with a total width of 34 feet for the entire relief. The huge, colorful sculpture, designed to expand and contract with temperature changes, was a technical challenge.

Left Bank Art Gallery (St. Simons Island, Georgia)
www.leftbankartgallery.com

Left Bank Art Gallery, owned by Mildred Wilcox, deals in contemporary and modern art. The gallery provides expert advice to individual collectors or to design professionals for large projects. For forty years, Left Bank Gallery has offered artworks from nationally and internationally recognized artists. Mildred Wilcox was a friend of Bill Hannon, the late owner of Murray Company, for whom Viktor worked for more than thirty years. The Schreckengost watercolor on display, *26th Street toward the Ocean*, was owned by Bill Hannon.

Lehigh University Art Galleries (Bethlehem, Pennsylvania)
www.luag.org

The Lehigh University Art Galleries in the Zoellner Arts Center of Lehigh University maintains and develops the university's permanent art collection of more than 6,000 art and design objects. Thirty exhibitions a year at the three university campuses, focusing on contemporary topics in art and culture, are also under the auspices of the LUAG. The Zoellner Arts Center is a multimillion-dollar cultural center on the historic Asa Packer Campus of Lehigh University, home to the Music and Theatre departments.

Massillon Museum (Massillon, Ohio)
www.massillonmuseum.org

The Massillon Museum originally opened in 1933 as the Baldwin Museum on the homesite of James Duncan, who founded Massillon in 1826. The museum's mission is to collect and exhibit local and regional art and local historical artifacts and act as an integral part of the area's cultural activities. Massillon Museum has hosted a one-man show for Viktor, who participated in their annual art show. One of his watercolors is owned by the museum.

Midwest Museum of American Art (Elkhart, Indiana)
www.midwestmuseum.us

The Midwest Museum of American Art focuses on nineteenth- and twentieth-century American art. The permanent collection of more than 1,700 works includes original paintings by Grandma Moses

and Norman Rockwell, as well as many of Rockwell's hand-signed lithographs. The home of the museum is a magnificent neoclassical former bank building with nine galleries, one of which is in the old bank vault. On display through March for the NCE will be Viktor's Pursuit Plane pedal car.

Mint Museum of Craft & Design *(Charlotte, North Carolina)*
www.mintmuseum.org

Located in Charlotte, North Carolina, the Mint Museum of Craft & Design was founded in 1953 to preserve and document contemporary studio craft. International in scope, the collection includes ceramic, fiber, glass, metal, and wood artworks. Randy Schull's furniture designs, Harvey Littleton's studio glass, and Michael Sherrill's ceramics are part of the permanent collection.

Monty's Blue Plate Diner *(Madison, Wisconsin)*
www.foodfightinc.com/montys.htm

Known as a Madison gathering place since it opened in 1990, Monty's Blue Plate Diner is owned by Food Fight, a company that prides itself on creating a memorable dining experience in each of its nine very different restaurants. Monty's is a 1950s-style diner deluxe, where the color blue predominates. Even the entrees are served on blue plates.

Museum of Fine Arts, Boston *(Boston, Massachusetts)*
www.mfa.org

Opened on the nation's centennial (July 4, 1886) with an impressive collection of 5,600 works of art, the MFA is now a world-class museum with more than 450,000 works of art and more than one million visitors a year. The artwork dates from prehistoric to modern, with masterpieces from the greatest artists in history. The collection includes every category of art, from paintings to sculpture to decorative art. MFA owns the largest group of paintings by Claude Monet outside of Paris, plus paintings by Rembrandt, van Gogh, Gauguin, and Renoir. American artwork is represented by such artists as Mary Cassatt, Winslow Homer, John Singer Sargent, and John Singleton Copley. A new wing for American art is planned as part of the ambitious new MFA building project. In the meantime, a *Jazz Bowl*, a gift from collector and dealer John Axelrod, can be found on view in the Lee Gallery and online (Early 20th Century, American). A silk scarf with a motif from the *Jazz Bowl* was produced for sale through the gift shop.

National Baseball Hall of Fame *(Cooperstown, New York)*
www.baseballhalloffame.org

The recently renovated National Baseball Hall of Fame is the largest repository of baseball memorabilia and information in the world. It is also an international destination for baseball enthusiasts

and a shrine where homage is paid to the greatest players of the game. More than 350,000 visitors travel to Cooperstown annually to view 35,000 artifacts, 130,000 baseball cards, 500,000 images of baseball photos, and 10,000 hours of baseball footage. The research library contains 2.6 million items on the country's favorite sport. Viktor's *Baseball Plates* will be showcased for the National Centennial Exhibition among the 35,000 baseball artifacts.

National Ceramic Museum & Heritage Center *(Nelsonville, Ohio)*
www.hocking.edu/academics/perry_campus_and_learning_labs/national_ceramic_museum_and_heritage_center/

The National Ceramic Museum and Heritage Center, located near Zanesville, Ohio, is not only a place to see some of the best art pottery in the world, but also a learning lab for Hocking College students. The museum's collection contains many fine examples of art pottery and other pieces that date from the 1880s to the present. Today, as in the past, the region is home to many excellent pottery manufacturers, fine artists, ceramic sculptors, and potters.

Navy Art Gallery *(Washington, D.C.)*
www.history.navy.mil/branches/nhcorg6.htm

All aspects and eras of U.S. naval history are depicted in the Navy Art Collection. In all, the collection contains more than 13,000 works of art, including paintings, drawings, sculpture, and prints. Viktor Schreckengost served in the Navy during World War II, from 1943 to 1945, where he worked on the refinement of radar technology and developed three-dimensional terrain models to aid pilots. During research flights over the ocean and various parts of Europe, Viktor painted several watercolors. He was fascinated at the perception of color from high above the earth. He was also horrified at the destruction caused by war. His World War II paintings capture both of these emotions. Viktor was discharged from the Navy with a special blue ribbon and commendation for his skill and initiative.

Nevada Museum of Art *(Reno, Nevada)*
www.nevadaart.org

The Nevada Museum of Art, the oldest art organization in Nevada, was founded in 1931 as the Nevada Art Gallery. In 1989 the name was changed to the Nevada Museum of Art. In 2003, the present building opened, designed by internationally recognized architect Will Bruder, and inspired by the Black Rock Desert. Underlining the focus of the museum's collection on the land and environment, the unusual building is "an environmental statement about our surroundings." The museum's 1,900 works of art are organized into five areas: altered landscape, contemporary collection, Sierra Nevada/Great Basin, Historical, and E. L. Wiegland. Viktor's *Culver Air Trophy* will be shown as part of a traveling silver show.

New York Historical Society *(New York, New York)*

www.nyhistory.org

Opened in November 2000, the Henry Luce III Center for the Study of American Culture at the New York Historical Society comprises 21,000 square feet and displays nearly 40,000 objects from the museum's permanent collection. Interactive computer ports and audio tours allow greater on-site access to the vast collection, while the internet permits viewing of more than 40 percent of the collection. The astounding holdings of the museum include one of the best American portraiture collections; a vast number of American paintings dating from the colonial period; one of the nation's finest and earliest drawing collections, including 500 watercolors by Audubon; and one of the most comprehensive Tiffany lamp collections in the world. Viktor Schreckengost often visited New York to keep in touch with current fashions and did a lot of design work there. His most famous piece, the *Jazz Bowl*, was inspired by New York City nightlife.

Nighttown *(Cleveland, Ohio)*

www.nighttowncleveland.com

A full-service restaurant and the area's best jazz bring patrons back again and again to Cleveland's Nighttown. Named after the Dublin red-light district in James Joyce's *Ulysses*, the establishment is decorated Irish-pub style. The menu includes top-grade beef, milk-fed veal, and top musicians like Grammy Award–winning trumpet player and composer Terence Blanchard. Viktor and Gene Schreckengost, avid jazz fans, are regular patrons. *Big City Jazz*, a Schreckengost watercolor that features a saxophone, hangs on the wall at Nighttown. Viktor played saxophone and clarinet in a jazz band in high school.

Nora Eccles Harrison Museum of Art *(East Logan, Utah)*

www.usu.edu/artmuseum/

Nora Eccles Harrison Museum of Art, part of the Utah State University's School of Art, was opened in 1982 with a gift of the building and more than 400 ceramic objects from the museum's namesake. The museum consists of three specially designated exhibition spaces for the permanent collection, which now numbers more than 4,300 objects, one of the largest in the intermountain region. The main focus of the collection is works in all media by modern and contemporary artists, but especially those of the western United States. The Schreckengost watercolor *Composition, Pottery Forms* is part of the permanent collection.

Northern Clay Center *(Minneapolis, Minnesota)*

www.northernclaycenter.org

Northern Clay Center, opened in 1990, is completely focused on the advancement of the ceramic arts. An award-winning faculty teaches a full complement of classes in ceramics, for adults, youth, and children. Basic, intermediate, and advanced techniques, from handbuilding to use of the potter's wheel, are covered. Galleries provide outlets for the pottery and sculpture of seventy artists. The Ceramic Artists Project Grant program, funded by the Jerome Foundation of Saint Paul, Minnesota, provides working space, equipment, monetary assistance, and other support for talented, unestablished clay artists. More than 50,000 people visit NCC each year. Northern Clay hosted an exhibition of Viktor's dinnerware in 2004.

Nottingham-Spirk Design Associates *(Cleveland, Ohio)*

www.ns-design.com

Since 1972, Nottingham-Spirk Design Associates has grown to become one of the leading new product invention and design development groups in the United States, responsible for more than 400 patents and thousands of successful products with combined retail sales of over $30 billion. John Nottingham and John Spirk have been partners since they graduated together from Cleveland Institute of Art and immediately formed their own company. Both were protégés of Viktor Schreckengost, head of the Industrial Design department at CIA at the time. The plastic toys they designed turned Little Tikes into a $600 million company. The red Dirt Devil/Royal vacuum and the Crest SpinBrush™ toothbrush are two other well-known products. The old First Church of Christ Scientist building has been transformed into the new Nottingham-Spirk Innovation Center, whose mission echoes the mantra of their old mentor: to bring inspiration, creativity, and improved efficiency to new products. In 2005, Nottingham-Spirk hosted a gala fund-raising event at their new facility, during which they exhibited and paid tribute to the design legacy of their former teacher, Viktor Schreckengost.

Ohio Historical Society *(Columbus, Ohio)*

www.ohiohistory.org

The Ohio State Historical Society was formed in 1885 as the Ohio State Archaeological and Historical Society. Its objective was to document Ohio's prehistoric heritage and progress and contributions to the nation's growth and development. Today, as the state's agent in historical matters, the society manages the state archives, administers the state's historic preservation office, and operates a network of sixty historic sites and museums. The society's collection consists of more than 1.5 million items pertaining to Ohio's history.

Pedaling History Bicycle Museum *(Orchard Park, New York)*

www.pedalinghistory.com

The Pedaling History Bicycle Museum had it beginnings in the 1970s when Carl and Clarice Burgwardt started a family hobby by purchasing an old highwheel. More than thirty years later, the "hobby" has become a passion, filling a museum with the largest and most complete cycling collection in the country. Three hundred bicycles on exhibit, 95 percent of them American-made, include the earliest models and some of the most unique, such as three military bikes built in the 1890s, equipped with a Colt machine gun, rifles, and pistols. The history of the bicycle and the social changes it engendered are incorporated into the exhibits, along with thousands of pieces of cycling-related paraphernalia. Viktor Schreckengost's influence on bicycles through his years of designing for Sears and Murray can be seen in a J. C. Higgins and a Murray bike owned by the museum.

Peninsula Library *(Peninsula, Ohio)*

www.peninsulalibrary.org

The Peninsula Library and Historical Society is more than fifty years old. Besides functioning as a standard lending library, the Peninsula Library and Historical Society preserve the history of communities in the Cuyahoga Valley, and to an extent, of Summit County and Northeast Ohio. The Peninsula Museum is a branch of the Library and Historical Society and is located on the second floor of the historic Boston Township Hall. The Library and Historical Society always enjoys the opportunity to be involved with Viktor.

Philbrook Museum of Art *(Tulsa, Oklahoma)*

www.philbrook.org

The Philbrook Museum of Art was originally completed in 1927 as an exquisite Italianate villa for the family of Tulsa oil baron Waite Phillips. The palatial, but sturdily constructed steel framework and concrete structure was easily converted to a public facility and gallery space after it was donated by the family. The formal Italian and informal English gardens built for Philbrook contribute to the tranquility of the setting. The art collection includes nineteenth-century European, African, American, Native American, Renaissance, and Baroque pieces.

Plains Art Museum *(Fargo, North Dakota)*

www.plainsart.org

The Plains Art Museum began in the mid-1960s as the Red River Art Center and was housed in the old post office of Moorhead, Minneapolis. Through hard work and long-term planning, a turn-of-the-twentieth-century warehouse in Fargo, North Dakota, was acquired and renovated into an art museum, which opened in 1997. In 2003, the longstanding dream of accreditation by the

American Association of Museums was realized. "The Plains Art Museum brings people and art together," according to the mission statement; this concept is carried out uniquely in the "Rolling Plains Art Gallery," a climate-controlled gallery in a semitrailer that carries original artwork and an art educator to communities throughout North Dakota and Minnesota. The permanent collection of the museum includes 2,400 pieces of regional, traditional American Indian, contemporary, and traditional folk art.

Princeton University Art Museum *(Princeton, New Jersey)*
www.princetonartmuseum.org

The Princeton University Art Museum was formed in 1947 from an earlier museum collection, and is now is one of the leading university art museums in the nation, with more than 60,000 works of art. Ancient to contemporary art is represented in collections from the Mediterranean, Western Europe, China, the United States, and Latin America. Chinese art is one of the museum's greatest strengths. Six thousand Asian artworks are featured on an Asian Art web site, which is integrated with an on-line education center for all ages. With such an outstanding collection, it is no wonder that Princeton University Art Museum also owns a *Jazz Bowl* by Viktor Schreckengost, which represents twentieth-century American ceramics.

Pro Football Hall of Fame *(Canton, Ohio)*
www.profootballhof.com

The Pro Football Hall of Fame was built in Ohio because football's roots were here and the locals were organized and passionate enough to raise the money and donate the ground for a shrine to this all-American sport. The forerunner to the NFL, the American Professional Football Association, was founded in Canton in 1920. The Hall of Fame, opened in 1963 with 19,000 square feet, has since undergone three expansions and a $1.6 million renovation to become its present size of 82,000 square feet. The Hall of Fame Gallery, which holds a bronze likeness of each Hall of Famer, is an interactive experience. In 2003, the Game Day Stadium opened, where pro football action is presented in a turntable theater featuring a 20' × 42' Cinemascope screen. The Hall of Fame boasts the world's most comprehensive archives on professional football. Around 200,000 visitors come each year, from every state in the Union and seventy foreign nations. Viktor produced a series of ceramic sports plates, one of which was the *Football Plate*.

Rachel Davis Fine Arts Center *(Cleveland, Ohio)*
www.racheldavisfinearts.com

In 1992, Rachel Davis opened her gallery, which specializes in nineteenth- and twentieth-century American and European fine and decorative arts. Her education in art history and chemistry and

her extensive business background in the field of authentication and documentation of fine arts and antiques qualify her to do appraisals of fine art and estate liquidations. She is very familiar with Viktor's work, which often passes through her auction gallery.

Regina A. Quick Center for the Arts *(St. Bonaventure, New York)*
www.sbu.edu/go/arts-center/index.htm

The Regina A. Quick Center for the Arts, on the campus of St. Bonaventure University, opened in 1995 as the home of campus art activities and a cultural hub for western New York. The center includes a theater, a museum, and instructional areas for art and music. The Quick Center is the only centennial venue focusing exclusively on the religious works of Viktor's multifaceted career. Senior Curator of the Quick Center, Ruta Marino, describes the exhibit as "religiously themed works created over five decades by one of the most influential designers of the twentieth century."

Renwick Gallery, Smithsonian American Art Museum *(Washington, D.C.)*
www.americanart.si.edu/renwick/index.cfm

The Renwick Art Gallery, a branch of the Smithsonian American Art Museum, is located near the White House in Washington, D.C., and is housed in the city's first art museum. The purpose of the Renwick is "to collect, exhibit, study, and preserve American crafts and decorative arts from the nineteenth to twenty-first centuries." The museum focuses on one-of-a-kind pieces created from clay, fiber, glass, metal, and wood. A longtime exhibitor of Viktor's work, the Renwick houses eight of his pieces.

Rock and Roll Hall of Fame *(Cleveland, Ohio)*
www.rockhall.com

Although original plans called for New York City as the site for the proposed Hall of Fame, Cleveland, Ohio, where rock and roll originated, was eventually chosen. Famed architect I. M. Pei designed the striking monument to rock stars and their music, which was opened on the shore of Lake Erie in 1995 at a cost of $84 million. The exhibits, videos, concerts, artifacts, lectures, and other events since hosted, along with the multitude of celebrities toasted, is legendary. Prints of *Rock Jazz Bass*, a Schreckengost watercolor previously displayed at the Rock and Roll Hall of Fame, are sold in the gift shop. During the signing party for Viktor's poster after Christmas of 2001, Terry Stewart, head of the Rock and Roll Hall of Fame, quipped "this is a better crowd than we get for rock stars" and observed that "all of America used Viktor's stuff." A personalized embroidered jacket was presented to Viktor from the Hall.

Roxboro Elementary School *(Cleveland Heights, Ohio)*
www.chuh.org/RoxE/RoxEl.html

Roxboro Elementary School began in 1901 as a two-room frame building on Fairmount Road near Cedar Avenue. After major remodeling and reconstruction over the years, Roxboro became a magnet school for the arts in 1985. Viktor Schreckengost designed the "Rox burro" logo used for many years on the PTA bulletins and school stationery. The logo was a charming little burro carrying books on his back.

Salem Historical Society *(Salem, Ohio)*
www.salemohio.com/historicalsociety/

The Salem Historical Society was formed in 1947 to preserve Salem's history. One-room schools, clothing, toys, kitchens, and a doctor's office are some of the themes covered in the various museum rooms. The museum houses a wealth of artifacts related to Salem history, including a special exhibit on Salem China Company. Viktor designed for the Salem China Company before and after World War II, serving as art director through the mid-1950s. Viktor's brother Don was a chief designer for Salem as well.

Schein-Joseph International Museum of Ceramic Art *(Alfred, New York)*
www.ceramicsmuseum.alfred.edu

The Schein-Joseph International Museum of Ceramic Art at Alfred University in Alfred, New York, was informally begun by Charles Fergus "Daddy" Binns, the founder of the College of Ceramics, as a resource for students to study and enjoy. Finally, in 1991, the museum was formally established, broadly focused on ceramics worldwide, with nearly 8,000 pieces. The collection contains graduate thesis ceramics from Alfred ceramists as well as pieces by internationally recognized artists. Schreckengost dinnerware is included. Ceramic history is illustrated by objects from past civilizations in various parts of the world, such as tomb sculpture from the Neolithic period, Nigerian market pottery, and European dinnerware. Modern ceramic applications, including a femoral hip joint replacement, are part of the collection. Guy Cowan, Viktor's first employer and longtime friend, attended Alfred's College of Ceramics; Viktor's brother Don Schreckengost taught there; and Viktor received the Binns medal. Viktor was also on the advisory committee for the College of Ceramics.

Sculpture Center *(Cleveland, Ohio)*
www.sculpturecenter.org

The Sculpture Center was founded by David Davis, a longtime friend of Viktor Schreckengost. Its vision statement is deceptively simple: "Make sculpture part of the public discussion." The center, with the help of others, is accomplishing its mission. Between 1996 and 2002, nineteen important public sculptures were conserved, from a large grouping around Cleveland Museum of Art to *General Moses*

Cleaveland in Cleveland Public Square to Schreckengost's Hugh O'Neill Memorial at the Cleveland Police Stables. The center also sponsors the "Window to Sculpture" program with Cleveland State University Art Gallery and the juried show of Ohio sculptors entitled "On a Pedestal" to encourage emerging artists. This year, Viktor will serve as juror of the "On a Pedestal" Show. Viktor's work, shown previously at the center, will be the focus of a June exhibition.

Sebring Historical Society *(Sebring, Ohio)*

The Sebring Historical Society was founded in the late 1980s. This enthusiastic group, of which Viktor is a member, has built a foundation of significant archival material relevant to Sebring's dinnerware industry and all other aspects of businesses and social life. They are in the last phase of restoration of the old Strand Theatre, which serves as their museum. Their collection includes many pieces of dinnerware designed by Viktor, who was born and raised in Sebring. Various individuals in the community also own artwork and artifacts related to the Schreckengost family. The family home is still standing on Indiana Avenue and is now owned by Paul Schreckengost, Viktor's nephew.

Severance Hall *(Cleveland, Ohio)*
www.clevelandorch.com/html/index.asp

Severance Hall, the opulent Art Deco home of the world-famous Cleveland Orchestra, was completed in 1931. A $1 million gift from John and Elisabeth Severance for a home for the Cleveland Orchestra was the gift originally pledged in 1928, but her untimely death shortly afterward prompted John to invest $7 million, instead, of his own and donated money to build a memorial to Elisabeth. The result was a state-of-the-art world-class concert hall whose acoustics helped the Cleveland Orchestra to develop its hallmark sound. In January 2000, after a $36 million dollar restoration and expansion, the building is hailed again as one of the world's best concert halls, visually and acoustically. Viktor created cover art for the Cleveland Orchestra. His rendering of Severance Hall in a 1980 calendar of famous Cleveland landmarks remains a much sought-after print.

Slater Memorial Museum—Norwich Free Academy *(Norwich, Connecticut)*
www.norwichfreeacademy.com/slater_museum/

Slater Memorial Museum, built in 1884, was gifted by William A. Slater as a memorial to his father, John Fox Slater. The elder Slater was a philanthropist who established a $1 million education fund, the largest of its kind in his day. A museum and art gallery were to be included in the edifice built at Norwich Free Academy. The permanent collection contains one of the three largest cast collections of classical artworks in the United States. Art from five continents comprises the holdings, with a fine collection of American nineteenth-century paintings. Two ceramic pieces by Viktor are owned by Slater Memorial Museum.

Smith Collection Museum *(Lincoln, Nebraska)*

www.speedwaymotors.com

Smith Collection Museum, founded by "Speedy" Bill and Joyce Smith in 1992, reflects the couple's lifelong passion for the automotive racing and street-rod industries. Bill Smith is owner and founder of Speedway Motors, a leading racing and performance outlet. A noted racer himself and builder of race engines, Smith spent more than fifty years gathering the world's most complete collection of antique and exotic racing engines and memorabilia plus seventy-five world-class race and special interest cars. He also collects tin-toy and gas-powered cars. His pedal car collection numbers more than 700—some more than a hundred years old. Not surprisingly, Smith also owns Blue Diamond Classics, the world's largest pedal car parts manufacturer and supplier. Viktor Schreckengost's involvement in the design and mass production of pedal cars for Murray Company from 1938 through the 1970s revolutionized the industry. His Pursuit Plane and his Champion models are the most widely recognized. The Smith Collection Museum owns more than fifteen of his pedal cars.

Smithsonian Archives of American Art *(Washington D.C. and New York, New York)*

www.aaa.si.edu

Founded in 1954, the AAA collects, maintains, and provides access to the largest collection of visual arts documentation in the nation. About sixteen million documents in the form of letters, photographs, diaries, business records, scrapbooks, etc. are available for research, either on microfilm or through the more recent technology of digitization. The lives and experiences of living artists are recorded through the AAA oral history project. The Archives has taken interest in Viktor's work for many years. Photographs of his dinnerware designs and sculptures, along with three microfilmed scrapbooks, are part of the AAA collection, and a section of Viktor's archive associated with his American Limoges dinnerware career is being gifted to the AAA by the Viktor Schreckengost Foundation.

South Dakota Art Museum *(Brookings, South Dakota)*

www3.sdstate.edu/Administration/SouthDakotaArtMuseum

Founded in 1947 and still the only accredited art museum in the state, the South Dakota Art Museum performs the role of the state's art museum. In 2000, a $1.9 million expansion and remodeling created new galleries and the Kids' Sensation Station. The museum's collection of 6,000 objects, local to international in origin, emphasize South Dakota and surrounding area. Paintings, drawings, prints, photographs, textiles, sculptures, and Native American artifacts and art are part of the collection. The permanent collection is used extensively for exhibitions, educational outreach,and scholarly research.

Southeastern Pedal Car Swap Meet *(Sevierville, Tennessee)*
www.pedalcarnews.com/home.htm

The Southeastern Pedal Car Swap Meet is the new version of Bob Ellsworth's former pedal car convention, the Southeastern Pedal Car Show. In the past, collectors, dealers, and enthusiasts from all over the country and beyond gathered for a showing of 1,000 or more pedal cars, including some of the rarest in the world. One pedal car newsletter described it as "a very large family reunion of pedal car lovers" where "grown men turn into little boys once more," and "trading is intense." This year the Swap Meet, which will not include a formal show, will be held May 3–6, 2006, at the Comfort Inn Suites in Sevierville, Tennessee. Bob Ellsworth will be showing a Viktor Schreckengost–designed Murray Torpedo pedal car.

St. Louis Antique Toy Show *(St. Louis, Missouri)*
www.andystoys.com

Antique toy expert Larry Waldman, who has consulted extensively with the Viktor Schreckengost Foundation in the development of a new Schreckengost toy exhibition, attends this annual antique toy show. He will be exhibiting examples of Schreckengost toys from his private collection at the toy show this year.

St. Paul's Episcopal Church *(Cleveland Heights, Ohio)*
www.stpauls-church.org

St. Paul's Episcopal Church, founded in 1846, is well known for its love of music and support of the visual arts in Cleveland Heights, Ohio. "Through support for the arts, we experience God in the beauty of creation. . . ." The South Wing Gallery of the church hosts four to five shows annually, with works by regional and national artists. The use of visual arts is found throughout the church in sculpture, stained glass, and tapestries. Woodcarvings such as the eagle on the lectern were designed by Viktor Schreckengost and carved by Jim Fillous. The altar screen and oak and grape leaf motifs in the knave are also Viktor's design. J. Byers Hays was architect for the South Wing Gallery; he worked with Viktor on many other projects as well.

Stamford Museum & Nature Center *(Stamford, Connecticut)*
www.stamfordmuseum.org/home.html

The Stamford Museum and Nature Center, founded in 1937, is a 118-acre educational and recreational complex of nature, art, and history. All ages enjoy the working farm; the Manor house with exhibition galleries for history, science, and art; and the planetarium/observatory. These resources, along with the art and dance studios, clay kiln and wheels, and the Science Center are used to teach year-round classes in nature, art, and history for all ages. Temporary exhibits are designed to engage

all ages. For example, two of Viktor's pedal cars were part of their 2004 exhibit *Pedal to the Metal: A History of Children's Pedal Cars*.

Tacoma Art Museum *(Tacoma, Washington)*
www.tacomaartmuseum.org/default.asp

The Tacoma Art Museum was founded by volunteers as the Tacoma Art Association in 1935. The museum moved around to five different locations until its own home was finally opened in 2003. American, European, and Asian art are featured in the permanent collection, with an emphasis on art and artists from the Northwest. Two of Viktor's pieces will be showing in their upcoming show, *The Great American Thing*.

Tallahassee Antique Car Museum *(Tallahassee, Florida)*
www.tacm.com

Tallahassee Antique Car Museum, owned by businessman DeVoe Moore, pays homage to history's classy automobiles, among other things. The eighty-one cars in the collection range from the 1894 Duryea 2 cylinder prototype to a 2001 Plymouth Prowler. A variety of other collectibles that caught the fancy of Moore are also on display, among them pristine pedal cars from bygone days. At least thirteen of the cars in the permanent collection of over one hundred were designed by Viktor Schreckengost, including a Pursuit Plane, a Torpedo, and a Champion, all manufactured by Murray.

Trader Fred's Antique Toys *(Thetford Center, Vermont)*
www.traderfreds.com/contact.htm

Trader Fred's Antique Toys, opened in 1973, specializes in the sale of antique toys, and the repair and restoration of old clocks and guns. Among the antique toys is a working Murray Fire Chief Pedal Car from 1961—the only year with starburst hubcaps—designed by Viktor Schreckengost.

Treats *(Rocky River, Ohio)*

Treats of Rocky River is a franchise of the Treats Corporation, which started as a single location in Yorkville, Toronto. Treats sells a large variety of fresh-baked goods, a variety of gourmet coffees and beverages, and, in many locations, light lunches. Rocky River was home to Cowan Pottery where Viktor created his famous *Jazz Bowl* in 1930. Treats of Rocky River has the largest collection of Cowan pottery in the world. On permanent display is Schreckengost's *Fish Vase*, created at Cowan in 1931 with the same drypoint technique used for the *Jazz Bowl*.

U.S. Navy Museum *(Washington, D.C.)*

www.history.navy.mil/branches/nhcorg8.htm

The U.S. Navy Museum is part of the U.S. Naval Historical Center, and is located in the Washington Navy Yard in southeast Washington, D.C. Viktor Schreckengost, a lieutenant in the Navy during World War II, was assigned to the Navy's Section of Special Devices. There he worked on radar recognition and three-dimensional mapmaking techniques, among other projects.

University Art Galleries *(Akron, Ohio)*

www3.uakron.edu/art/galleries.shtml

University Art Galleries are the galleries of the Myers School of Art at the University of Akron. The Emily Davis Gallery, which is the main visual fine-arts gallery, presents about twelve exhibits annually of contemporary artists. The major rubber companies of Akron commissioned Viktor to design costumes completely from synthetic rubber materials for the annual, lavish Akron Rubber Ball. The fanciful costumes represented the elements and resources used to create rubber.

University of Kentucky Art Museum *(Lexington, Kentucky)*

www.uky.edu/ArtMuseum/

The University of Kentucky Art Museum maintains a growing permanent collection of nearly 4,000 European and American paintings, sculptures, prints, drawings, photographs, and decorative arts. There are also holdings in art of the Americas, Africa, and Asia. This venue contacted the Viktor Schreckengost Foundation with the information that it owns two Schreckengost pieces that the Foundation had previously been unable to locate. The two sculptures, *Leghorns* and *Caw caw caw caw caw*, were privately owned works that were bequeathed to the University of Kentucky Art Museum in Lexington.

University of Wyoming Art Museum *(Laramie, Wyoming)*

www.uwyo.edu/artmuseum/

The University of Wyoming Art Museum, established in 1972, is located in the architecturally acclaimed Centennial Complex designed by Antoine Predock. With the challenging mission to "collect, preserve, exhibit, and interpret the breadth of the visual and cultural artifacts throughout time," the permanent collection has grown to include more than 7,000 objects including paintings, drawings, and prints of European and American origin; Persian and Indian miniatures; Japanese prints; decorative arts; crafts; and Native American and African artifacts.

Wadsworth Atheneum Museum of Art *(Hartford, Connecticut)*
www.wadsworthatheneum.org

Named in honor of its founder, Daniel Wadsworth, and the Greek goddess of wisdom, Athena, the Wadsworth Atheneum, founded in 1842, is America's oldest public art museum. Wadsworth donated his masterpieces of American art from the Hudson River School artists. A leader from the beginning in art collecting, the Wadsworth was the first American museum to acquire works by modernists such as Salvador Dali, Caravaggio, and Frederic Church. From the largest, most comprehensive collection of early American furniture in the country to modern work by Frank Lloyd Wright, the history of American furniture-making is richly illustrated. Viktor Schreckengost's *Poor Man's Jazz Bowl* is a part of this forward-looking collection.

Western Reserve Historical Society *(Cleveland, Ohio)*
www.wrhs.org

Founded in 1867, the Western Reserve Historical Society operates seven historical properties in northeast Ohio. It is the nation's largest private regional historical society. Located in Cleveland's University Circle, the site includes a research library, a history museum, and the Crawford Auto-Aviation Museum. The Auto-Aviation Museum contains nearly 200 automobiles and aircraft, with emphasis on autos built in Cleveland starting in 1898. The earliest airplane is a circa 1912–14 Curtiss Hydroaeroplane. Located near Viktor's alma mater, Cleveland Institute of Art, the Western Reserve Historical Society offers a glimpse of Cleveland life as it was during his college years.

Westlake Porter Public Library *(Westlake, Ohio)*
www.westlakelibrary.org

Located in Westlake, Ohio, the public library has been serving the community since 1884. The mission of the library is ". . . to educate, empower, enlighten, and excite." The present site was reopened in 2002 after an expansion more than doubled the space to 75,000 square feet. The modern facility offers a drive-up window, a reading garden, a café, and a gift shop along with traditional and state-of-the-art library services.

Wolfsonian Museum of American Art—Florida International University *(Miami Beach, Florida)*
www.wolfsonian.fiu.edu

The Wolfsonian-FIU is located in the heart of historic Miami Beach, within walking distance of the world-famous Art Deco hotels. Its fascinating collection of objects from the modern era (1885–1945) focuses on how art and design shape and reflect the human experience. The museum further engages the visitor by complementing its collection with thought-provoking discussions of the context and con-

nection among its objects. On permanent loan at the Wolfsonian is Viktor Schreckengost's Culver Air Trophy, which, during the National Centennial Exhibition, will be traveling in a silver exhibition.

World's Largest Toy Museum *(Branson, Missouri)*
www.worldslargesttoymuseum.com

The World's Largest Toy Museum in Branson, Missouri, features thousands of toys from the 1800s to the present. The museum's collection includes a Murray Pursuit Plane pedal car, a classic Schreckengost design.

Zanesville Art Center *(Zanesville, Ohio)*
www.zanesvilleartcenter.org

The Zanesville Art Center exists to "support the arts, artists, and arts education in southeastern Ohio, ensuring that fine arts and cultural programs are available for all." The art center is home to an extensive collection of Ohio glass and pottery, as well as works by other ancient and modern American and international artists. Through August 6, 2006, a major loan exhibition of Cowan Pottery works will feature Viktor's Art Deco work as well those of his first employer, Guy Cowan, and fellow employees of the famous Cowan Pottery Company. The exhibition is made possible by the renovation of the Cowan Pottery Museum in Rocky River, Ohio.

CATALOGUE OF IMAGES

The *Jazz Bowl* Story

page 25 (bottom right): *Danse Moderne Jazz Plate,* 1931. Ceramic. Owner: The Western Reserve Historical Society. Photographer: Gary Kirchenbauer.

Page 30 and 31?

Ceramics

page 32 (top left): Miscellaneous Figures, 1929–30. Ceramic. Photograph. The Viktor Schreckengost Archives.

page 32 (bottom left): Gazelle Figurine, ca 1929. Ceramic. Photograph. The Viktor Schreckengost Archives.

page 32 (top center): *Harlem Melodies,* 1930. H. 31.8 cm. Ceramic. Owner: John Axelrod.

page 32 (bottom center): Miscellaneous Figures, 1929–30. Ceramic. Photograph. The Viktor Schreckengost Archives.

page 32 (top right): Viktor's classroom in Vienna. Photograph. The Viktor Schreckengost Archives.

page 32 (middle right): Steer Figurine, ca 1929. Ceramic. Photograph. The Viktor Schreckengost Archives.

page 32 (bottom right): *Hand-Thrown Head,* 1929. Ceramic. Photographer: Gary Kirchenbauer.

page 34 (top): *Fish Vase,* blue, 1931. H. 15.2 cm. Ceramic. Owner: Mark Bassett. Photographer: Gary Kirchenbauer.

page 34 (bottom): *House Tops,* 1931. H. 22.9 cm. Ceramic. Owner: Viktor Schreckengost. Photographer: Gary Kirchenbauer.

page 35 (top): *Globular Vases,* 1931. H. 16.5 cm. Ceramic. Owner: Viktor Schreckengost. Photographer: Gary Kirchenbauer.

Page 35 (bottom): *Crusader Decanter,* 1931. H. 38.1 cm. Ceramic.

page 36 (top left): Sport Plate Sketch #1. Sketch. The Viktor Schreckengost Archives. Photographer: Derrill Dalby.

page 36 (bottom left): Sport Plate Sketch #2. Sketch. The Viktor Schreckengost Archives. Photographer: Derrill Dalby.

page 36 (top right): Sport Plate Sketch #3. Sketch. The Viktor Schreckengost Archives. Photographer: Derrill Dalby.

page 36 (bottom right): Sport Plate Sketch #4. Sketch. The Viktor Schreckengost Archives. Photographer: Derrill Dalby.

page 37 (left): Polo plate, 1934. Diam 24.3. cm. Ceramic. Owner: The Cowan Pottery Museum. Photographer: Gary Kirchenbauer.

page 37 (top right): Tennis plate, 1930. Ceramic. Owner: Viktor Schreckengost. Photographer: Gary Kirchenbauer.

page 37 (bottom right):	*The Chase* plate, 1930. Ceramic. Owner: Viktor Schreckengost. Photographer: Gary Kirchenbauer.
page 38 (top):	*The Hunt*, 1931. Diam 41.9 cm (bowl); 29.2 cm (plates). Ceramic. Owner: National Museum of American Art. Photographer: Gary Kirchenbauer.
page 38 (bottom):	*Leda and the Swan*, 1931. Diam. 41.8 cm. Ceramic. Owner: The Cleveland Museum of Art. Photographer: Gary Kirchenbauer.
page 39 (top left):	*Still Life* plaque, 1931. Diam 41.3 cm. Ceramic. Owner: The Cleveland Museum of Art. Photographer: Gary Kirchenbauer.
page 39 (top right):	*Plaque #5, Warrior Heads*, 1931. Diam 45.7 cm. Ceramic. Owner: The Cleveland Museum of Art. Photographer: Gary Kirchenbauer.
page 39 (bottom left):	*Neptune* plaque, ca 1935. Ceramic. Owner: Viktor Schreckengost. Photographer: Gary Kirchenbauer.
page 39 (bottom right):	*Janus* plaque, 1936. Diam 39 cm. Ceramic. Owner: Viktor Schreckengost. Photographer: Gary Kirchenbauer.
Page 40 (all):	Akron Art Institute exhibition, 1931. Photographs. The Viktor Schreckengost Archives.
page 41 (left column, top):	Ceramic Greeting Card, 1934. Ceramic. Owner: Viktor Schreckengost. Photographer: Derrill Dalby.
page 41 (left column, bottom):	Ceramic Greeting Card, 1935. Ceramic. Owner: Viktor Schreckengost. Photographer: Derrill Dalby.
page 41 (center column, top):	Ceramic Greeting Card, 1937. Ceramic. Owner: Viktor Schreckengost. Photographer: Derrill Dalby.
page 41 (center column, top middle):	Ceramic Greeting Card, 1937. Ceramic. Owner: Viktor Schreckengost. Photographer: Derrill Dalby.
page 41 (center column, bottom middle):	Ceramic Greeting Card, 1938. Ceramic. Owner: Viktor Schreckengost. Photographer: Derrill Dalby.
page 41 (center column, bottom):	Ceramic Greeting Card, 1939. Ceramic. Owner: Viktor Schreckengost. Photographer: Derrill Dalby.
page 41 (right column, top):	Ceramic Greeting Card, 1940. Ceramic. Owner: Viktor Schreckengost. Photographer: Derrill Dalby.
page 41 (right column, middle):	Ceramic Greeting Card, 1941. Ceramic. Owner: Viktor Schreckengost. Photographer: Derrill Dalby.
page 41 (right column, bottom):	Ceramic Greeting Card, 1942. Ceramic. Owner: Viktor Schreckengost. Photographer: Derrill Dalby.

Sculpture

page 52 (center):	*The Four Elements: Fire,* 1939. Ceramic. Owner: Viktor Schreckengost. Photographer: Gary Kirchenbauer.
page 52 (right):	*The Four Elements: Water,* 1939. Ceramic. Owner: Viktor Schreckengost. Photographer: Gary Kirchenbauer.
page 53:	*Glory, Glory,* ca 1938. H. 48.3 cm. W. 25.4 cm. D. 24.1 cm. Ceramic.
page 54 (left):	*The Abduction,* ca 1940. H. 34.6 cm. Ceramic. Owner: Viktor Schreckengost.Photographer: Gary Kirchenbauer.
page 54 (center):	*The Circus Group #1: Henri the Great,* 1935. H. 22.8 cm. Ceramic. Owner: Viktor Schreckengost. Photographer: Gary Kirchenbauer.
page 54 (top right):	*Blue Revel,* 1931. H. 127 cm. Oil. Owner: The Cleveland Museum of Art. Photographer: Derrill Dalby.
page 54 (bottom right):	*The Circus Group #1: Little Nel,* 1935. H. 14.4 cm. Ceramic. Owner: Viktor Schreckengost. Photographer: Gary Kirchenbauer.
page 55 (left):	*Shadrach, Meshach, and Abed Nego,* 1938. H. 71.7 cm. Ceramic.
page 55 (center):	*Harlem Melodies,* 1930. H. 31.8 cm. Ceramic. Owner: John Axelrod.
page 55 (top right):	*The Circus Group #1: Jum and Jumbo,* 1935. H. 25.8 cm. Ceramic. Owner: Viktor Schreckengost. Photographer: Gary Kirchenbauer.
page 55 (bottom right):	*The Circus Group #1: Six Cellinis,* 1935. H. 39.5 cm. Ceramic. Owner: Viktor Schreckengost. Photographer: Gary Kirchenbauer.
page 56 (top):	*Kublai,* 1950. H. 48.3 cm. W. 61.0 cm. Ceramic. Owner: Viktor Schreckengost. Photographer: Gary Kirchenbauer.
page 56 (bottom left):	*Tiger,* 1951. H. 26.2 cm. Ceramic. Owner: Viktor Schreckengost. Photographer: Gary Kirchenbauer.
Page 56 (bottom right):	*Leap-Frog,* 1950. H. 53.3 cm. Ceramic. Owner: Viktor Schreckengost. Photographer: Gary Kirchenbauer.
page 57 (top):	*Spring,* 1941. H. 38.1 cm. Ceramic. Owner: Everson Museum of Art. Photographer: Gary Kirchenbauer.
page 57 (bottom left):	*Brahman,* 1951. H. 48.3 cm. W. 63.5 cm. Ceramic. Owner: Viktor Schreckengost. Photographer: Gary Kirchenbauer.
page 57 (bottom right):	*Naama,* 1939. H. 45.7 cm. Ceramic. Owner: The Cleveland Museum of Art. Photographer: Gary Kirchenbauer.
page 58 (clockwise from top right):	*Impalas,* 1977. H. 27.9 cm. W. 35.6 cm. Ink with wash. Owner: Jennifer and Gregory Bloom; *Ram,* 1976. H. 35.6 cm.

W. 27.9 cm. Ink with wash. Owner: Sheila Bills; *Polar Bears #8*. H. 27.9 cm. W. 35.6 cm. Ink with wash. Owner: Don Campbell; *Rhinos #10*. H. 27.9 cm. W. 35.6 cm. Ink with wash. Owner: David Nowacek; *Elephants #25*, 1994. H. 27.9 cm. W. 35.6 cm. Ink with wash. Owner: Paul & Renee Schreckengost; *Giraffes #7*, 1995. H. 35.6 cm. W. 27.9 cm. Ink with wash. Owner: Don Campbell; *Camel*, 1953. H. 17.8 cm. W. 25.4 cm. Sketch. Owner: Viktor Schreckengost; *Bovine #9*, 1953. H. 16 cm. W. 22 cm. Graphite and watercolor. Owner: Viktor Schreckengost. Photographer: Gary Kirchenbauer.

page 59 (top): *The Dictator*, 1939. H. 33 cm. Ceramic. Owner: Everson Museum of Art. Photographer: Gary Kirchenbauer.

page 59 (left): *Apocalypse '42*, 1942. H. 40.6 cm. Ceramic. Owner: National Museum of American Art. Photographer: Gary Kirchenbauer

page 59 (right): *Filibuster*, 1949. H. 45.7 cm. Ceramic. Owner: Virginia Museum of Fine Arts. Photographer: Gary Kirchenbauer.

page 60: *Madonna*, 1931. H. 25.4 cm. W. 19.1 cm. D. 12.7 cm. Ceramic. Owner: Viktor Schreckengost. Photographer: Gary Kirchenbauer.

page 61 (top): *Peter the Fisherman* exhibition poster, 1976. Poster. The Viktor Schreckengost Archives.

page 61 (bottom left): *Peter the Fisherman*, 1954. H. 78.2 cm. W. 34.3 cm. Ceramic. Owner: Viktor Schreckengost. Photographer: Gary Kirchenbauer.

page 61 (bottom right): *St. Peter*, 1951. H. 76.2 cm. W. 43.2 cm. D. 35.6 cm. Ceramic. Owner: Viktor Schreckengost. Photographer: Craig S. Bara.

page 62 (top left): *Hesperornis #2*, 1950. H. 152.4 cm. W. 228.6 cm. Plaster. Owner: Cleveland Metroparks Zoo. Photographer: Gary Kirchenbauer.

page 62 (top right): *Diatryma*, 1950. H. 152.4 cm. W. 228.6 cm. Plaster. Owner: Cleveland Metroparks Zoo. Photographer: Gary Kirchenbauer.

page 62 (bottom left): *Dodo*, 1950. H. 152.4 cm. W. 228.6 cm. Plaster. Owner: Cleveland Metroparks Zoo. Photographer: Gary Kirchenbauer.

page 62 (bottom right): *American Bald Eagle #5*, 1950. H. 152.4 cm. W. 228.6 cm. Plaster. Owner: Cleveland Metroparks Zoo. Photographer: Gary Kirchenbauer.

page 63: *Early Settler (Johnny Appleseed)*, 1954. H. 533.4 cm. W. 1036 cm. Owner: Lakewood High School/Civic Auditorium.

Page 64: Sketches #1–8 , *Early Settler (Johnny Appleseed)*. H. 55.9 cm. W. 71.1 cm. Sketches. Owner: Viktor Schreckengost. Photographer: Derrill Dalby.

page 65 (left):	Viktor at work on *Early Settler*, 1954. Photograph. Owner: The Viktor Schreckengost Archives.
page 65 (right):	*Mammoths and Mastodons*, 1956. H. 381 cm. W. 762 cm. Photo of ceramic. Owner: Cleveland Metroparks Zoo. Photo: The Viktor Schreckengost Archives.
page 67 (top left):	*Polar Map*, *Zodiac Mural* sketch, 1955. H. 55.9 cm. W. 71.1 cm. Sketch. Owner: Viktor Schreckengost. Photographer: Derrill Dalby.
page 67 (top right):	*Time Zones*, *Zodiac Mural* sketch, 1955. H. 55.9 cm. W. 71.1 cm. Sketch. Owner: Viktor Schreckengost. Photographer: Derrill Dalby.
page 67 (middle left):	*Libra*, *Zodiac Mural* sketch, 1955. H. 55.9 cm. W. 71.1 cm. Sketch. Owner: Viktor Schreckengost. Photographer: Derrill Dalby.
page 67 (middle right):	*Gemini*, *Zodiac Mural* sketch, 1955. H. 55.9 cm. W. 71.1 cm. Sketch. Owner: Viktor Schreckengost. Photographer: Derrill Dalby.
page 67 (bottom left):	*Moon*, *Zodiac Mural* sketch, 1955. H. 55.9 cm. W. 71.1 cm. Sketch. Owner: Viktor Schreckengost. Photographer: Derrill Dalby.
page 67 (bottom right):	*Sun*, *Zodiac Mural* sketch, 1955. H. 55.9 cm. W. 71.1 cm. Sketch. Owner: Viktor Schreckengost. Photographer: Derrill Dalby.

Two-Dimensional Works

page 70 (clockwise from top right):	*Complimentary Parrot and Sunflower*, 1920s. H. 36.8 cm. W. 29.21 cm. Sketch. Owner: Viktor Schreckengost. Photographer: Derrill Dalby; *Cactus in Pink and Purple*, 1920s. H. 50.8 cm. W. 46.7 cm. Sketch. Owner: Viktor Schreckengost. Photographer: Derrill Dalby; *Merry Christmas with Candles*, 1920s. H. 17.1 cm. W. 24.1 cm. Sketch. Owner: Viktor Schreckengost. Photographer: Derrill Dalby; *Radiator Screen*, 1920s. H. 40.1 cm. W. 50.8 cm. Sketch. Owner: Viktor Schreckengost. Photographer: Derrill Dalby; *God with Book and Angels*, 1920s. H. 46.5 cm. W. 64.8 cm. Sketch. Owner: Viktor Schreckengost. Photographer: Derrill Dalby; *Ceiling Light*, 1920s. H. 35.6 cm. W. 50.8 Sketch. Owner: Viktor Schreckengost. Photographer: Derrill Dalby; *Textures*, 1920s. H. 35.6 cm. W. 27.9 cm. Sketch. Owner: Viktor Schreckengost. Photographer: Derrill Dalby.
page 71 (top left):	*Female Nude Sitting*, 1920s. H. 63.5 cm. W. 48.3 cm. Sketch. Owner: Viktor Schreckengost. Photographer: Derrill Dalby.

page 75 (left):	*Blue Revel* sketch, ca 1931. Sketch. Owner: Viktor Schreckengost.
page 75 (right):	*Moroccan Lutes*, 1934. H. 101.6 cm. W. 76.2 cm. Watercolor. Owner: Center for Therapy through the Arts.
page 76:	*November Morning*, 1937. H. 142.4 cm. Oil. Owner: Viktor Schreckengost. Photographer: Derrill Dalby.
page 77:	*November Morning Sketches #1–8*, ca 1937. Sketches. Owner: Viktor Schreckengost.
page 78 (top left):	*Looking Down*, ca 1945. H. 55.9 cm. W. 76.2 cm. Watercolor. Owner: Viktor Schreckengost. Photographer: Derrill Dalby.
page 78 (top right):	*Low Ceiling*, ca 1945. H. 55.9 cm. W. 76.2 cm. Watercolor. Owner: Viktor Schreckengost. Photographer: Derrill Dalby.
page 78 (middle left):	*Closing In*, ca 1945. H. 55.9 cm. W. 76.2 cm. Watercolor. Owner: Viktor Schreckengost. Photographer: Derrill Dalby.
page 78 (middle right):	*Scattered to Clearing*, ca 1945. H. 55.9 cm. W. 76.2 cm. Watercolor. Owner: Viktor Schreckengost. Photographer: Derrill Dalby.
page 78 (bottom):	*Banking Left*, ca 1945. Watercolor. Owner: Viktor Schreckengost.
page 79 (top left):	*Orchid (Blue)*, 1940s. H. 76.2 cm. W. 55.9 cm. Watercolor. Owner: Viktor Schreckengost. Photographer: Derrill Dalby.
page 79 (top right):	*All Quiet (France)*, 1946. H. 48.3 cm. W. 73.7 cm. Watercolor. Owner: Viktor Schreckengost. Photographer: Derrill Dalby.
page 79 (bottom):	*Orchid (Pink)*, 1940s. H. 50.8 cm. W. 54.6 cm. Watercolor. Owner: Viktor Schreckengost. Photographer: Derrill Dalby.
page 80 (top left):	*Wild Dream*, late 1940s. H. 55.9 cm. W. 76.2 cm. Watercolor. Owner: Viktor Schreckengost. Photographer: Derrill Dalby.
page 80 (bottom left):	*Studio Window*, 1947. H. 55.9 cm. W. 71.1 cm. Watercolor. Owner: Viktor Schreckengost. Photographer: Gary Kirchenbauer.
page 80 (top right):	*Dried Fruit*, 1946. H. 54.6 cm. W. 73.7 cm. Watercolor. Owner: Viktor Schreckengost. Photographer: Gary Kirchenbauer.
page 80 (bottom right):	*Floral #5*, 1973. H. 101.6 cm. W. 76.2 cm. Watercolor. Owner: Viktor Schreckengost. Photographer: Derrill Dalby.
page 81 (top left):	*Hewn Forms*. H. 55.9 cm. W. 76.2 cm. Watercolor. Owner: Viktor Schreckengost. Photographer: Derrill Dalby.
page 81 (top right):	*Composition, Pottery Forms*, 1952. H. 55.9 cm. W. 76.2 cm. Watercolor. Owner: Nora Eccles Harrison Museum of Art, Utah State University. Image used with permission.

page 81 (bottom):	*From the East.* H. 55.9 cm. W. 76.2 cm. Ink with wash. Owner: Viktor Schreckengost. Photographer: Derrill Dalby.
page 82 (top):	*Aaron with Serpent*, 1976. H. 101.6 cm. W. 76.2 cm. Ink with Wash. Owner: Helen Cullinan.
page 82 (bottom):	*St. Francis*, 1976. H. 76.2 cm. W. 101.6 cm. Watercolor. Owner: The Viktor Schreckengost Foundation.
page 83:	*The Apostles*, 1951. H. 76.2 cm. W. 55.9 cm. Watercolor. Owner: Gary Schreckengost.
page 84 (left):	Roxboro Elementary mascot logo, 1958. Sketch. Owner: Roxboro Elementary School.
page 84 (right):	Cover of *Today's Art* (August 1962) featuring Viktor's painting, *Morning Light on the Riverfront*. Magazine cover. The Viktor Schreckengost Archives.
page 85 (top left):	*Afterglow in the City*, 1974. H. 76.2 cm. W. 101.6 cm. Watercolor.
page 85 (bottom left):	*Uptown*, 1989. H. 101.6 cm. W. 76.2 cm. Watercolor. Owner: Bonnie & George Ewing.
page 85 (right):	*New York Buildings, Blue Background*. H. 97.5 cm. W. 74.9 cm. Watercolor.
page 86 (top):	*Bridge in Winter*, 1976. H. 55.9 cm. W. 76.2 cm. Watercolor. Owner: Chuck Rosenblatt.
page 86 (bottom):	*Tapestry of a City*, 1973. H. 55.9 cm. W. 76.2 cm. Watercolor.
page 87 (top left):	*In the Mood*, 1995. H. 101.6 cm. W. 76.2 cm. Ink with wash.
page 87 (top right):	*Baritone in Brass*, 1958. H. 76.2 cm. W. 55.9 cm. Ink with wash. Owner: Milton and Tamar Maltz.
page 87 (bottom left):	*Lute*, 1968. H. 73.7 cm. W. 94.0 cm. Ink with wash. Owner: Paul & Renee Schreckengost.
page 87 (bottom right):	*Rock Jazz Bass*, 1994. H. 101.6 cm. W. 76.2 cm. Watercolor. Owner: Bonnie & George Ewing.
page 88 (clockwise from top right):	*Little Italy*, 1979. H. 55.9 cm. W. 76.2 cm. Watercolor. Owner: Thomas P. Curran; *Entrance to the City*, 1979. H. 55.8 cm. W. 76.2 cm. Watercolor. Owner: International Printing; *Liberty Boulevard*, 1979. H. 55.9 cm. W. 76.2 cm. Watercolor; *Engine Number 21*, 1979. H. 55.9 cm. W. 76.2 cm. Watercolor. Owner: Weston Hurd LLP; *Bend in the Cuyahoga*. Watercolor; *Severance Hall*, 1979. H. 55.9 cm. W. 76.2 cm. Watercolor.
page 89 (clockwise from top right):	*Sacred Landmark*, 1964. H. 76.2 cm. W. 55.9 cm. Watercolor. Owner: Karen Webb Owen; *Garfield's Monument*, 1979. H. 55.9 cm. W. 76.2 cm. Watercolor; *Shaker Square*, 1979.

H. 55.9 cm. W. 76.2 cm. Watercolor. Owner: Mrs. George Dively; *Lakeside Northeast*, 1979. H. 55.9 cm. W. 76.2 cm. Watercolor; *West Side Market*, 1979. H. 55.9 cm. W. 76.2 cm. Watercolor; *Over the Bridge*, 1972. H. 55.9 cm. W. 76.2 cm. Watercolor.

page 90: *Guerrero XXI*, 1990. H. 101.6 cm. W. 76.2 cm. Watercolor. Owner: Viktor Schreckengost.

**page 91
(clockwise from top right):** *Guerrero Still Life VII*, 1989. H. 55.9 cm. W. 76.2 cm. Ink with wash. Owner: Amy Gomes; *Guerrero Still Life XIIB*, 1990. H. 55.9 cm. W. 76.2 cm. Ink with wash. Owner: Elizabeth Pastor; *Guerrero Still Life XXV*, 1991. H. 76.2 cm. W. 101.6 cm. Watercolor. Owner: Viktor Schreckengost; *Guerrero Still Life XXVI*, 1995. H. 55.9 cm. W. 76.2 cm. Watercolor. Owner: Jennifer and Gregory Bloom; *Guerrero Still Life X*, 1989. H. 55.9 cm. W. 76.2 cm. Ink with wash. Owner: Private collection; *Guerrero Still Life III*, 1989. H. 55.9 cm. W. 76.2 cm. Ink with wash. Owner: Private collection.

Theater and Costume Design

page 94 (left): Sambo marionette, Helen Joseph Puppets, 1934. Ceramic. Owner: Viktor Schreckengost. Photographer: Derrill Dalby.

page 94 (right): Pinocchio marionette, Helen Joseph Puppets, 1934. Ceramic. Owner: Viktor Schreckengost. Photographer: Derrill Dalby.

page 95 (left): Topsy marionette, Helen Joseph Puppets, 1934. Ceramic. Owner: Viktor Schreckengost. Photographer: Derrill Dalby.

page 95 (right): Sailor marionette, Helen Joseph Puppets, 1934. Ceramic. Owner: Viktor Schreckengost. Photographer: Derrill Dalby.

page 96 (top): *Murder in the Red Barn: Act 1 Scene 3*, ca 1937. H. 76.2 cm. W. 55.9 cm. Sketch. Owner: Viktor Schreckengost. Photographer: Derrill Dalby.

page 96 (bottom): *Murder in the Red Barn: Flat Catcher*, ca 1937. H. 55.9 cm. W. 76.2 cm. Sketch. Owner: Viktor Schreckengost. Photographer: Derrill Dalby.

page 97: *Murder in the Red Barn: Dame Marten*, ca 1937. H. 55.9 cm. W. 76.2 cm. Sketch. Owner: Viktor Schreckengost. Photographer: Derrill Dalby.

page 98 (top): *Poor Richard: Act 3 and 4*. H. 55.9 cm. W. 71.1 cm. Sketch. Owner: Viktor Schreckengost. Photographer: Derrill Dalby.

page 98 (bottom): *Poor Richard: Act 1*. H. 55.9 cm. W. 71.1 cm. Sketch. Owner: Viktor Schreckengost. Photographer: Derrill Dalby.

page 99 (top):	*Murder in the Cathedral: Knight 4.* H. 55.8 cm. W. 76.2 cm. Sketch. Owner: Viktor Schreckengost. Photographer: Derrill Dalby.
page 99 (bottom):	*Murder in the Cathedral: Thomas Becket (Bishop).* H. 55.9 cm. W. 76.2 cm. Sketch. Owner: Viktor Schreckengost. Photographer: Derrill Dalby.
page 100 (left):	Fire-Female costume sketch, Akron Rubber Ball, 1939. Watercolor. Owner: Akron Art Museum. Photographer: Gary Kirchenbauer.
page 100 (center):	Industry-Female costume sketch, Akron Rubber Ball, 1939. Watercolor. Owner: Akron Art Museum. Photographer: Derrill Dalby.
page 100 (right):	Air-Female costume sketch, Akron Rubber Ball, 1939. Watercolor of costume. Owner: Akron Art Museum. Photographer: Gary Kirchenbauer.

Industrial Design

page 103 (top):	Advertisement for White Motors Truck with cab-over-engine design by Viktor Schreckengost. Advertisement. The Viktor Schreckengost Archives.
page 103 (bottom):	Cab-over-engine design sketch, ca 1933. Sketch. Owner: Viktor Schreckengost.
page 104:	Alexis de Sakhnoffsky, *Esquire* magazine photo. Photograph. Owner: The Viktor Schreckengost Archives.
page 105 (top left):	Design for bicycle, blue. W. 50.8 cm. Sketch. Owner: Viktor Schreckengost. Photographer: Derrill Dalby.
page 105 (top right):	Design for bicycle, green. W. 50.8 cm. Sketch. Owner: Viktor Schreckengost. Photographer: Derrill Dalby.
page 105 (bottom left):	Design for bicycle, yellow. W. 50.8 cm. Sketch. Owner: Viktor Schreckengost. Photographer: Derrill Dalby.
page 105 (bottom right):	Design for bicycle, red with tank. W. 50.8 cm. Sketch. Owner: Viktor Schreckengost. Photographer: Derrill Dalby.
page 106:	Murray showroom, designed by Viktor Schreckengost. Photograph. The Viktor Schreckengost Archives.
page 107 (top):	Steelcraft City Delivery Truck, 1939. Metal. Owner: The Viktor Schreckengost Foundation. Photographer: Derrill Dalby.
page 107 (center):	Steelcraft World's Fair Bus, 1939. Metal. Owner: The Viktor Schreckengost Foundation. Photographer: Derrill Dalby.

page 112 (bottom):	Murray Mercury pedal car promotional drawing, 1947 Murray catalogue. Promotional brochure. The Viktor Schreckengost Archives.
page 113 (top):	Murray Speedway Pace Car, first issued 1959. Metal.
page 113 (middle):	Murray Good Humor Cart pedal car promotional drawing, 1955 Murray catalogue. Promotional brochure. The Viktor Schreckengost Archives.
page 113 (bottom):	Murray Police Cycle pedal car promotional drawing, 1955 Murray catalogue. Promotional brochure. The Viktor Schreckengost Archives.
page 114 (top):	Jolly Roger Flagship pedal car promotional drawing, 1967 Murray catalogue. Promotional brochure. Owner: The Viktor Schreckengost Archives.
page 114 (bottom left):	Jolly Roger dashboard compass detail. Undated promotional photograph. The Viktor Schreckengost Archives.
page 114 (bottom middle):	Jolly Roger lamp and staff ornamentation. Undated promotional photograph. The Viktor Schreckengost Archives.
page 114 (bottom right):	Jolly Roger outboard motor detail, 1967 Murray catalogue. Promotional brochure. The Viktor Schreckengost Archives.
page 117:	Murray Mercury bicycle, 1939. Metal. Owner: Jessica & Danielle Mercer.
page 118:	J.C. Higgins bicycle. Metal. Owner: Jessica & Danielle Mercer.
page 119:	Canadian bicycle enthusiast Mike Siewert with his restored 1951 Murray Strato-line bicycle. Photograph courtesy of Mike Siewert.
page 120 (top):	Sears Spaceliner bicycle, first issued 1965. Metal. Owner: Bicycle Museum of America. Photographer: Gary Kirchenbauer.
page 120 (bottom):	Murray Mark II Eliminator bicycle. Metal. Owner: Steve Keppler.
page 121:	Delta Rocket Ray bicycle headlamp. Metal. Owner: Viktor Schreckengost.
page 122 (left):	Delta Buddy flashlight. Metal. Owner: Viktor Schreckengost. Photographer: Derrill Dalby.
page 122 (middle):	Power Lite flashlight. Metal. Owner: Viktor Schreckengost. Photographer: Derrill Dalby.
page 122 (right):	Holophane lighting fixture. Metal. Owner: Viktor Schreckengost. Photographer: Derrill Dalby.
page 123 (top):	Murray-Go-Round Stroller advertisement, November 1951. The Viktor Schreckengost Archives.

page 137 (bottom left):	American Limoges Triumph shape, Silver Age pattern. Ceramic. Owner: Sebring Historical Society. Photographer: Derrill Dalby.
page 137 (bottom right):	Salem China Victory shape, Parkway pattern. Ceramic. Owner: James L. Murphy. Photographer: Derrill Dalby.
page 138 (top left):	Salem China Christmas Eve plate. Ceramic. Owner: Viktor Schreckengost. Photographer: Derrill Dalby.
page 138 (top right):	American Limoges Snowflake shape, Snowflakes pattern. Ceramic. Owner: Viktor Schreckengost.
page 138 (bottom left):	Salem China Christmas Eve dinnerware. Ceramic. Owner: Viktor Schreckengost. Photographer: Derrill Dalby.
page 138 (bottom right):	American Limoges Snowflake shape, blue glaze. Ceramic. Owner: Viktor Schreckengost. Photographer: Gary Kirchenbauer.
page 139 (top left):	Concept drawing #1 for Jiffy Ware, yellow. H. 50.8 cm. W. 76.2 cm. Sketch. Owner: Viktor Schreckengost. Photographer: Derrill Dalby.
page 139 (top right):	American Limoges Jiffy Ware, yellow. Ceramic. Owner: Viktor Schreckengost. Photographer: Derrill Dalby.
page 139 (middle left):	American Limoges Jiffy Ware, chocolate brown. Ceramic. Owner: Viktor Schreckengost. Photographer: Derrill Dalby.
page 139 (middle right):	American Limoges Jiffy Ware, red and white, 1942. Ceramic. Owner: Viktor Schreckengost. Photographer: Derrill Dalby.
page 139 (bottom):	Salem China Hotco in blue. Ceramic. Owner: Viktor Schreckengost. Photographer: Derrill Dalby.
page 140 (top left):	Concept drawing: Blue Water Pitcher #2. H. 50.8 cm. W. 76.2 cm. Sketch. Owner: Viktor Schreckengost. Photographer: Derrill Dalby.
page 140 (top right):	Concept drawing: Chicken Water Pitcher. H. 50.8 cm. W. 76.2 cm. Sketch. Owner: Viktor Schreckengost. Photographer: Derrill Dalby.
page 140 (middle left):	Concept drawing: Orange Water Pitcher. H. 50.8 cm. W. 76.2 cm. Sketch. Owner: Viktor Schreckengost. Photographer: Derrill Dalby.
page 140 (middle right):	Concept drawing: Red Water Pitcher #3 H. 50.8 cm. W. 76.2 cm. Sketch. Owner: Viktor Schreckengost. Photographer: Derrill Dalby.

page 147 (top row: left to right): American Limoges Manhattan shape, Silver Elegance pattern. Ceramic. Owner: Viktor Schreckengost. Photographer: Derrill Dalby; American Limoges Manhattan shape, Meerschaum pattern. Ceramic. Owner: Mark Bassett. Photographer: Gary Kirchenbauer; American Limoges Triumph shape, Bermuda pattern. Ceramic. Owner: Viktor Schreckengost. Photographer: Derrill Dalby; American Limoges Triumph shape, Jamaica pattern. Ceramic. Owner: Viktor Schreckengost. Photographer: Derrill Dalby.

page 147 (middle row, left to right): American Limoges Manhattan shape, Flower Shop pattern. Ceramic. Owner: Richard and Heather McClellan. Photographer: Derrill Dalby; Salem China Free Form shape, Aquaria pattern. First issued 1956. Ceramic. Owner: Viktor Schreckengost. Photographer: Derrill Dalby; Salem China Lotus Bud shape, Cherry Blossom pattern. Ceramic. Owner: Viktor Schreckengost; Salem China Lotus Bud shape, Moonflower pattern. Ceramic. Owner: Viktor Schreckengost. Photographer: Derrill Dalby.

page 147 (bottom row, left to right): Salem China Geranium pattern. Ceramic. Owner: Viktor Schreckengost. Photographer: Derrill Dalby; Salem China Flair shape, Peach and Clover pattern. Ceramic. Owner: Sunny Morton. Photographer: Derrill Dalby; Salem China Constellation shape, Jackstraw yellow pattern. Ceramic. Owner: Viktor Schreckengost. Photographer: Derrill Dalby; Salem China Contour shape, North Star pattern. Ceramic. Owner: Viktor Schreckengost. Photographer: Derrill Dalby.

page 148: Salem China Tricorne Shape dinnerware set, 1933. Ceramic. Owner: Dr. Stephen and Paula Ockner. Photographer: Gary Kirchenbauer.

page 149: Zodiac plate, ca 1930s; "Tom and Jerry" set, ca 1930s.

INDEX

Titles of artwork are shown in *italics*. Page numbers in **bold** refer to illustrations of artwork.